Kama Sutra

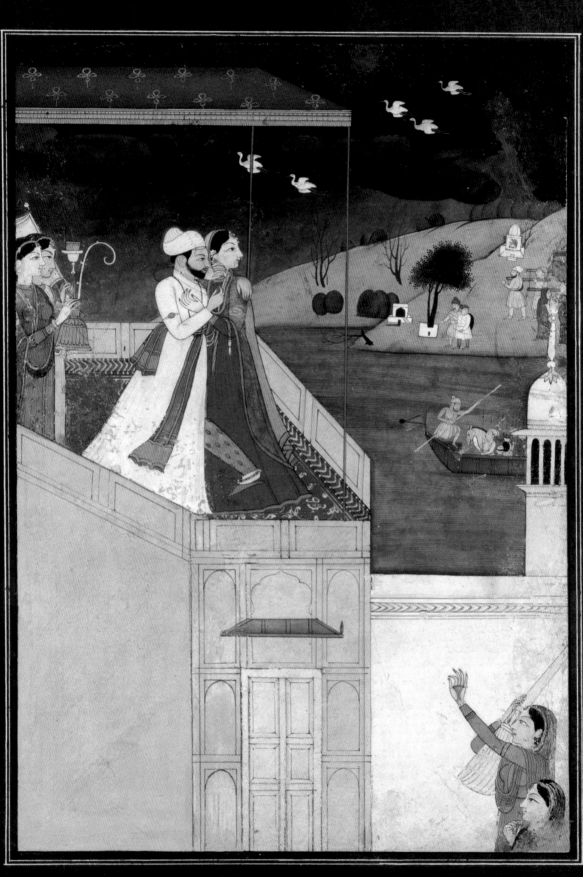

Kama Sutra

Lustre Press
·
Roli Books

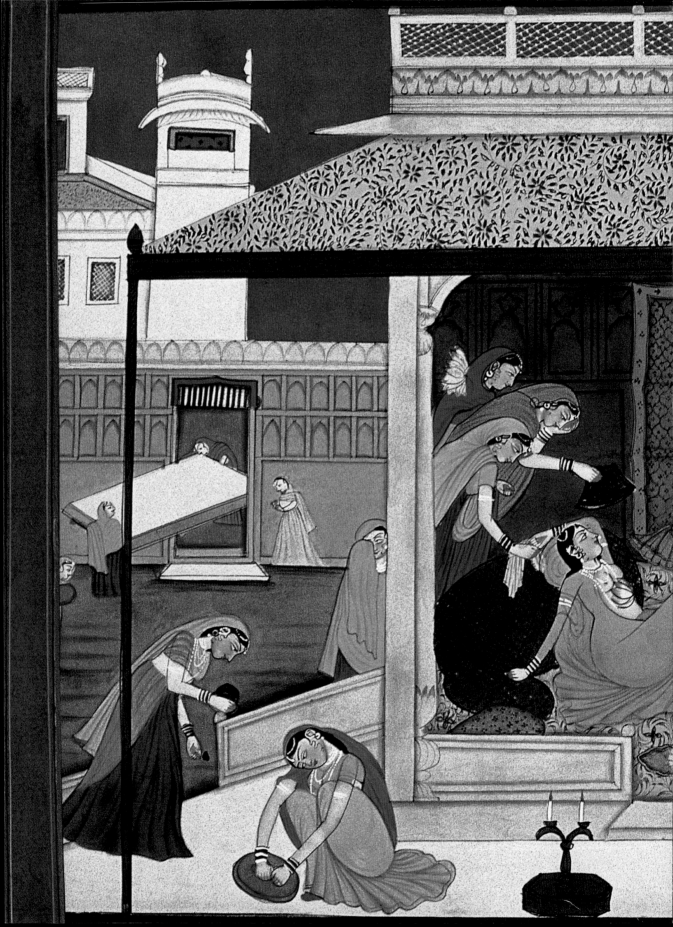

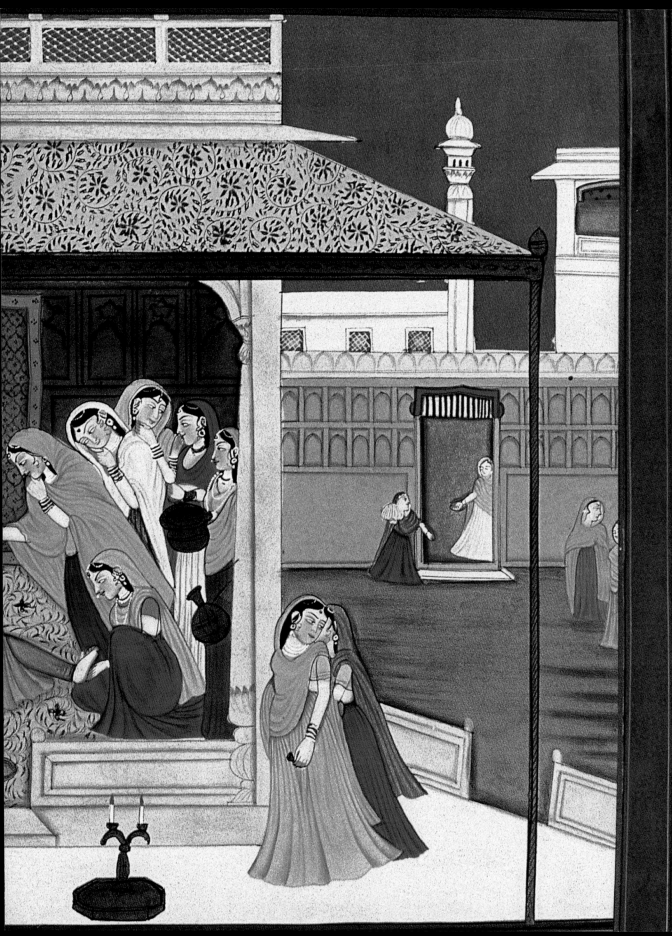

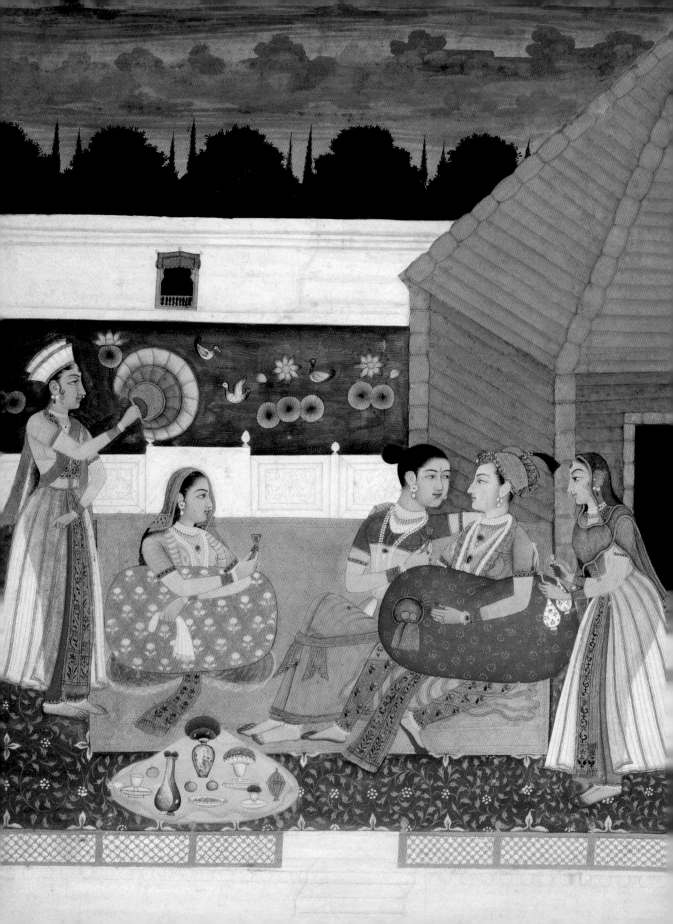

Contents

Introduction 8

PART I
On Sexual Congress
Of the study of the Kama Shastra 22
Of different kinds of congress and love quarrels 30
Of kinds of sexual union 40
Of the embrace 52
Of kissing 60
Of pressing, or marking, or scratching with the nails 68
Of the various modes of striking, and appropriate sounds 74
Of biting 80
Of the various kinds of congress 86
Of role reversal 94
Of the Auparishtaka or mouth congress 102
Of the ways of exciting desire 112

PART II
On Seduction
Of the characteristics of men and women 118
Of examining the state of a woman's mind 128
Of winning over the woman 136
Of the art of enticement 144

PART III
On Marriage
Of acquiring the right kind of wife 154
Of creating confidence in the girl 162
Of living as a virtuous wife 172
Of the conduct of husbands and wives 186
Of manifestations of the feeling by outward signs & deeds 198

Preceding pages: The women's quarters are abuzz as they prepare the beloved for her nightly encounter with her lover, while she pines and can barely wait.

Facing page: Sensuality in everything is the key to enjoyable lovemaking. Poetry, conversations of philosophy, and music, are all parts of the whole.

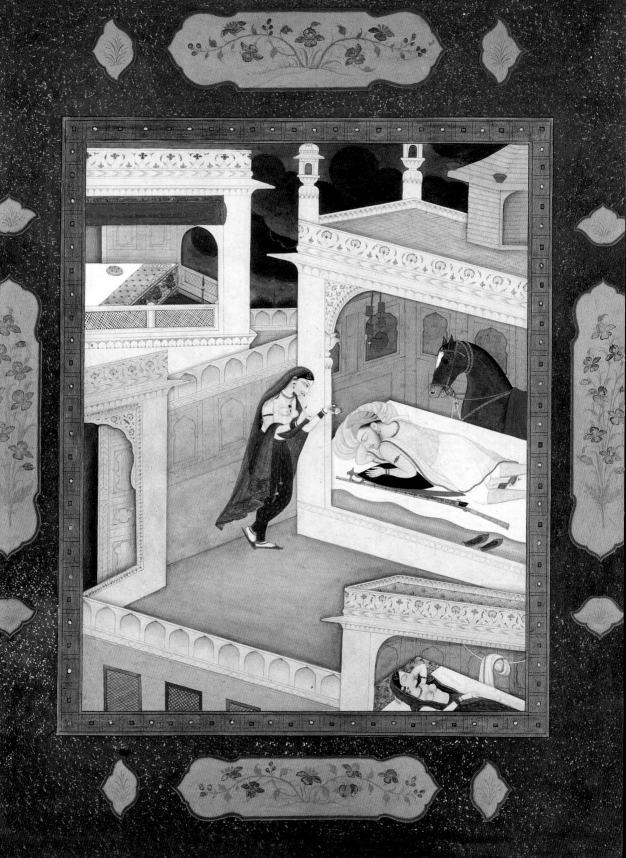

Introduction

It may be interesting to some persons to learn how it came about that Vatsyayana was first brought to light and translated into the English language. It happened thus. While translating with the pundits the *Anunga Runga*, or the Stages Of Love, reference was frequently found to be made to one Vatsya. The sage Vatsya was of this opinion, or that opinion. The sage Vatsya said this, and so on. Naturally questions were asked who the sage was, and the pundits replied that Vatsya was the author of the standard work on love in Sanscrit literature, that no Sanscrit library was complete without his work, and that it was most difficult now to obtain in its entire state. The copy of the manuscript obtained in Bombay was defective, and so the pundits wrote to Benares, Calcutta and Jeypoor for copies of the manuscript from Sanscrit libraries in those places. Copies having been obtained, they were then compared with each other, and with the aid of a commentary called *Jayamangla* a revised copy of the entire manuscript was prepared, and from this copy

Facing page: The woman comes to woo her lover, while his mistress sleeps nearby.

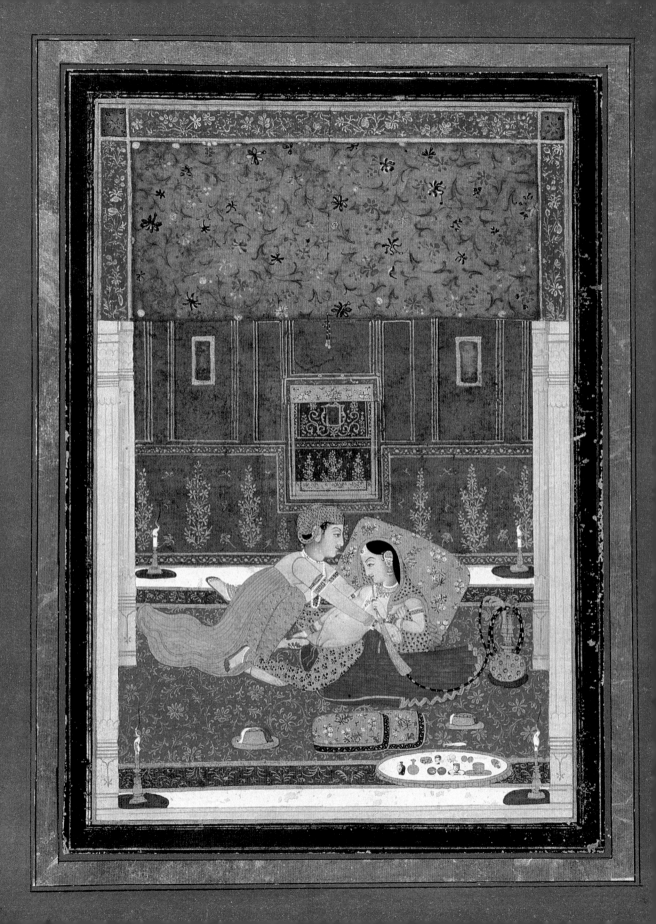

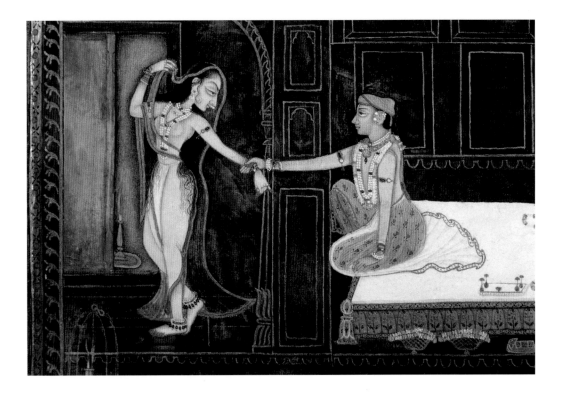

the English translation was made. The following is the certificate of the chief pundit:

'The accompanying manuscript is corrected by me after comparing four different copies of the work. I had the assistance of a commentary called *Jayamangla* for correcting the portion in the first five parts, but found great difficulty in correcting the remaining portion because, with the exception of one copy thereof which was tolerably correct, all the other copies I had were far too incorrect. However, I took that portion as correct in which the majority of the copies agreed with each other.'

The *Aphorisms On Love* by Vatsyayana contain about one thousand two hundred and fifty *slokas* or verses, and are divided into parts, parts into chapters, and sixty-four paragraphs. Hardly anything is known about the author. His real name is supposed to be Mallinaga or Mrillana,

Above: The man has to draw the woman towards him and assure her of his love and desire.

Facing page: A shy woman must be won over by good food, wine, and gentle cajoling.

Following pages: Jealous Radha and her friend watch Lord Krishna flirt with the other gopis (cowherd girls).

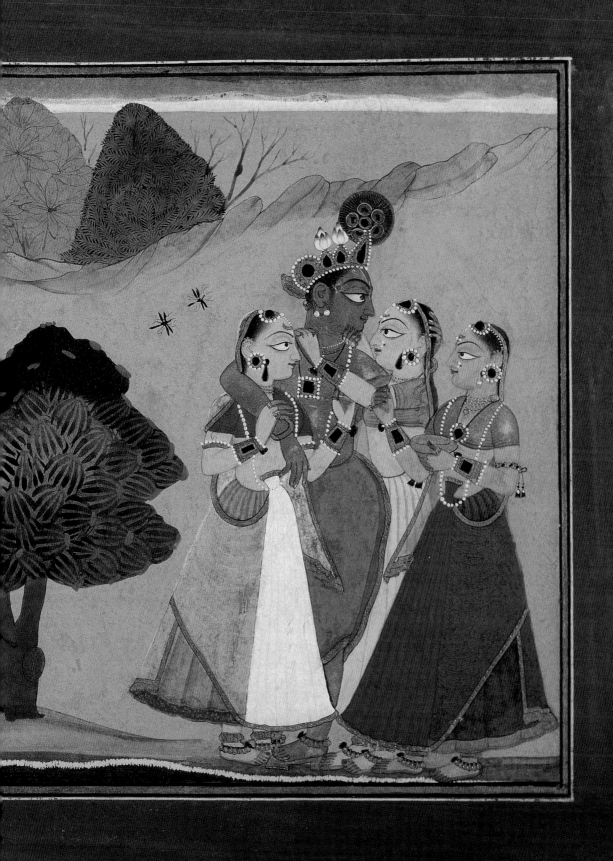

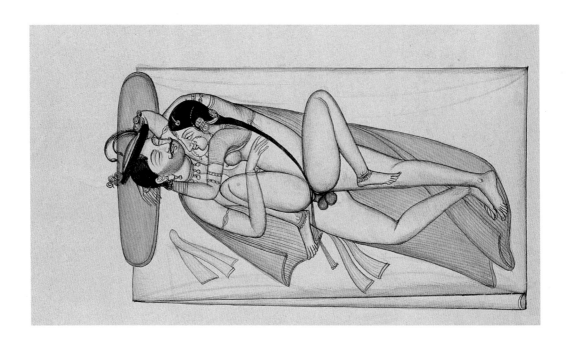

Even the hard ground is suitable for experienced lovers.

Vatsyayana being his family name. At the close of the work this is what he writes about himself:

'After reading and considering the works of Babhravya and other ancient authors, and thinking over the meaning of the rules given by them, this treatise was composed, according to the precepts of the Holy Writ, for the benefit of the world, by Vatsyayana, while leading the life of a religious student at Benares, and wholly engaged in the contemplation of the Deity. This book is not to be used merely as an instrument for satisfying our desires. A person acquainted with the true principles of this science, who preserves his *Dharma* (virtue or religious merit), his *Artha* (worldly wealth) and his *Kama* (pleasure or sensual gratification), and who has regard to the customs of the people, is sure to obtain the mastery over his senses. In short, an intelligent and knowing person, attending to *Dharma* and *Artha* and also to *Kama*, without becoming the slave of his passions, will obtain success in everything that he may do.'

It is impossible to fix the exact date either of the life of Vatsyayana or of his work. It is supposed that he

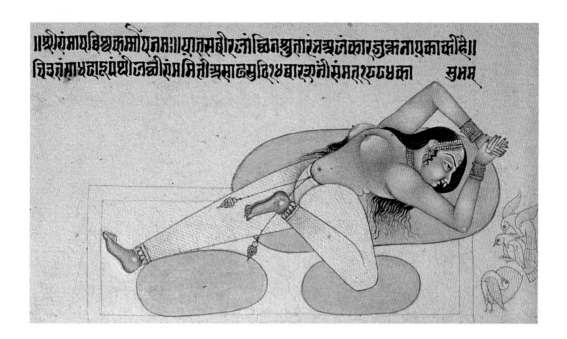

must have lived between the first and sixth century of the Christian era, on the following grounds: He mentions that Satkarni Satvahan, a king of Kuntal, killed Malayavati his wife with an instrument called *kartari* by striking her in the passion of love, and Vatsya quotes this case to warn people of the danger arising from some old customs of striking women when under the influence of this passion. Now this king of Kuntal is believed to have lived and reigned during the first century AD, and consequently Vatsya must have lived after him. On the other hand, Virahamihira, in the eighteenth chapter of his *Brihatsamhita*, treats of the science of love, and appears to have borrowed largely from Vatsyayana on the subject. Now Virahamihira is said to have lived during the sixth century AD, and as Vatsya must have written his works previously, therefore a time not earlier than the first century AD, and not later than the sixth century AD, must be considered as the approximate period of his existence.

On the text of the *Aphorisms Of Love* by Vatsyayana, only two commentaries have been found, one called

An arduous woman watches birds copulate and remembers her lover.

Jayamangla or *Sutrabashya,* and the other *Sutravritti.* The date of the *Jayamangla* is fixed between the tenth and thirteenth century AD, because while treating of the sixty-four arts an example is taken from the *Kavyaprakasha,* which was written about the tenth century AD. Again, the copy of the commentary procured was evidently a transcript of a manuscript which once had a place in the library of a Chalukyan king named Vishaladeva, a fact elicited from the following sentence at the end of it:

'Here ends the part relating to the art of love in the commentary on the *Vatsyayana Kama Sutra,* a copy from the library of the king of kings, Vishaladeva, who was a powerful hero, as it were a second Arjuna, and the head jewel of the Chalukya family.'

Now it is well known that this king ruled in Guzerat from 1244 to 1262 AD, and founded a city called Visalnagur. The date, therefore, of the commentary is taken to be not earlier than the tenth and not later than the thirteenth century. The author of it is supposed to be one Yashodhara, the name given him by his preceptor being Indrapada. He seems to have written it during the time of affliction caused by his separation from a clever and shrewd woman, at least that is what he himself says at the end of each chapter. It is presumed that he called his work after the name of his absent mistress, or the word may have some connection with the meaning of her name.

Facing page: Just as the male buffaloes in the lake watch excitedly the copulation of their mates, thus too the men look on and eagerly enjoy a woman together.

This commentary was most useful in explaining the true meaning of Vatsyayana, for the commentator appears to have had a considerable knowledge of the times of the older author, and gives in some places

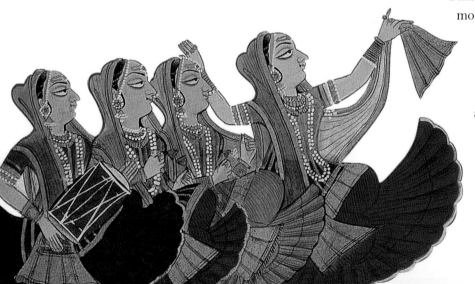

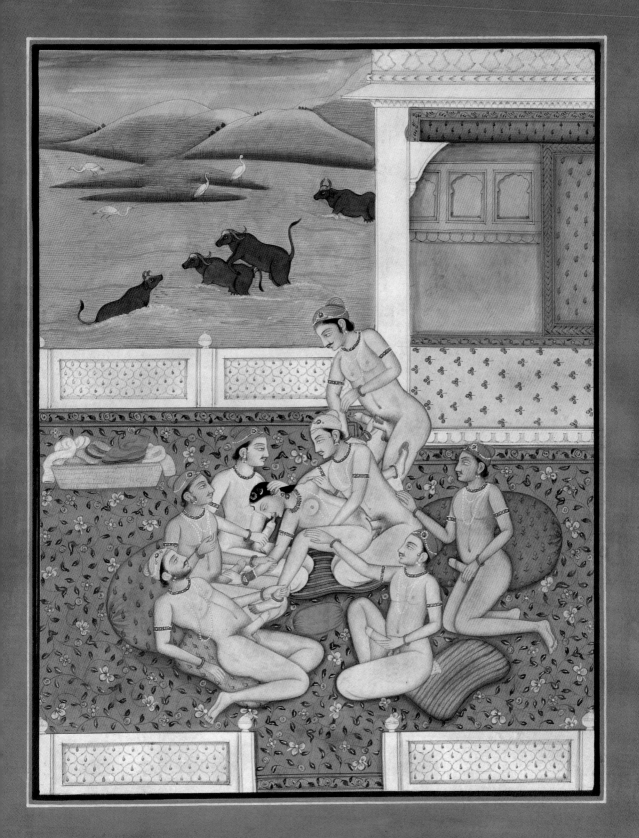

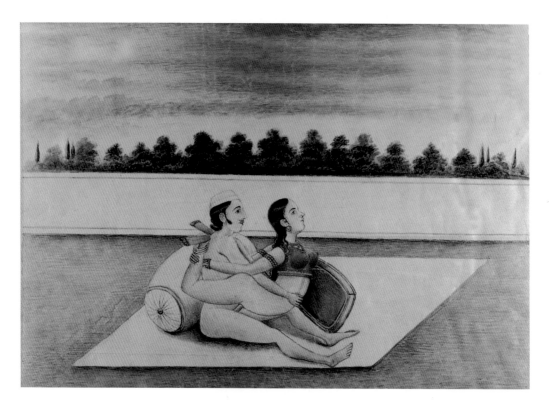

Above: A couple in love can perform sexual yoga when in the mood of doing something new.

Facing page: The position where the woman is on top is exciting for both lovers.

Following pages: The feeding of paan *(spiced betel leaf) to each other is an ancient, erotic prelude to sexual congress.*

very minute information. This cannot be said of the other commentary, called *Sutravritti*, which was written about 1789 AD by Narsing Shastri, a pupil of a Sarveshwar Shastri; the latter was descendant of Bhaskar, and so also was our author, for at the conclusion of every part he calls himself Bhaskar Narsing Shastri. He was induced to write the work by order of the learned Raja Vrijalala, while he was residing in Benares, but as to the merits of this commentary it does not deserve much commendation. In many cases the writer does not appear to have understood the meaning of the original author, and has changed the text in many places to fit in with his own explanations.

An abridged translation of the original work now follows. It has been prepared in complete accordance with the text of the manuscript, and is given, without further comments, as made from it. ॐ

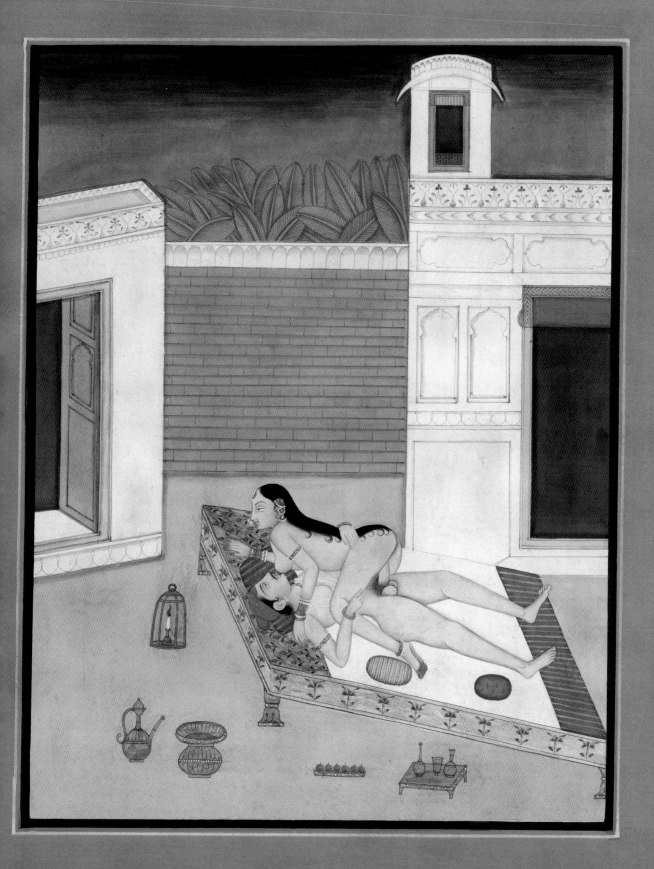

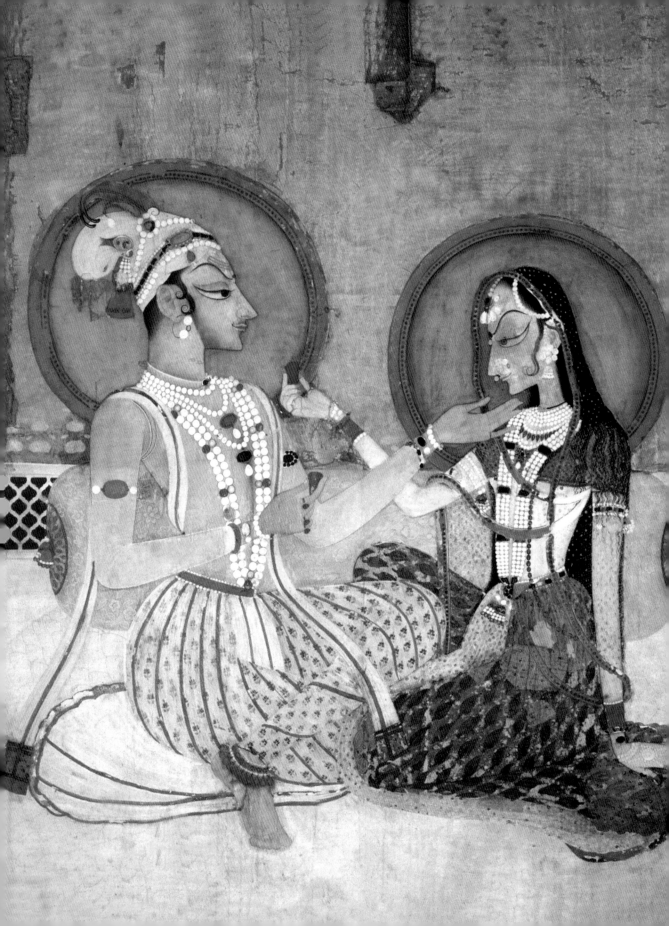

Part I
On Sexual Congress

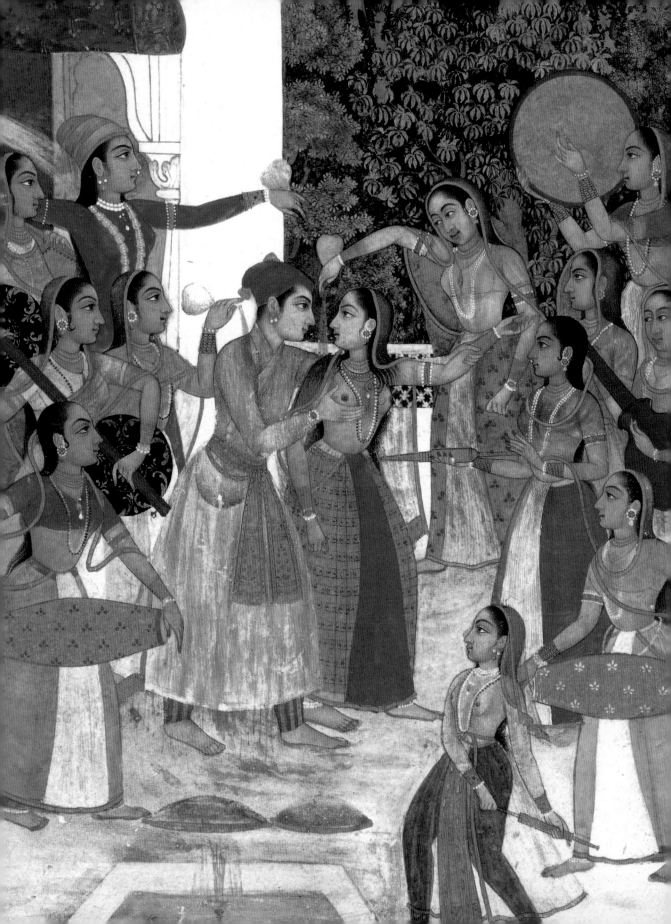

Of the Study of the Kama Shastra

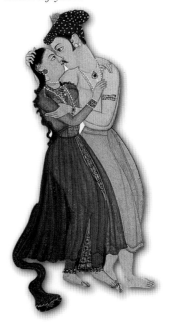

Facing page: The day of Holi, a festival where bodies intermingle with colour and water, is ideal for frolicking and fun. Women sing, play music, spray water on each other, and even dress up as men, to increase mutual enjoyment.

Men should study the *Kama Sutra* and the arts and sciences subordinate thereto, in addition to the study of the arts and sciences contained in *Dharma* and *Artha*. Even young maids should study this *Kama Sutra* along with arts and sciences before marriage, and after it they could continue to do so with the consent of their husbands.

Here some learned men object, and say that females, not being allowed to study any science, should not study the *Kama Sutra*. But Vatsyayana is of the view that this objection does not hold good, for women already know the practice of *Kama Sutra*, and that practice is derived from the *Kama Shastra*, or the science of *Kama* itself. Moreover, it is not only in this but in many other cases that though the practice of a science is known to all, only a few persons are acquainted with the rules and laws on which the science is based. Thus the Yadnikas or sacrificers, though ignorant of grammar, make use of appropriate words when addressing the different deities,

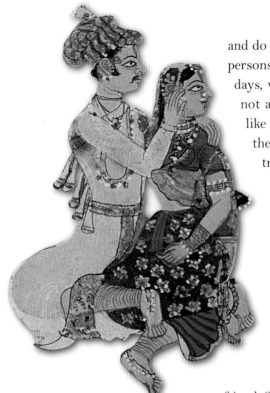

and do not know how these words are framed. Again, persons do the duties required of them on auspicious days, which are fixed by astrology, though they are not acquainted with the science of astrology. In a like manner riders of horses and elephants train these animals without knowing the science of training animals, but from practice only. And similarly the people of the most distant provinces obey the laws of the kingdom from practice, and because there is a king over them, and without further reason. And from experience we find that some women, such as daughters of princes and their ministers, and public women, were actually versed in the *Kama Shastra*.

A female, therefore, should learn the *Kama Shastra*, or at least part of it, by studying its practice from some confidential friend. She should study alone in private the sixty-four practices that form a part of the *Kama Shastra*. Her teacher should be one of the following persons, viz. the daughter of a nurse brought up with her and already married, or a female friend who can be trusted in everything, or the sister of her mother (i.e. her aunt), or an old female servant, or a female beggar who may have formerly lived in the family, or her own sister, who can always be trusted.

The following are the arts to be studied, together with the *Kama Sutra*: singing; playing on musical instruments; dancing; union of dancing, singing, and playing instrumental music; writing and drawing; tattooing; arraying and adorning an idol with rice and flowers; spreading and arranging beds or couches of flowers, or flowers upon the ground; colouring the teeth, garments, hair, nails and body, i.e. staining, dyeing, colouring and painting the same; fixing stained glass into a floor; the art of making beds, and spreading out carpets and cushions for reclining; playing on musical

Facing page: As the limbs intertwine, the passion unfolds with greater vigour.

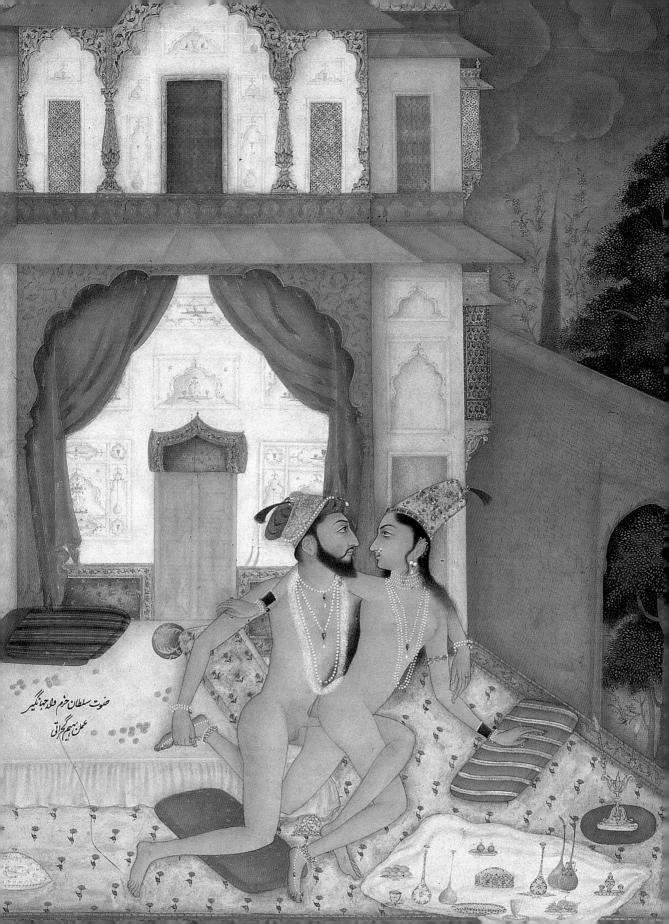

glasses filled with water; storing and accumulating water in aqueducts, cisterns and reservoirs; picture making, trimming and decorating; stringing of rosaries, necklaces, garlands and wreaths; binding of turbans and chaplets, and making crests and topknots of flowers; scenic representations; stage playing; art of making ear ornaments; art of preparing perfumes and odours; proper disposition of jewels and decorations, and adornment in dress; magic or sorcery; quickness of hand or manual skill; culinary art, i.e. cooking and cookery; making lemonades, sherbets, acidulated drinks, and spirituous extracts with proper flavour and colour; tailor's work and sewing; making parrots, flowers, tufts, tassels, bosses, knobs, etc., out of yarn or thread; solution of riddles, enigmas, covert speeches, verbal puzzles and enigmatical questions; the art of mimicry or imitation; reading, including chanting and intoning; study of sentences difficult to pronounce; practice with sword, single stick, quarter staff and bow and arrow; drawing inferences, reasoning and inferring; carpentry; architecture, or the art of building; knowledge about gold and silver coins, and jewels and gems; chemistry and mineralogy; colouring jewels, gems and beads; knowledge of mines and quarries; gardening: knowledge of treating the diseases of trees and plants, of nourishing them, and determining their ages; art of cock fighting, quail fighting and ram fighting; art of teaching parrots and starlings to speak; art of applying perfumed ointments to the body, and of dressing the hair with unguents and perfumes and braiding it; art of understanding writing in cypher, and the writing of words in a peculiar way; art of speaking by changing the forms of words, by changing the beginning and end of words, adding unnecessary letters between every syllable of a word, and so on; knowledge of language and of the vernacular dialects; art of making flower carriages; art of framing mystical diagrams, of addressing spells and

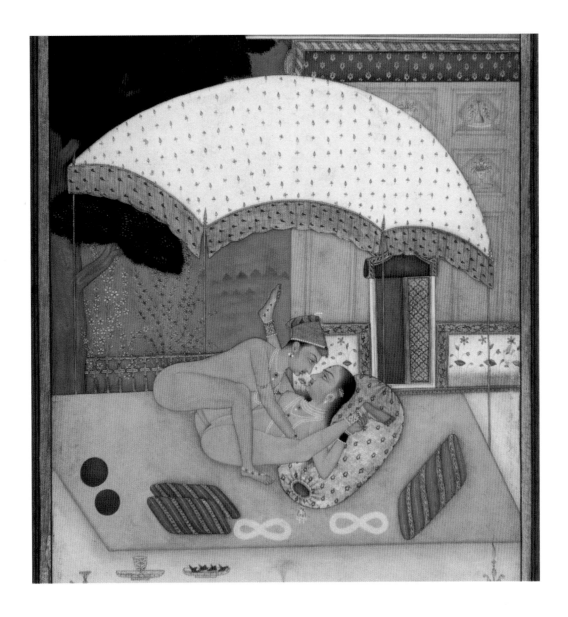

charms, and binding armlets; mental exercises, such as completing stanzas or verses on receiving a part of them; composing poems; knowledge of dictionaries and vocabularies; knowledge of ways of changing and disguising the appearance of persons; knowledge of ways of changing the appearance of things, such as making cotton appear as silk, coarse and common things appear as fine and good; various ways of gambling; art

Not touching the entire body makes the pleasure collect and intensify at specific points.

Facing page: With practice, difficult positions can be mastered for deriving ultimate enjoyment from flexibility and a sense of prowess.

of obtaining possession of the property of others by means of mantras or incantations; skill in youthful sports; knowledge of the rules of society, and of how to pay respect and compliments to others; knowledge of the art of war, of arms, of armies, etc; knowledge of scanning or constructing verses; arithmetical recreations; making artificial flowers; making figures and images in clay.

A public woman endowed with a good disposition, beauty and other winning qualities, and also versed in the above arts, obtains the name of a Ganika, or public woman of high quality, and receives a seat of honour in an assemblage of men. She is, moreover, always respected by the king, and praised by learned men, and her favour being sought for by all, she becomes an object of universal regard. The daughter of a king too, as well as the daughter of a minister, being learned in the above arts, can make their husbands favourable to them, even though these may have thousands of other wives besides themselves. And in the same manner, if a wife becomes separated from her husband, and falls into distress, she can support herself easily, even in a foreign country, by means of her knowledge of these arts. Even the bare knowledge of them gives attractiveness to a woman, though the practice of them may be only possible or otherwise according to the circumstances of each case. A man who is versed in these arts, who is loquacious and acquainted with the arts of gallantry, gains very soon the hearts of women, even though he is only acquainted with them for a short time. ॐ

28

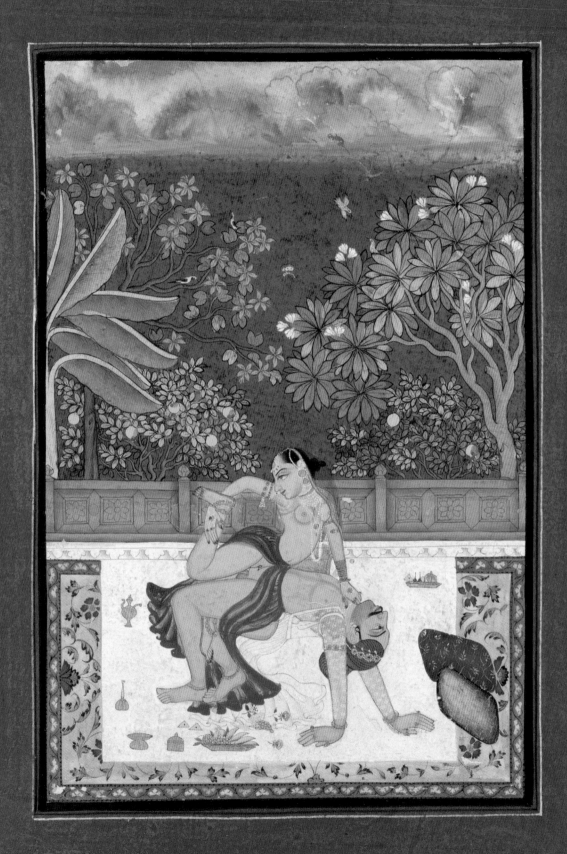

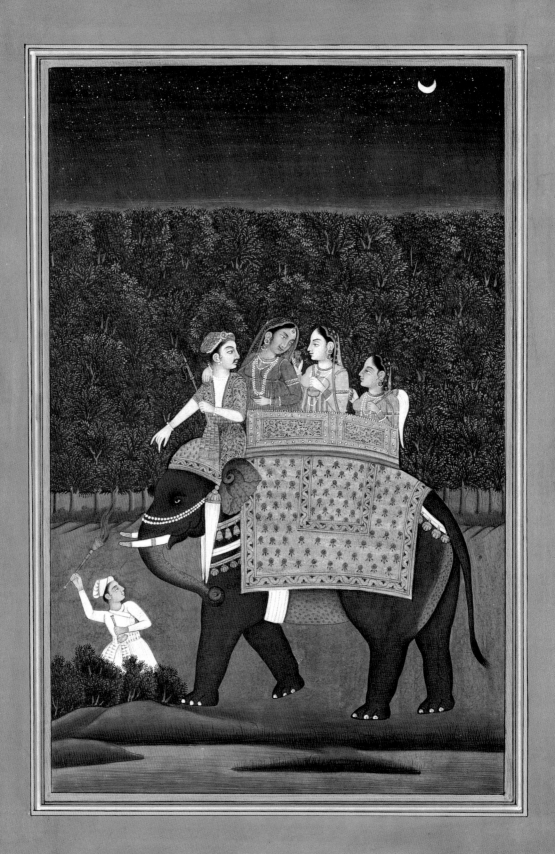

Of Different Kinds of Congress and Love Quarrels

In the pleasure room, decorated with flowers, and fragrant with perfumes, attended by his friends and servants, the citizen should receive the woman, who will come bathed and dressed, and invite her to take refreshments and to drink freely. He should then seat her on his left side, and holding her hair, and touching also the end knot of her garment, he should gently embrace her with his right arm. They should then carry on an amusing conversation on various subjects, and may also talk suggestively of things which would be considered as coarse, or not to be mentioned generally in society. They may then sing, either with or without gesticulations, and play on musical instruments, talk about the arts, and persuade each other to drink. At last when the woman is overcome with love and desire, the citizen should dismiss the people that may be with him, giving them flowers, ointments, and betel leaves, and then when the two are left alone, they should proceed as has been described in the following chapters.

Facing page: On a night of the crescent moon, lovers and the beloved's friend indulge in pleasurable conversation.

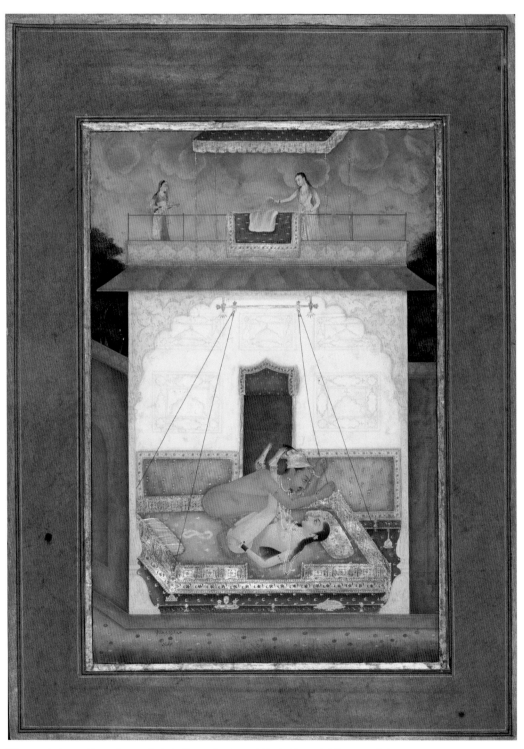

The man balances the swing, as their bodies swing to and fro in the weightless act of love.

Facing page: The man tugs at the outermost folds of the woman's clothing to indicate his intentions, as she playfully feigns innocence.

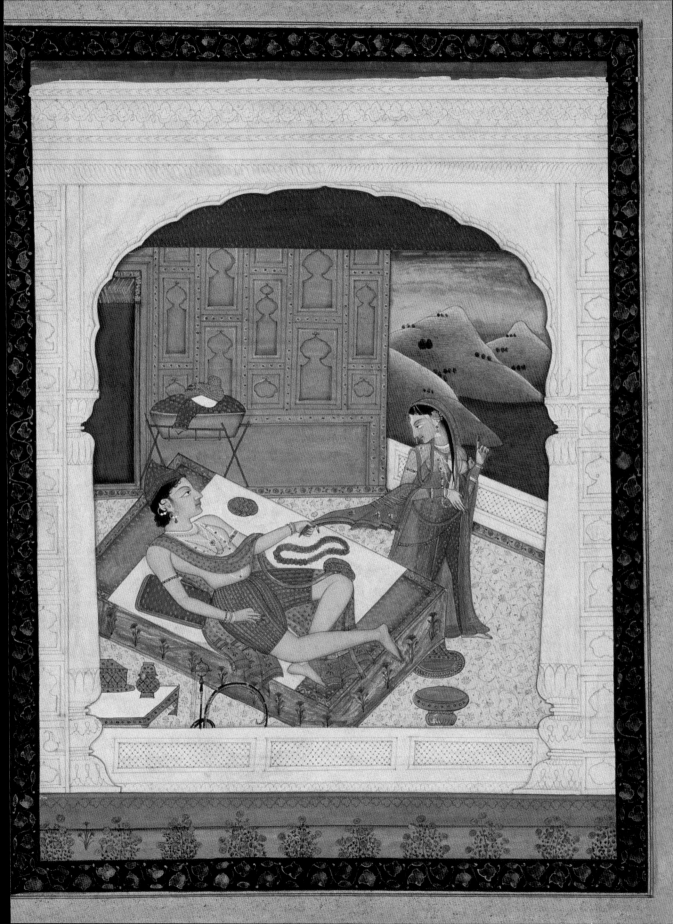

Such is the beginning of sexual union. At the end of the congress, the lovers with modesty, and not looking at each other, should go separately to the washing-room. After this, sitting in their own places, they should eat some betel leaves, and the citizen should apply with his own hand to the body of the woman some pure sandalwood ointment, or ointment of some other kind. He should then embrace her with his left arm, and with agreeable words should cause her to drink from a cup held in his own hand, or he may give her water to drink. They can then eat sweetmeats, or anything else, according to their liking, and may drink fresh juice, soup, gruel, extracts of meat, sherbet, the juice of mango fruits, the extract of the juice of the citron tree mixed with sugar, or anything that may be liked in different countries, and known to be sweet, soft, and pure. The lovers may also sit on the terrace of the palace or house, and enjoy the moonlight, and carry on an agreeable conversation. At this time, too, while the woman lies in his lap, with her face towards the moon, the citizen should show her the different planets, the morning star, the polar star, and the seven Rishis, or Great Bear. This is the end of sexual union.

Congress is of the following kinds: viz. loving congress; congress of subsequent love; congress of artificial love; congress of transferred love; congress like that of eunuchs; deceitful congress; congress of spontaneous love.

• When a man and a woman, who have been in love with each other for some time, come together with great difficulty, or when one of the two returns from a journey, or is reconciled after having been separated on account of a quarrel, this congress is called the 'loving congress'. It is carried on according to the liking of lovers, and as long as they choose.

• When two persons come together, while their love for each other is still in its infancy their congress is called the 'congress of subsequent love'.

• When a man carries on the congress by exciting

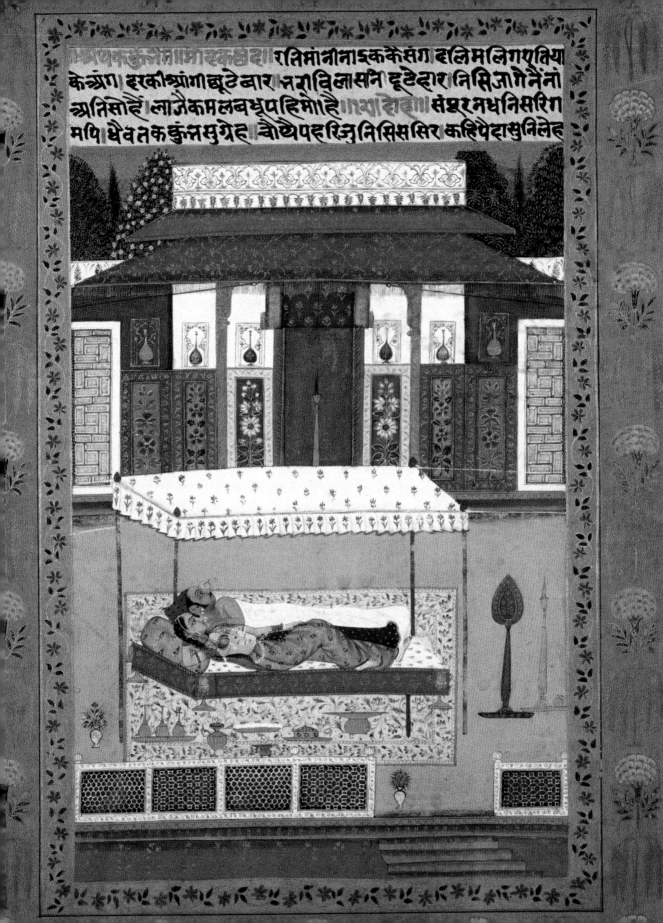

रतिमानानाइककेसग बलिमलिगएधिया के न्ग इरकीश्रागाछूटेबार नरविलासनि दूटेहार निसिजोगेनैनो अतिसोहें लाजैकमलबधूपहिमोहे संहरमधनिसरिग मपि धैवतककुन्जसुग्रेह चौथैपहरिज्जनिसिसिसिर कहिपेदासुनिलेह

himself by means of the sixty-four ways, such as kissing, etc., or when a man and a woman come together, their congress is then called 'congress of artificial love'. At this time all the ways and means mentioned in the *Kama Shastra* should be used.

• When a man, from the beginning to the end of the congress, though having connection with the woman, thinks all the time that he is enjoying another one whom he loves, it is called the 'congress of transferred love'.

• Congress between a man and a female water carrier, or female servant of a caste lower than his own, lasting only until the desire is satisfied, is called 'congress like that of eunuchs'. Here external touches, kisses, and manipulations are not to be employed.

• The congress between a courtesan and a rustic, and that between citizens and the women of villages, and bordering countries, is called 'deceitful congress'.

• The congress that takes place between two persons who are attached to one another, and which is done according to their own liking, is called 'spontaneous congress'.

Thus end the kinds of congress. We shall now speak of love quarrels.

A woman who is very much in love with a man cannot bear to hear the name of her rival mentioned, or to have any conversation regarding her, or to be addressed by her name through mistake. If such events take place, a great quarrel arises, and the woman cries, becomes angry, tosses her hair about, strikes her lover, falls from her bed or seat and, casting aside her garlands and ornaments, throws herself down on the ground.

At this time, the lover should attempt to reconcile her with conciliatory words, and should take her up carefully and place her on her bed. But she, not replying to his questions, and with increased anger, should bend his head down by pulling his hair, and having kicked him once, twice, or thrice on his arms, head, bosom or back, should then proceed to the door of the room. Dattaka

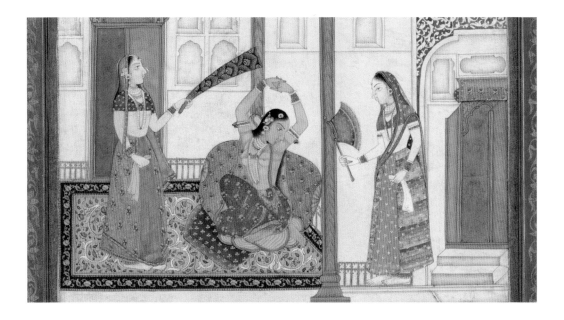

says that she should then sit angrily near the door and shed tears, but should not go out, because she would be found fault with for going away. After a time, when she thinks that the conciliatory words and actions of her lover have reached their utmost, she should then embrace him, talking to him with harsh and reproachful words, but at the same time showing a loving desire for congress.

When the woman is in her own house, and has quarrelled with her lover, she should go to him and show how angry she is, and leave him. Afterwards the citizen having sent the Vita, the Vidushaka or the Pithamudra to pacify her, she should accompany them back to the house, and spend the night with her lover. Thus ends the love quarrel.

A man, employing the sixty-four means mentioned by Babhravya, obtains his object, and enjoys women of the first quality. A man devoid of other knowledge, but well acquainted with the sixty-four divisions, becomes a leader in any society of men and women. He is looked upon with love by his own wife, by the wives of others, and by courtesans. ತಿ

A woman languishes in her lover's memory, as her attendants try to cool her.

Following pages: Kamadeva, the lord of love, helps the lovers gain their desire. The scenes unfold as Lord Krishna, the divine lover, woos the coy Radha, and out in the garden, a man converses with and woos his male lover.

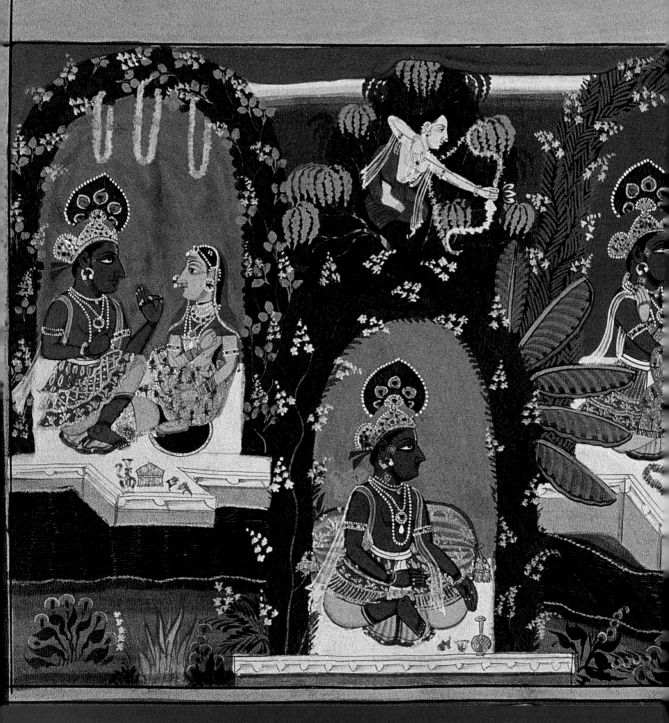

कोयरोहैखनावइसीधारा अधररोअतन लीएदै निंत्रोहैजीवा उ॥ कीसां जांने ॥
इसेथकेथारे विबेमन आरोक्यो है॥ हेराधेनरायलवते अतुसर॥ ॥४॥

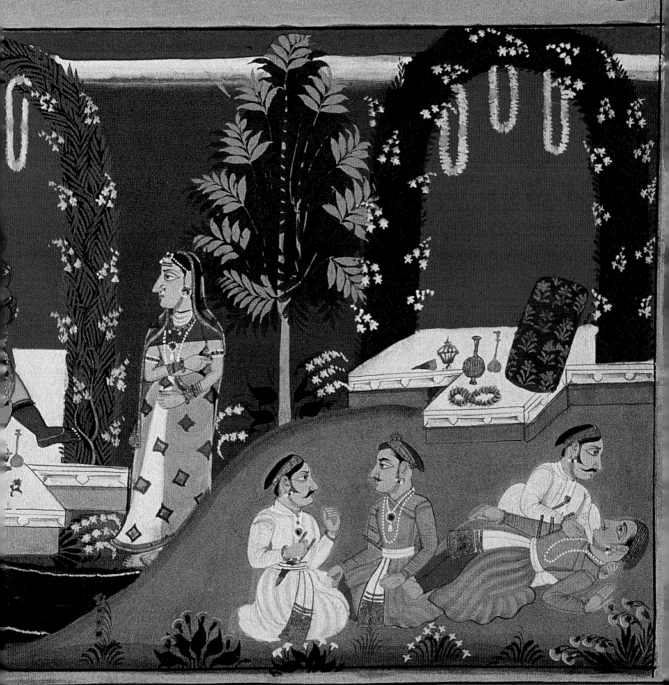

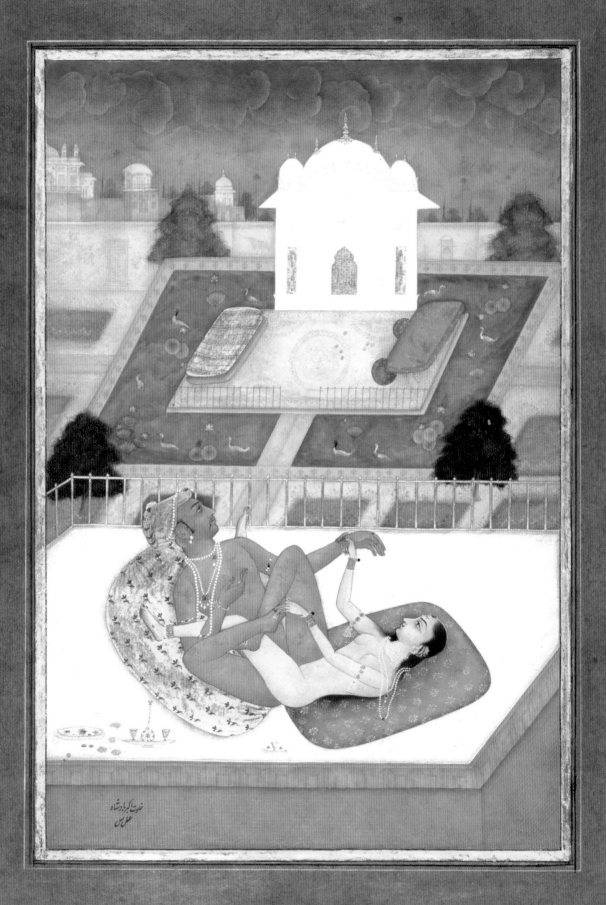

Of Kinds of Sexual Union

M an is divided into three classes viz. the hare man, the bull man, and the horse man, according to the size of his *lingam*. Woman also, according to the depth of her *yoni*, is either a female deer, a mare, or a female elephant. There are thus three equal unions between persons of corresponding dimensions, and there are six unequal unions, when the dimensions do not correspond, or nine in all.

In these unequal unions, when the male exceeds the female in point of size, his union with a woman who is immediately next to him in size is called high union, and is of two kinds; while his union with the woman most remote from him in size is called the highest union, and is of one kind only. On the other hand, when the female exceeds the male in point size, her union with a man immediately next to her in size is called the low union, and is of two kinds; while her union with a man most remote from her in size is called the lowest union, and is of one kind only.

Facing page: Different sizes of men and women have been described by Vatsyayana and they should be matched suitably for utmost fulfilment.

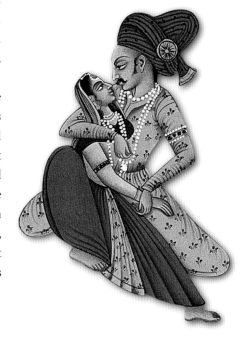

In other words, the horse and mare, the bull and deer, form the high union, while the horse and deer forms the highest union. On the female side, the elephant and bull, the mare and hare, form low unions, while the elephant and the hare make lowest union.

There are, then, nine kinds of union according to dimensions. Amongst all these, equal unions are the best; those of a superlative degree, i.e. the highest and the lowest, are the worst, and the rest are middling, and with them the high are better than the low.

There are also nine kinds of union according to the force of passion or carnal desire, as follows: a man is called a man of small passion whose desire at the time of sexual union is not great, whose semen is scanty, and who cannot bear the warm embrace of the female. Those who differ from this temperament are called men of middling passion, while those of intense passion are full of desire. In the same way, women are supposed to have the degrees of feeling as specified above.

Lastly, according to time there are three kinds of men and women, viz. the short-timed, the moderate-timed, and the long-timed, and of these as in the previous statements, there are nine kinds of union.

But on this last head there is a difference of opinion about the female which should be stated.

Auddalika says, 'Females do not emit as males do. The males simply remove their desire, while the females, from their consciousness of desire, feel a certain kind of pleasure, which gives them satisfaction, but it is impossible for them to tell you what kind of pleasure they feel. The fact from which this becomes evident is that males, when engaged in coition, cease of themselves after emission, and are satisfied, but it is not so with females.'

The opinion is, however, objected to on the grounds, that if a male be long-timed, the female loves him the more, but if he be short-timed, she is dissatisfied with him. And this circumstance, some say, would prove that the female emits also. But this opinion does not hold

Facing page: Delightful music on a full moon night creates the mood for a memorable song of love.

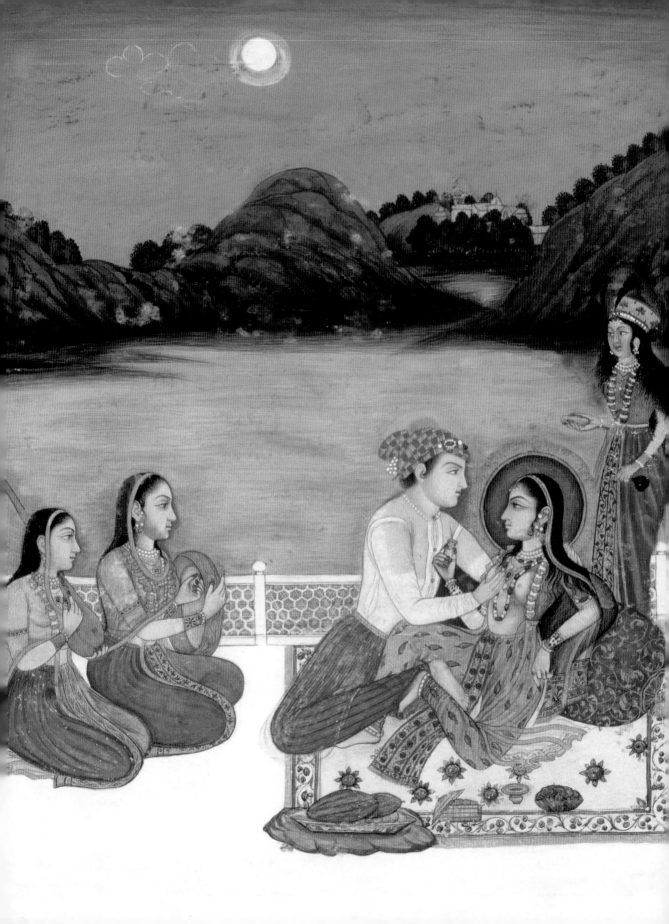

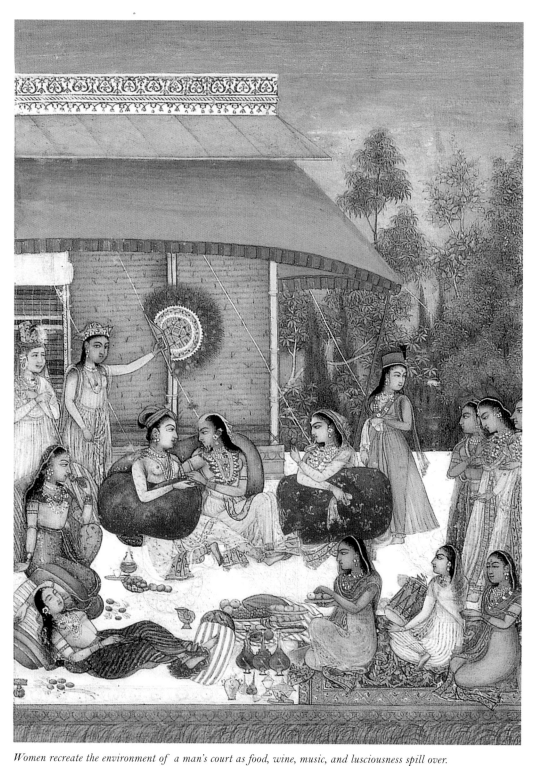

Women recreate the environment of a man's court as food, wine, music, and lusciousness spill over.

Facing page: Just as many men can enjoy one woman, thus can one man give pleasure to many women at once.

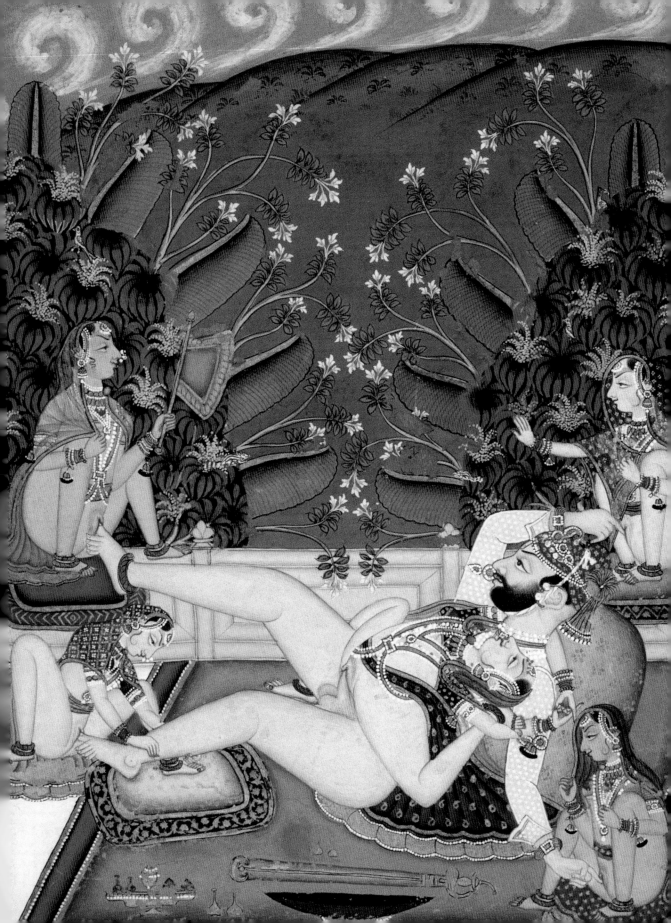

Facing page: Lord Krishna with his troupe of singers and musicians, all enwrapped around him, as he travels spreading joie de vivre.

good, for if it takes a long time to allay a woman's desire, and during this time she is enjoying great pleasure, it is quite natural then that she should wish for its continuation. And on this subject there is a verse as follows: 'By union with men the lust, desire, or passion of women is satisfied, and the pleasure derived from the consciousness of it is called their satisfaction.'

The followers of Babhravya, however, say that the semen of women continues to fall from the beginning of the sexual union to its end, and it is right that it should be so, for if they had no semen there would be no embryo. To this there is no objection. In the beginning of coition the passion of the woman is middling, and she cannot bear the vigorous thrusts of her lover, but by degrees her passion increases until she ceases to think about her body, and then finally she wishes to stop from further coition.

This objection, however, does not hold good, for even in ordinary things that revolve with great force, such as a potter's wheel, or a top, we find that the motion at first is slow, but by degrees it becomes very rapid. In the same way the passion of the woman having gradually increased, she has a desire to discontinue coition, when all the semen has fallen away. And there is a verse with regard to this as follows: 'The fall of the semen of the man takes place only at the end of coition, while the semen of the woman falls continually, and after the semen of both has all fallen away then they wish for the discontinuance of coition.'

Lastly, Vatsyayana is of the view that the semen of the female falls in the same way as that of the male. Now some may ask here: If men and women are beings of the same kind, and are engaged in

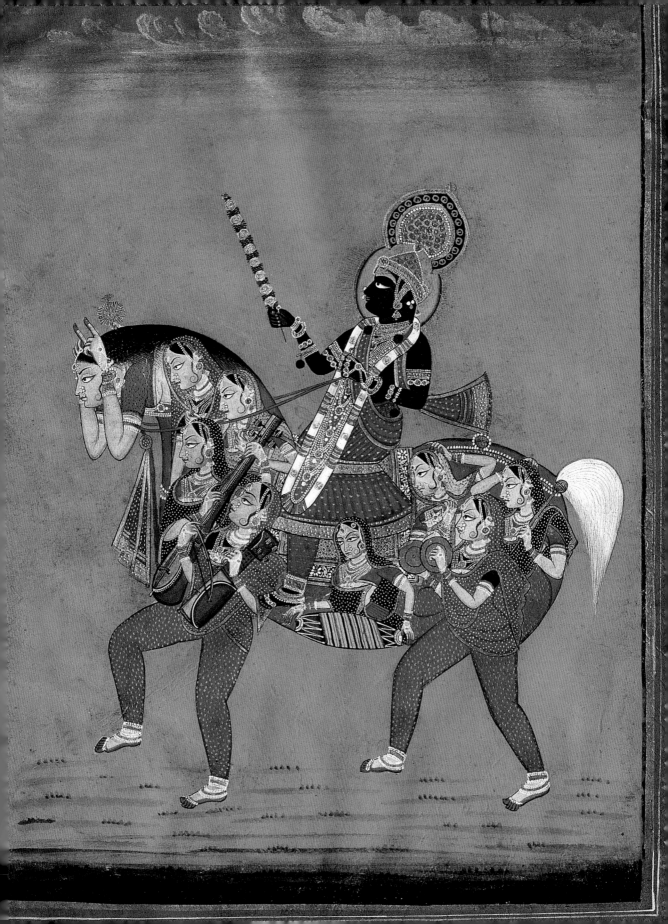

bringing about the same result, why should they have different work to do? Vatsyayana says that this is so, because the ways of working, by which men are the actors, and women are the persons acted upon, is owing to the nature of the male and the female, otherwise the actor would be sometimes the person acted upon, and vice versa. And from this difference in the ways of working follows the difference in the consciousness of pleasure, for a man thinks, 'This woman is united with me,' and a woman thinks, 'I am united with this man.'

It may be said that if the ways of working in men

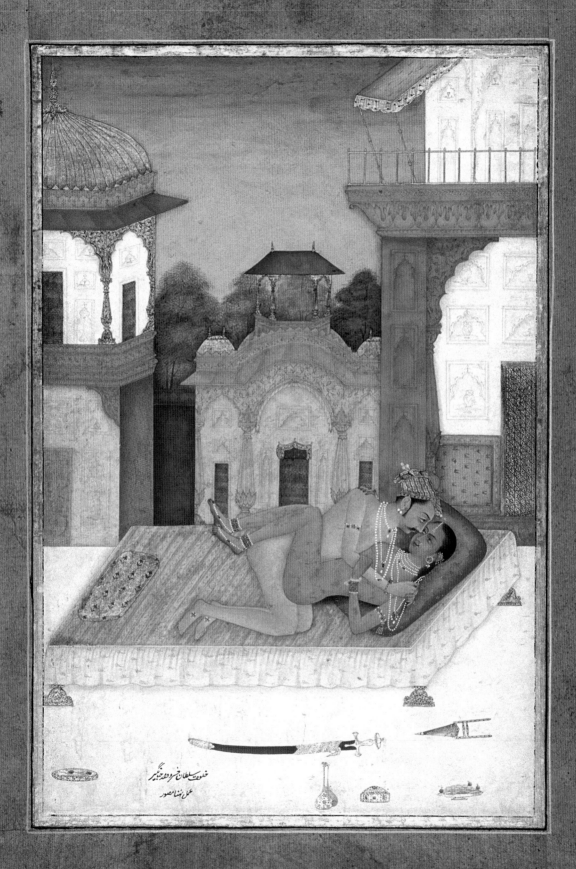

and women are different, why should not there be a difference even in the pleasure they feel, and which is the result of those ways.

But this objection is groundless, for the person acting and the person acted upon being of different kinds, there is a reason for the difference in their ways of working; but there is no reason for any difference in the pleasure they feel, because they both naturally derive pleasure from the act they perform.

On this again some may say that when different persons are engaged in doing the same work, we find that they accomplish the same end or purpose; while, on the contrary, in the case of men and women we find that each of them accomplishes his or her own end separately, and this is inconsistent. But this is a mistake, for we find that sometimes two things are done at the same time, as for instance in the fighting of rams, both the rams receive the shock at the same time on their heads. Again, in throwing one wood apple against another, and also in a fight or struggle of wrestlers. If it be said that in these cases the things employed are of the same kind, it is answered that even in the case of men and women, the nature of the two persons is the same. And as the difference in their ways of working arises from the difference of their conformation only, it follows that men experience the same kind of pleasure as women do.

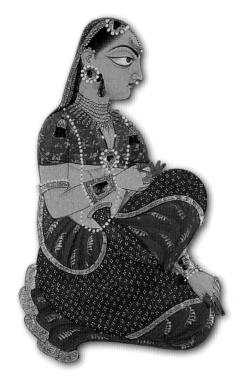

There is also a verse on this subject as follows: 'Men and women being of the same nature, feel the same kind of pleasure, and therefore a man should marry such a woman as will love him ever afterwards.'

The pleasure of men and women thus being proved to be of the same kind, it follows that in regard to time, there are nine kinds of sexual intercourse, in the same way as there are nine kinds of union, according to the force of passion.

There being thus nine kinds of union with regard to dimensions, force of passion, and time, respectively, by making combinations of them, innumerable kinds of

union would be produced. Therefore in each particular kind of sexual union, men should use such means as they may think suitable for the occasion.

At the first time of sexual union the passion of the male is intense, and his time is short, but in subsequent unions on the same day the reverse of this is the case. With the female, however, it is the contrary, for at the first time her passion is weak, and then her time short, until her passion is satisfied.

Men learned in the humanities are of the opinion that love is of four kinds: love acquired by continual habit; love resulting from the imagination; love resulting from belief; love resulting from the perception of external objects.

• Love resulting from the constant and continual performance of some act, is called love acquired by constant practice and habit, as for instance the love of sexual intercourse, the love of hunting, the love of drinking, the love of gambling, etc.

• Love which is felt for things to which we are not habituated, and which proceeds entirely from ideas, is called love resulting from imagination, as for instance, that love which some men and women and eunuchs feel for the Auparishtaka or mouth congress, and that which is felt by all for such things as embracing, kissing, etc.

• The love which is mutual on both sides, and proved to be true, when each looks upon the other as his or her very own, such is called love resulting from belief by the learned.

• The love resulting from the perception of external objects is quite evident and well known to the world, because the pleasure which it affords is superior to the pleasure of the other kinds of love, which exists only for its sake.

What has been said in this chapter upon the subject of sexual union is sufficient for the learned; but for the edification of the ignorant, the same will now be treated of at length and in detail. ॐ

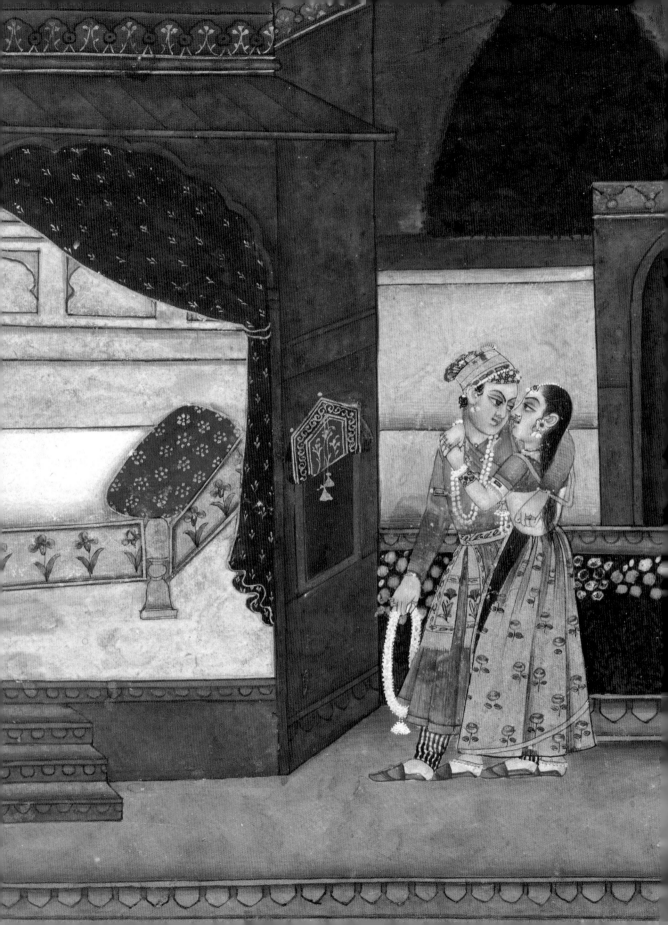

Of the Embrace

This part of the *Kama Shastra*, which treats of sexual union, is called 'Sixty-four', *Chatushshashti*. Some old authors say that it is called so, because it contains sixty-four chapters. Others are of opinion that the author of this part being a person named Panchala, and the person who recited the part of the *Rig Veda* called Dashatapa, which contains sixty-four verses, being also called Panchala, the name 'sixty-four' has been given to the part of the work in honour of the *Rig Veda*. The followers of Babhravya say on the other hand that this part contains eight subjects, viz. the embrace, kissing, scratching with the nails or fingers, biting, lying down, making various sounds, playing the part of the man, and the Auparishtaka or mouth congress. Each of these subjects being of eight kinds, and eight multiplied by eight being sixty-four, this part is therefore named 'sixty-four'. But Vatsyayana affirms that as this part contains also the following subjects, viz. striking, crying, the acts of man during congress, the various kinds of

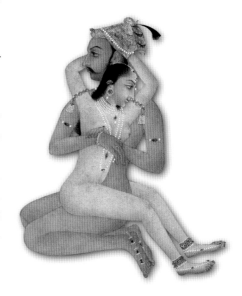

congress, and other subjects, the name 'sixty-four' is given to it only accidentally. As, for instance, we say this tree is 'Saptaparna', or seven-leaved, this offering of rice is 'Panchavarna', or five-coloured, but the tree has not seven leaves, neither has the rice five colours.

However the part sixty-four is now treated of, and the embrace, being the first subject, will now be considered. Now the embrace, which indicates the mutual love of a man and a woman who have come together is of four kinds viz. touching; piercing; rubbing; pressing. The action in each case is denoted by the meaning of the word which stands for it.

• When a man under some pretext or other, goes in front or alongside of a woman and touches her body with his own, it is called the 'touching embrace'.

• When a woman in a lonely place bends down, as if to pick up something, and pierces, as it were, a man sitting or standing, with her breasts, and the man in return takes hold of them, it is called a 'piercing embrace'.

The above two kinds of embrace take place only between persons who do not, as yet, speak freely with each other.

• When two lovers are walking slowly together, either in the dark, or in a place of public resort, or in a lonely place, and rub their bodies against each other, it is called a 'rubbing embrace'.

• When on the above occasion one of them presses the other's body forcibly against a wall or pillar, it is called a 'pressing embrace'.

These two last embraces are peculiar to those who know the intentions of each other.

At the time of the meeting, the four following kinds of embrace are used viz. *Jataveshitaka* or the twining of a creeper; *Vrikshadhirudhaka* or climbing a tree; *Tiltandulaka* or the mixture of sesamum seed with rice; *Kshaniraka* or milk and water embrace.

Facing page: As Krishna and Radha embrace, the gopis touch them to enhance everyone's pleasure.

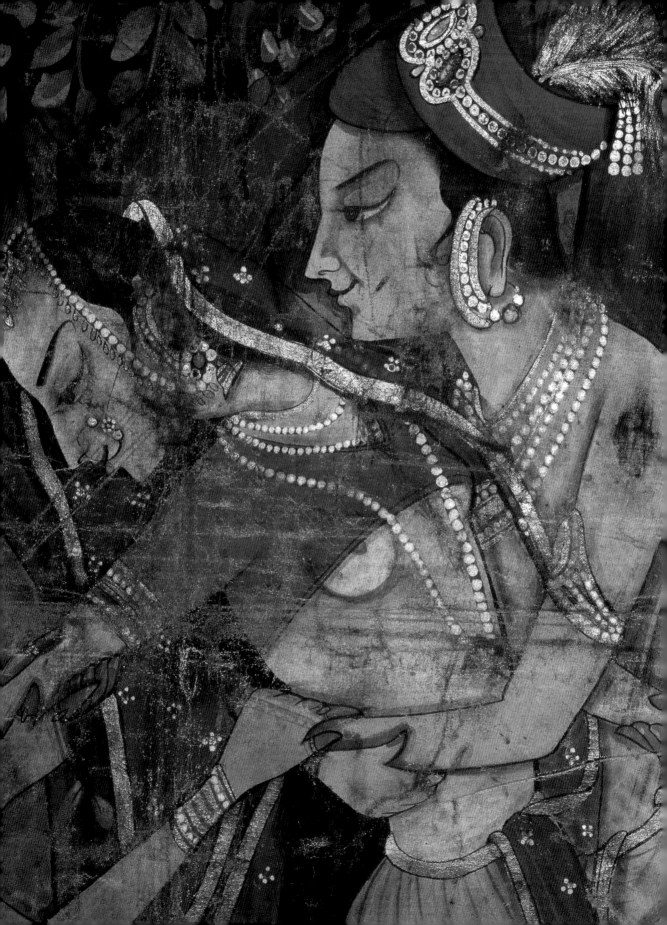

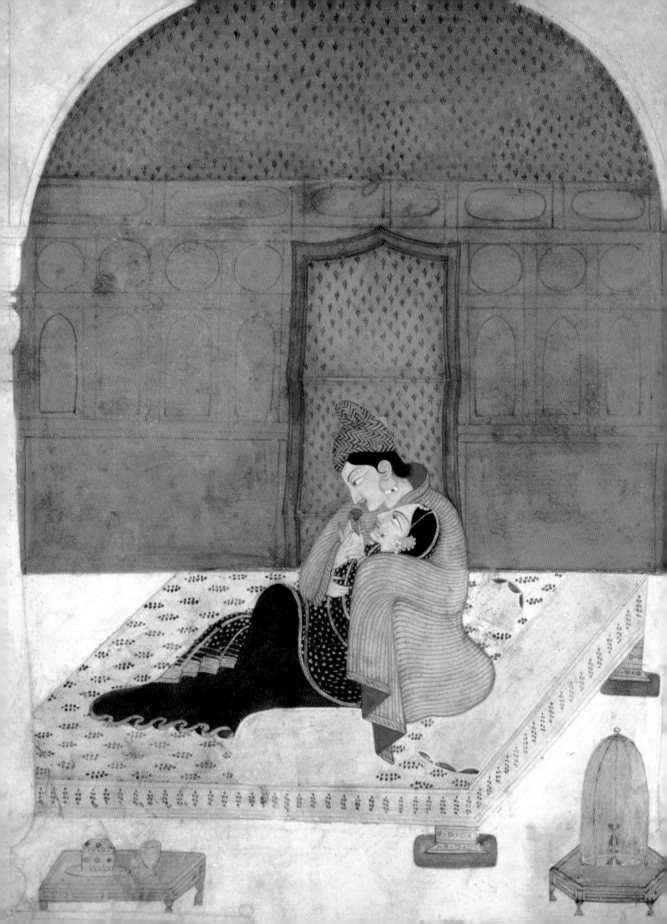

• When a woman, clinging to a man as a creeper twines round a tree, bends his head down to hers with the desire of kissing him and embraces him, and looks lovingly towards him, it is called an embrace like the 'twining of a creeper'.

• When a woman, having placed one of her feet on the foot of her lover, and the other on one of his thighs, passes one of her arms round his back, and the other on his shoulders, makes slightly the sounds of singing and cooing, and wishes,as it were, to climb up to him in order to have a kiss, it is called an embrace like the' climbing of a tree'.

These two kinds of embrace take place when the lover is standing.

• When lovers lie on a bed, and embrace each other so closely that the arms and thighs of the one are encircled by the arms and thighs of the other, and, are, as it were, rubbing up against them, this is called an embrace like tfte 'mixture of sesamum seed with rice'.

• When a man and a woman are much in love with each other and, not thinking of any pain or hurt, embrace each other as if they were entering into each other's bodies either while the woman is sitting on the lap of the man, or in front of him, or on a bed, then it is called an embrace like a' mixture of milk and water'.

These two kinds of embrace take place at the time of sexual union.

Babhravya has thus related to us the above eight kinds of embraces.

Suvarnanabha moreover gives us four ways of embracing simple members of the body, which are: the embrace of the thighs; the embrace of the *jaghana* i.e. the part of the body from the navel downwards to the thighs; the embrace of the breasts; the embrace of the forehead.

Facing page: The beloved feeds sweet paan *to the lover, basking in his lush embrace.*

57

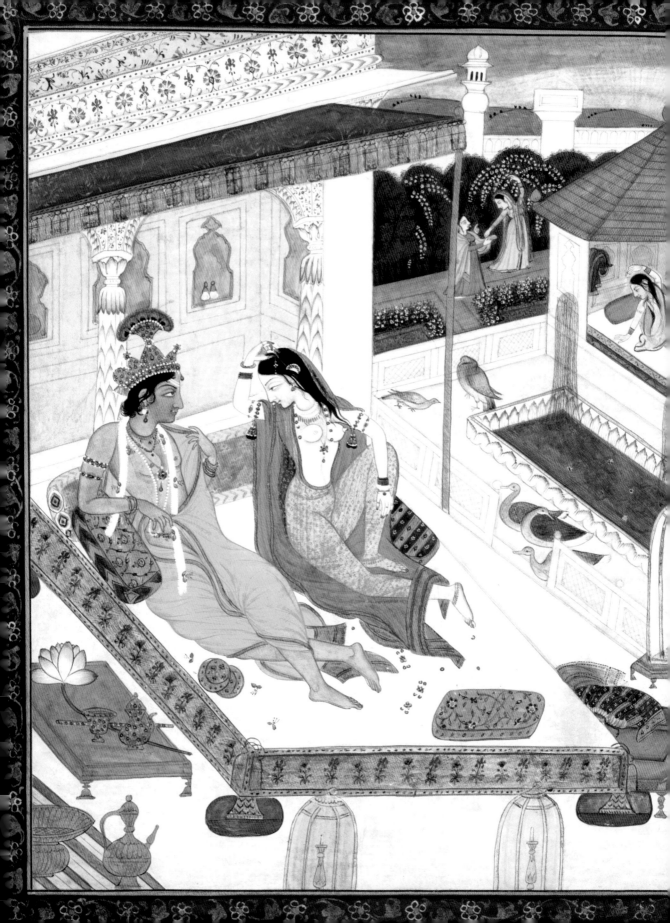

• When one of two lovers presses forcibly one or both of the thighs of the other between his or her own it is called the 'embrace of thighs'.

• When a man presses the *jaghana* or middle part of the woman's body against his own, and mounts upon her to practice, either scratching with the nail or finger, or biting, or striking, or kissing, the hair of the woman being loose and flowing, it is called the 'embrace of the *jaghana*'.

• When a man places his breast between the breasts of a woman and presses her with it, it is called the 'embrace of the breasts'.

• When either of the lovers touches the mouth, the eyes and the forehead of the other with his or her own, it is called the 'embrace of the forehead'.

Some say that even shampooing is a kind of embrace, because there is a touching of bodies in it. But Vatsyayana thinks that as shampooing is performed at a different time, and for a different purpose, and it is also of a different character, it cannot be said to be included in the embrace.

There are also some verses on the subject as follows: 'The whole subject of embracing is of such a nature that men who ask questions about it, or who hear about it, or who talk about it, acquire thereby a desire for enjoyment. Even those embraces that are not mentioned in the *Kama Shastra* should be practised at the time of sexual enjoyment, if they are in any way conducive to the increase of love or passion. The rules of the *Shastra* apply so long as the passion of man is middling, but when the wheel of love is once set in motion, there is then no *Shastra* and no order.' ❧

Facing page: The act of love is relished best with natural beauty all around.

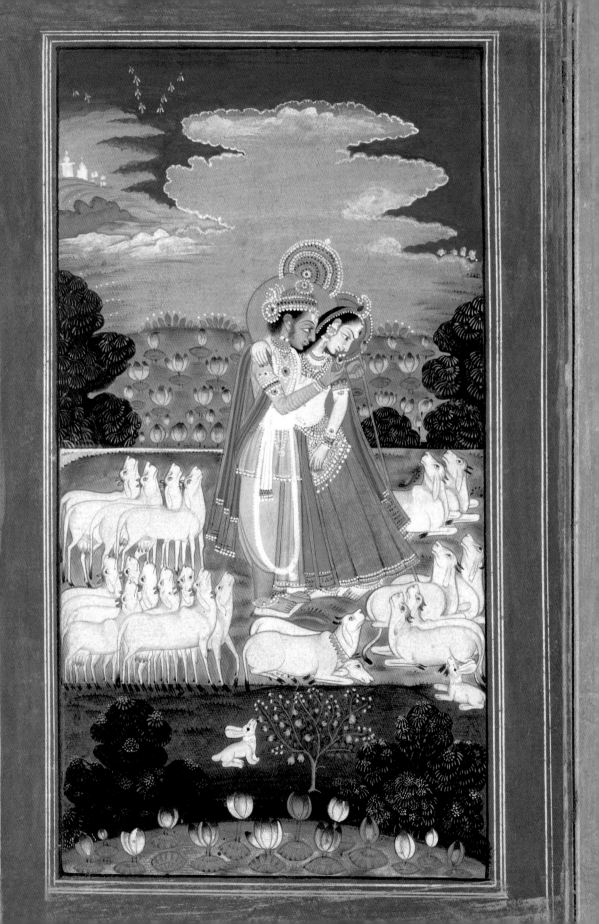

Of Kissing

It is said by some that there is no fixed time or order between the embrace, the kiss, and the pressing or scratching with the nails or fingers, but that all these things should be done generally before sexual union takes place, while striking and making the various sounds generally takes place at the time of the union. Vatsyayana however, thinks that anything may take place at any time, for love does not care for time or order.

On the occasion of the first congress, kissing and the other things mentioned above should be done moderately, they should not be continued for a long time, and should be done alternately. On subsequent occasions, however, the reverse of all this may take place, and moderation will not be necessary, they may continue for a long time, and for the purpose of kindling love, they may be all done at the same time.

The following are the places for kissing – the forehead, the eyes, the cheeks, the throat, the bosom, the breasts, the lips, and the interior of the mouth. In case

Facing page: 'O Radha! I gaze upon your beautiful face, which is like a blossoming lotus in the lake of pure love, a lotus decorated with the black bees of the curling locks of hair, a face that is moon bringing tidal waves to the nectar ocean of bliss.'

Following pages: Radha tries to hide her face as Krishna coaxes her to kiss him.

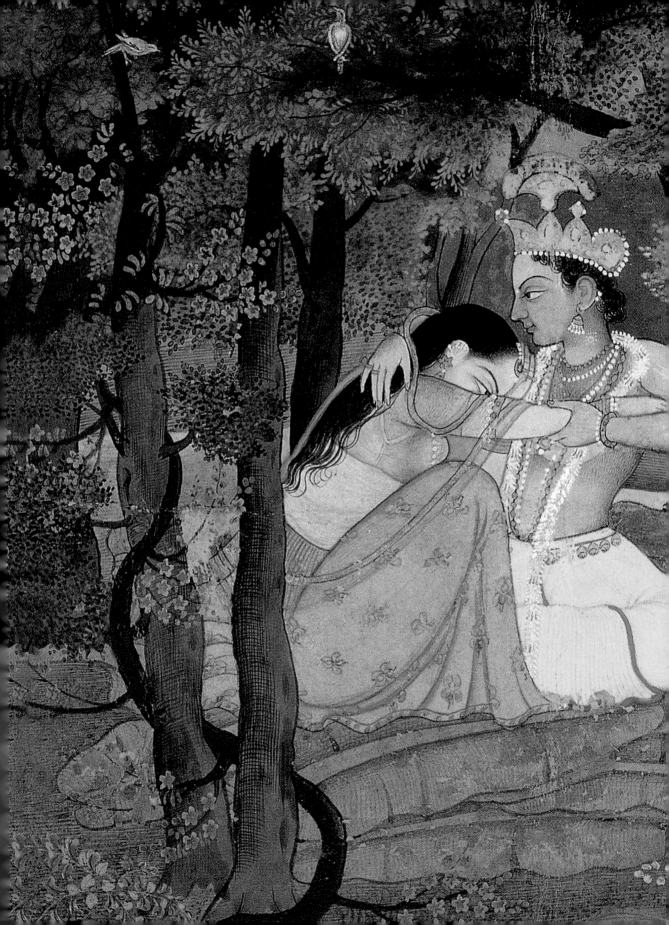

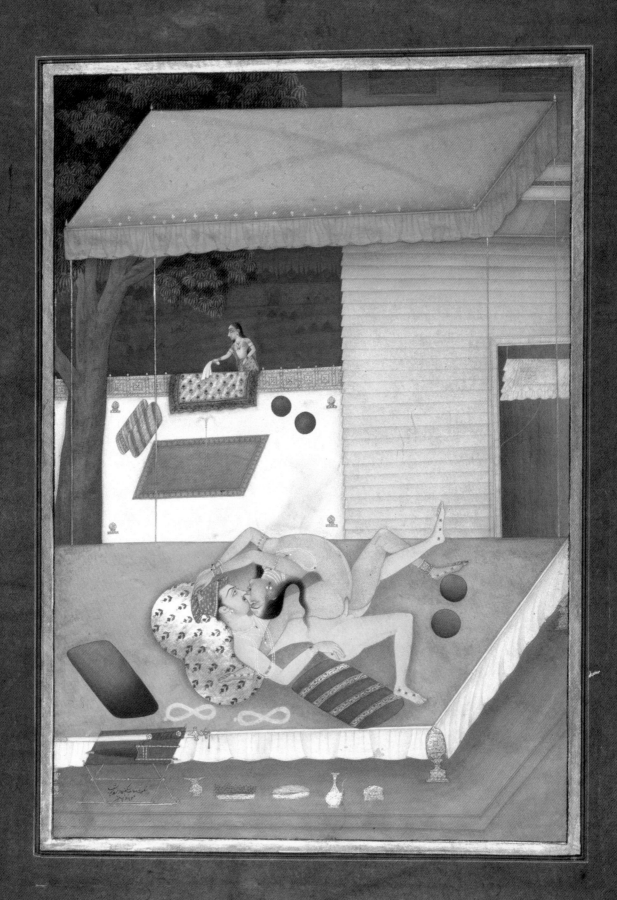

of a young girl, there are three sorts of kisses: the nominal kiss; the throbbing kiss; the touching kiss.

• When a girl only touches the mouth of her lover with her own, but does not herself do anything, it is called the 'nominal kiss'.

• When a girl, setting aside her bashfulness a little, wishes to touch the lip that is pressed into her mouth, and with that object moves her lower lip, but not the upper one, it is called the 'throbbing kiss'.

• When a girl touches her lover's lip with her tongue, and having shut her eyes, places her hands on those of her lover, it is called the 'touching kiss'.

Other authors describe four other kinds of kisses: the straight kiss; the bent kiss; the turned kiss; the pressed kiss.

• When the lips of two lovers are brought into direct contact with each other, it is called a 'straight kiss'.

• When the heads of two lovers are bent towards each other, and when so bent, kissing takes place, it is called a 'bent kiss'.

• When one of them turns up the face of the other by holding the head and chin, and then kissing, it is called a 'turned kiss'.

• Lastly, when the lower lip is pressed with much force, it is called a 'pressed kiss'.

There is also a fifth kind of kiss called the 'greatly pressed kiss', which is effected by taking hold of the lower lip between two fingers, and then after touching it with the tongue, pressing it with great force with the lip.

As regards kissing, a wager may be laid as to which will get hold of the other first. If the woman loses, she should pretend to cry, should keep her lover off by shaking her hands, and turn away from him and dispute with him saying, 'Let another wager be laid.' If she loses this a second time, she should appear doubly distressed, and when her lover is off his guard or asleep, she should get hold of his lower lip, and hold it in her teeth, so that

Facing page: When the lovers are intimate and know each other's bodies well, they can innovate novel ways of kissing during lovemaking.

it should not slip away, and then she should laugh, make a loud noise, deride him, dance about, and say whatever she likes in a joking way, moving her eyebrows, and rolling her eyes. Such are the wagers and quarrels as far as kissing is concerned, but the same may be applied with regard to the pressing or scratching with the nails and fingers, biting and striking. All these however, are only peculiar to men and women of intense passion.

When a man kisses the upper lip of a woman, while she in return kisses his lower lip, it is called 'the kiss of the upper lip'.

When one of them takes both the lips of the other between his or her own, it is called a 'clasping kiss'. A woman, however, only takes this kind of kiss from a man who has no moustache. And on the occasion of the kiss, if one of them touches the teeth, the tongue, and the palate of the other, with his or her tongue, it is called the 'fighting of the tongues'. In the same way, the pressing of the teeth of the one against the mouth of the other is to be practised.

Kissing is of four kinds, viz. moderate, contracted, pressed and soft, according to the different parts of the body that are kissed, for different kinds of kisses are appropriate for different parts of the body.

Comfort with each other enables lovers to move and manoeuvre as they please.

When a woman looks at the face of her lover while he is asleep, and kisses it to show her intention or desire, it is called a 'kiss that kindles love'.

When a woman kisses her lover while he is engaged in business, or while he is quarrelling with her, or while he is looking at something else, so that his mind may be turned away, it is called a 'kiss that turns away'.

When a lover coming home late at night kisses his beloved, who is asleep on her bed, in order to show her his desire, it is called a 'kiss that awakens'. On such an occasion the woman may pretend to be asleep at the time of her lover's arrival, so that she may know his intention and obtain respect from him.

66

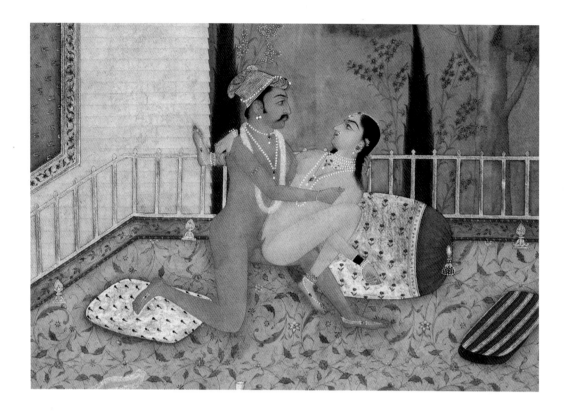

When a person kisses the reflection of the person he loves in a mirror, in water, or on a wall, it is called a 'kiss showing the intention'.

When a person kisses a child sitting on his lap, or a picture, or an image, or figure, in the presence of the person beloved by him, it is called a 'transferred kiss'.

When at night at a theatre, or in an assembly of caste men, a man coming up to a woman kisses a finger of her hand if she be standing, or a toe of her foot if she be sitting, or when a woman is shampooing her lover's body, places her face on his thigh, (as if she was sleepy) so as to inflame his passion, and kisses his thigh or great toe, it is called a 'demonstrative kiss'.

Whatever things may be done by one of the lovers to the other, the same should be returned by the other i.e. if the woman kisses him he should kiss her in return, if she strikes him he should also strike her in return. ❧

The man lifts the woman entirely thus making her feel light and easy.

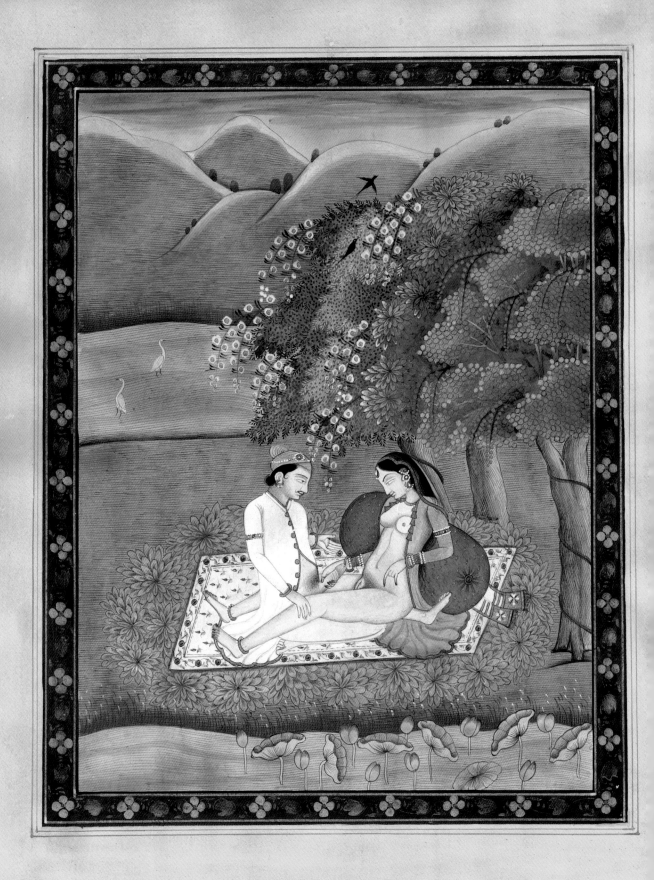

Of Pressing, or Marking, or Scratching with the Nails

When love becomes intense, pressing with the nails or scratching the body with them is practised, and it is done on the following occasions: on the first visit; at the time of setting out on a journey; on the return from a journey; at the time when an angry lover is reconciled; and lastly, when a woman is intoxicated. But pressing with the nails is not a usual thing except with those who are intensely passionate. It is employed together with biting, by those to whom the practice is agreeable.

Pressing with the nails is of the eight following kinds, according to the forms of the marks which are produced: sounding; half moon; a circle; a line; a tiger's nail or claw; a peacock's foot; the jump of a hare; the leaf of a blue lotus.

The places that are to be pressed with the nails are as follows: the armpit, the throat, the breasts, the lips, the *jaghana* or middle parts of the body, and the thighs. The qualities of good nails are that they should be bright,

Facing page: The man and woman touch each other openly in the jungle, giving way to their natural desires.

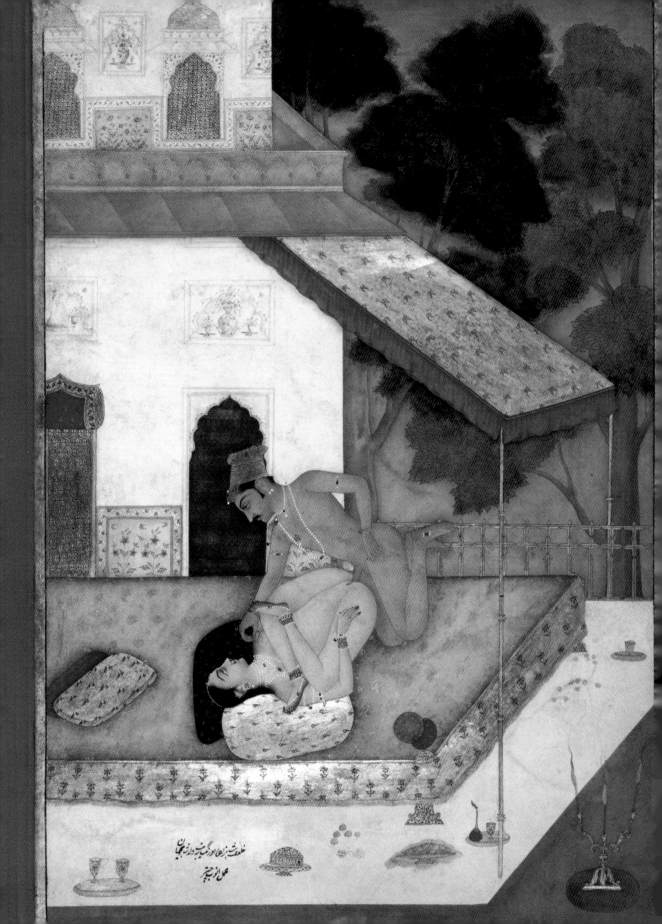

well set, clean, entire, convex, soft, and glossy in appearance.

• When a person presses the chin, the breasts, the lower lip, or the *jaghana* of another so softly that no scratch or mark is left, but only the hair on the body becomes erect from the touch of the nails, and the nails themselves make a sound, it is called a 'sounding or pressing with the nails'. This pressing is used in the case of a young girl when her lover shampoos her, scratches her head, and wants to trouble or frighten her.

• The curved mark with the nails, which is impressed on the neck and the breasts, is called 'the half moon'.

• When the half moons are impressed opposite to each other, it is called a 'circle'. This mark with the nails is generally made on the navel, the small cavities about the buttocks, and on the joint of the thigh.

• A mark in the form of a small line, and which can be made on any part of the body, is called a 'line'.

• This same line, when it is curved, and made on the breast, is called a 'tiger's nail'.

• When a curved mark is made on the breast by means of the five nails, it is called a 'peacock's foot'. This mark is made with the object of being praised, for it requires a great deal of skill to make it properly.

• When five marks with the nails are made close to one another near the nipple of the breast, it is called 'the jump of a hare'.

• A mark made on the breast or on the hips in the form of a leaf of the blue lotus, is called the 'leaf of a blue lotus'.

When a person is going on a journey, and makes a mark on the thighs, or on the breast, it is called a 'token of remembrance'. On such an occasion three or four lines are impressed close to one another with the nails. Marks of other kinds than the above may also be made with the nails, for the ancient authors say, that as there are innumerable degrees of skill among men (the practice of this art being known to all), so there are

Facing page: There are innumerable ways of making love, although the Kama Sutra relates only sixty-four.

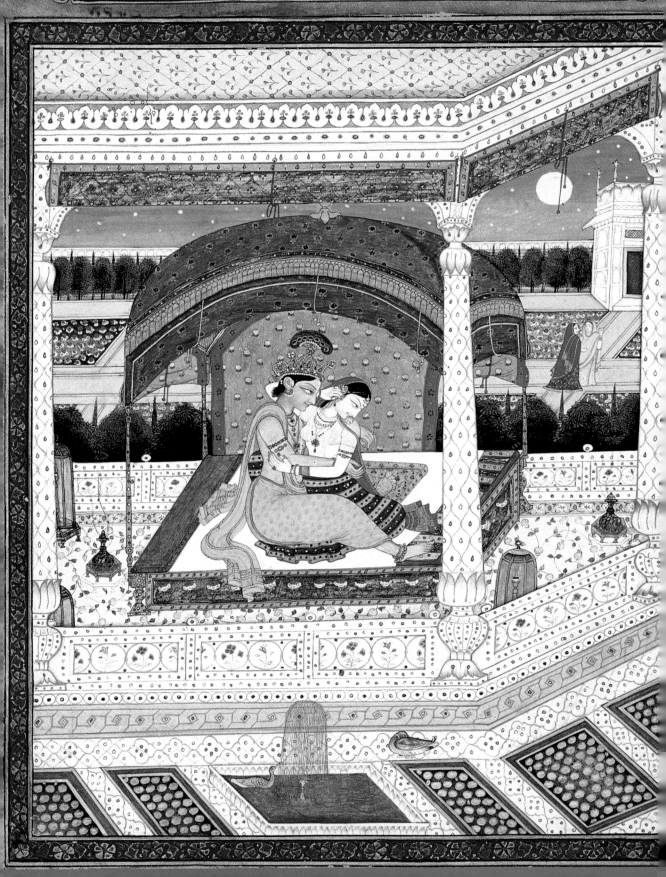

innumerable ways of making these marks. And as pressing or marking with the nails is independent of love, no one can say with certainty how many different kinds of marks with the nails do actually exist. The reason for this is, Vatsyayana says, that as variety is necessary in love, so love is to be produced by means of variety. It is on this account that courtesans, who are well acquainted with various ways and means, become so desirable, for if variety is sought in all the arts and amusements, such as archery and others, how much more should it be sought after in the present case.

The marks of the nails should not be made on married women, but particular kinds of marks may be made on their private parts for the remembrance and increase of love.

The love of a woman who sees the marks of nails on the private parts of her body, even though they are old and almost worn out, becomes again fresh and new. If there be no marks of nails to remind a person of the passages of love, then love is lessened in the same way as when no union takes place for a long time. Even when a stranger sees at a distance, a young woman with the marks of nails on her breast, he is filled with love and respect for her.

A man, also, who carries the marks of nails and teeth on some parts of his body, influences the mind of a woman, even though it be ever so firm. In short, nothing tends to increase love so much as the effects of marking with the nails, and biting. ७

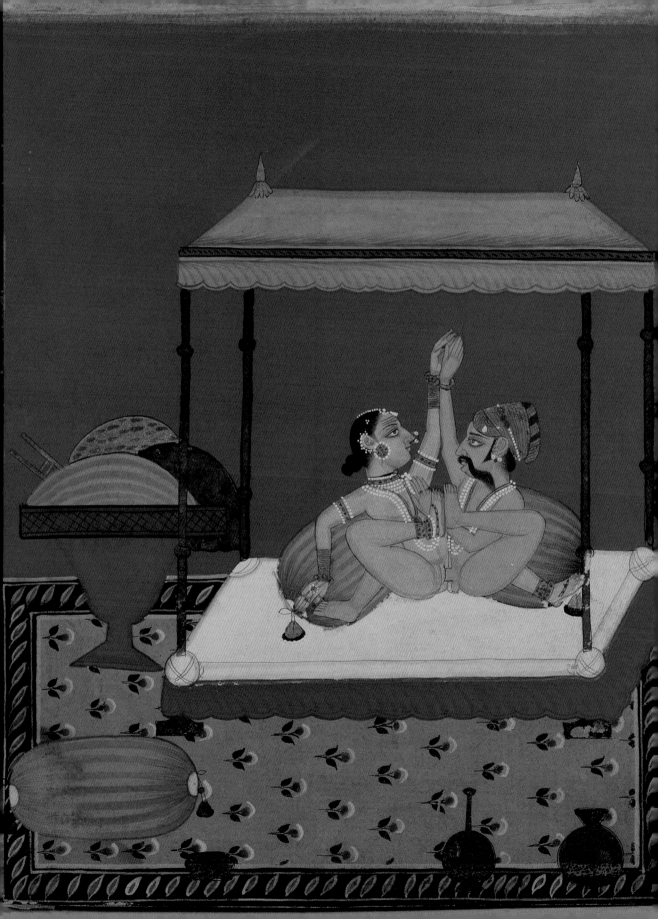

Of the Various Modes of Striking, and Appropriate Sounds

Sexual intercourse can be compared to a quarrel, on account of the contrarities of love and its tendency to dispute. The place of striking with passion is the body, and on the body the special places are: the shoulders; the head; the space between the breasts; the back; the *jaghana* or middle part of the body; the sides. Striking is of four kinds: striking with back of the hand; striking with the fingers a little contracted; striking with the fist; striking with the open palm of the hand.

On account of its causing pain, striking gives rise to the hissing sound, which is of various kinds, and to the eight kinds of crying, viz. the sound of Hin; the thundering sound; the cooing sound; the weeping sound; the sound Phut; the sound Phat; the sound Sut; the sound Plat.

Besides these, there are also words having a meaning, such as 'mother', and those that are expressive of prohibition, sufficiency, desire of liberation, pain or

Facing page: Attempting to break the monotony lovers create their very own dance of love.

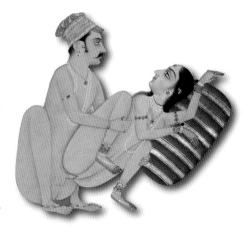

praise, and to which may be added sounds like those of the dove, the cuckoo, the green pigeon, the parrot, the bee, the sparrow, the flamingo, the duck, and the quail, which are all occasionally made use of.

Blows with the fist should be given on the back of the woman, while she is sitting on the lap of the man, and she should give blows in return, abusing the man as if she were angry, and making the cooing and weeping sounds. While the woman is engaged in congress, the space between the breasts should be struck with the back of the hand, slowly at first, and then proportionately to the increasing excitement, until the end.

At this time, the sound Hin and others may be made, alternately or optionally, according to habit. When the man, making the sound Phat, strikes the woman on the head, with the fingers of his hand a little contracted, it is called Prasritaka. In this case, the appropriate sounds are the cooing sound, the sound Phat, and the sound Phut of the interior in the mouth, and at the end of congress, the sighing and weeping sounds. The sound Phat is an imitation of the sound of a bamboo being split, while the sound Phut is like the sound made by something falling into water. At all times, when kissing and such like things are begun, the woman should give a reply with a hissing sound. During the excitement when the woman is not accustomed to striking, she continually utters words expressive of prohibition, sufficiency, or desire of liberation, as well as the words 'father', 'mother', intermingled with the sighing, weeping and thundering sounds. Towards the conclusion of the congress, the breasts, the *jaghana*, and the sides of the woman should be pressed with the open palms of the hand, with some force, until the end of it, and then sounds like those of the quail, or the goose should be made.

There are also two verses on the subject as follows: 'The characteristics of manhood are said to consist of roughness and impetuosity, while weakness, tenderness,

sensibility, and an inclination to turn away from unpleasant things are the distinguishing marks of womanhood. The excitement of passion, and pecularities of habit may sometimes cause contrary results to appear, but these do not last long, and in the end the natural state is resumed.'

The wedge on the bosom, the scissors on the head, the piercing instrument on the cheeks, and the pincers on the breasts and sides, may also taken into consideration with the other four modes of striking, and thus give eight ways altogether. But these four ways of striking with instruments are peculiar to the people of the southern countries, and the marks caused by them are seen on the breasts of their women. They are local peculiarities, but Vatsyayana is of the opinion that the practice of them is painful, barbarous and base, and quite unworthy of imitation.

In the same way, anything that is a local peculiarity should not always be adopted elsewhere, and even in the place where the practice is prevalent, excess of it should always be avoided. Instances of the dangerous use of them may be given as follows. The king of the Panchalas killed the courtesan Madhavasena, by means of the wedge during congress. King Shatakarni Shatavahana of Kuntalas deprived his great Queen Malayavati of her

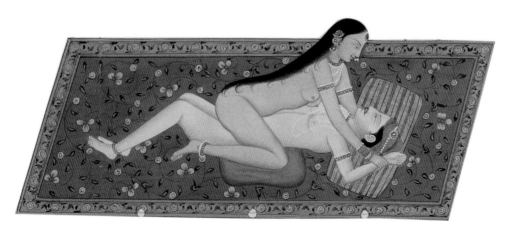

life by a pair of scissors, and Naradeva, whose hand was deformed, blinded a dancing girl by directing a piercing instrument in a wrong way.

Such passionate actions and amorous gesticulations or movements, which arise on the spur of the moment, and during sexual intercourse, cannot be defined, and are as irregular as dreams. A horse, having once attained the fifth degree of motion goes on with blind speed, regardless of pits, ditches, and posts in his way; and in the same manner a loving pair becomes blind with passion in the heat of congress, and go on with great impetuosity, applying not the least regard to excess. For this reason, one who is well acquainted with the science of love, and knowing his own strength, as also the tenderness, impetuosity, and strength of the young women, should act accordingly. The various modes of enjoyment are not for all times or for all persons, but they should only be used at the proper time, and in the proper countries and places. ୬

Facing page: Both the woman and the man should engage in light conversation during lovemaking.

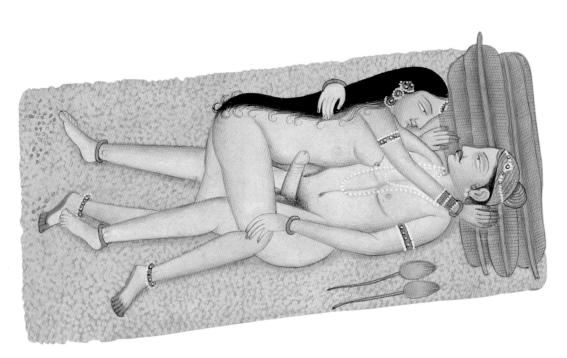

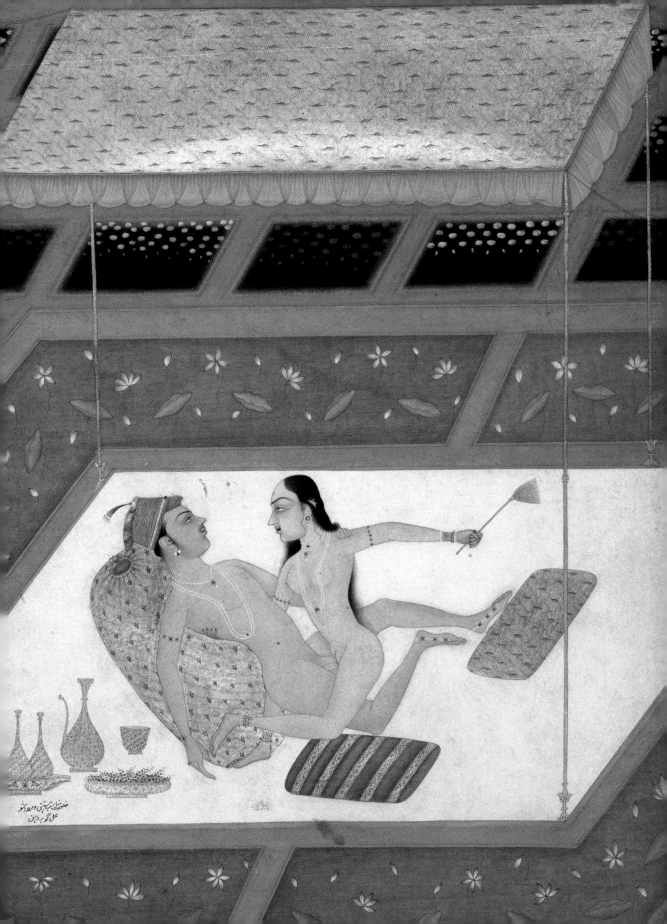

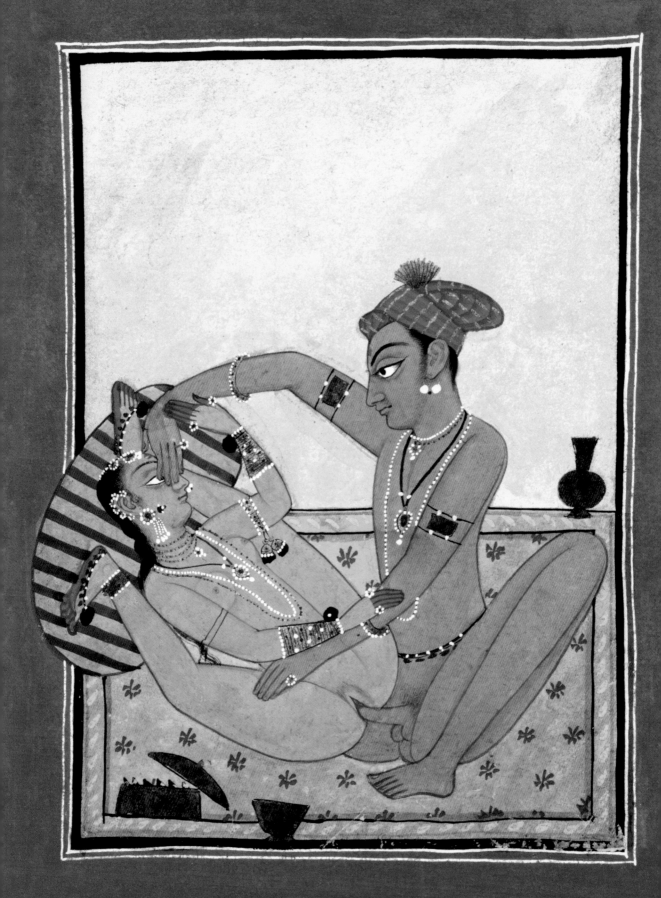

Of Biting

All the places that can be kissed, are also the places that can be bitten, except the upper lip, the interior of the mouth, and the eyes. The qualities of good teeth are as follows: they should be equal, possessed of a pleasing brightness, capable of being coloured, of proper proportions, unbroken, and with sharp ends.

The defects of teeth on the other hand, are that they are blunt, protruding from the gums, rough, soft, large, and loosely set.

The following are the different kinds of biting: the hidden bite; the swollen bite; the point; the line of points; the coral and the jewel; the line of jewels; the broken cloud; the biting of the boar.

• The biting which is shown only by the excessive redness of the skin that is bitten, is called the 'hidden bite'.

• When the skin is pressed down on both sides, it is called the 'swollen bite'.

• When a small portion of the skin is bitten with two teeth only, it is called the 'point'.

Facing page: The man holds the woman's nose to create anxiety and thus heighten their pleasure.

Following pages: The woman arches her back to look in the same direction as the man, albeit for an upside-down view.

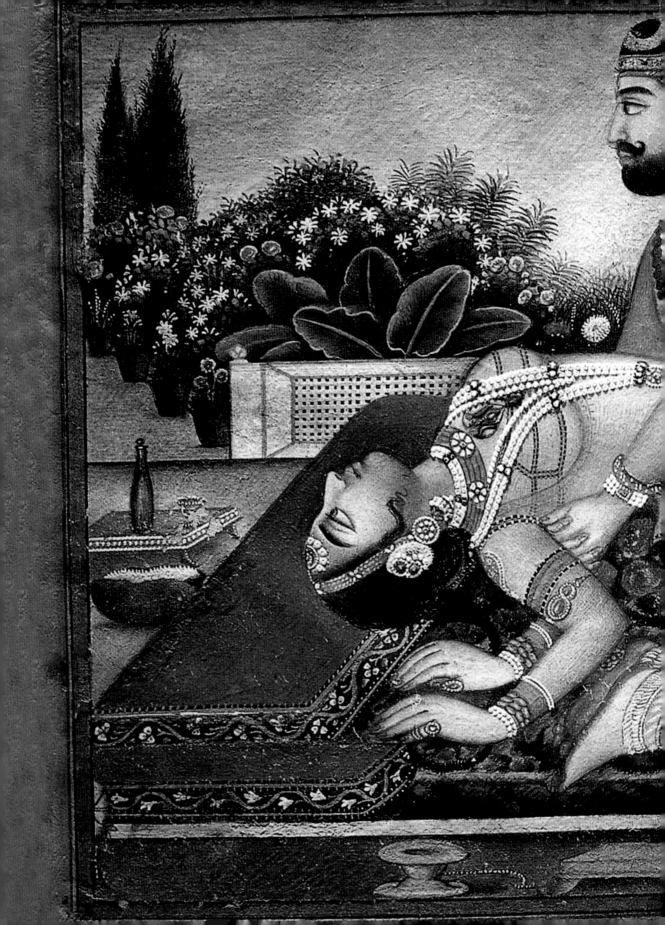

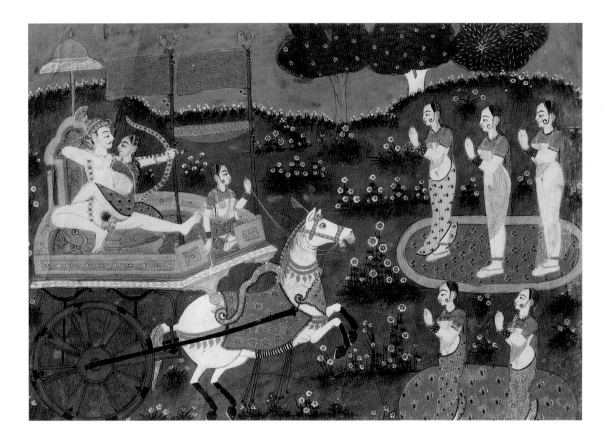

The chariot of love transports lovers into a blissful paradise.

• When such small portions of the skin are bitten with all the teeth, it is called the 'line of points'.

• The biting done by bringing together the teeth and the lips, is called the 'coral and the jewel'. The lip is the coral, and the teeth the jewel.

• When biting is done by all the teeth, it is called the 'line of jewels'.

• The biting which consists of unequal rising in a circle, and which comes from the space between teeth, is called the 'broken cloud'. This is impressed on the breasts.

• The biting which consists of many broad rows of marks near to one another, and with red intervals, is called the 'biting of a boar'. This is impressed on the breasts and the shoulders; and these two last modes of biting are peculiar to persons of intense passion.

The lower lip is the place on which the 'hidden bite', the 'swollen bite' and the point are made; again, the 'swollen bite' and the 'coral and the jewel' bite are done on the cheek. Kissing, pressing with the nail, and biting are the ornaments of the left cheek, and when the word cheek is used it is to be understood as the left cheek. Both the 'line of points' and the 'line of jewels' are to be impressed on the throat, the armpit, and the joints of the thighs; but the 'line of point' alone is to be impressed on the forehead and the thighs.

The marking with the nails, and the biting of the following things viz. an ornament of the forehead, an ear ornament, a bunch of flowers, a betel leaf, or a *tamala* leaf, which are worn by or belong to the woman that is beloved, are signs of the desire of enjoyment. Among the things mentioned above viz. embracing, kissing, etc., those which increase passion should be done first, and those which are only for amusement or variety should be done afterwards.

There are also some verses on this subject as follows: 'When a man bites a woman forcibly, she should angrily do the same to him with double force. Thus a point should be returned with a line of points, and a line of points with a broken cloud, and if she be excessively chafed, she should at once begin a love quarrel with him. At such a time she should take hold of her lover by the hair, and bend his head down, and kiss his lower lip, and then, being intoxicated with love, she should shut her eyes and bite him in various places. Even by day, and in a place of public resort, when her lover shows her any mark that she may have inflicted on his body, she should smile at the sight of it, and turning her face as if she were going to chide him, she should show him with angry look the marks on her own body that have been made by him. Thus, if men and women act according to each other's liking, their love for each other will not be lessened even in one hundred years.' ॐ

The woman's flowing hair stimulate her lover further.

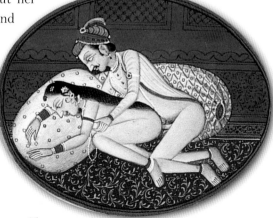

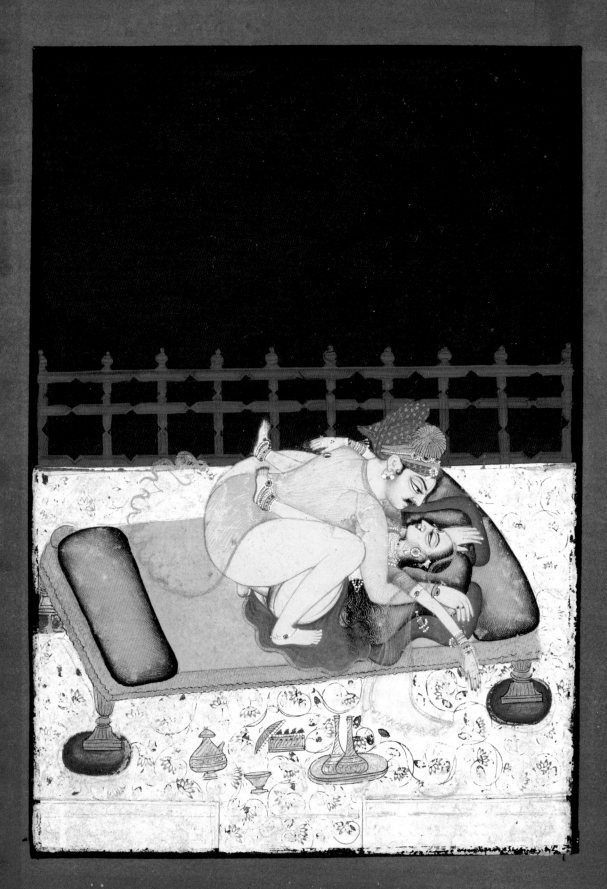

Of the Various Kinds of Congress

On the occasion of 'high congress' the Mrigi (Deer) woman should lie down in such a way as to widen her *yoni*, while in a 'low congress' the Hastini (Elephant) woman should lie down so as to contract hers. But in an 'equal congress' they should lie down in the natural position. What is said above concerning the Mrigi and the Hastini, applies also to the Vadawa (Mare) woman. In a 'low congress' the woman should particularly make use of medicine, to cause her desire to be satisfied quickly.

The Deer woman has the following three ways of lying down: the widely opened position; the yawning position; the position of the wife of Indra.

• When she lowers her head and raises her middle parts, it is called the 'widely opened position'. At such a time, the man should apply some unguent, so as to make the entrance easy.

•When she raises her thighs and keeps them wide apart and engages in congress, it is called the 'yawning position'.

Facing pages: Making love in different animal-like postures is encouraged by Vatsyayana.

•When she places her thighs with her legs doubled on them upon her sides, and thus engages in congress, it is called the position of Indrani, and this is learnt only by practice. The position is also useful in the case of the 'highest congress'.

The 'clasping position' is used in 'low congress', and in the 'lowest congress', together with the 'pressing position', the 'twining position', and the 'mare's position'.

When the legs of both the male and the female are stretched straight out over each other, it is called the 'clasping position'. It is of two kinds, the side position and the supine position, according to the way in which they lie down. In the side position, the male should invariably lie on his left side, and cause the woman to lie on her right side, and this rule is to be observed in lying down with all kinds of women.

When, after congress has begun in the clasping position, the woman presses her lover with her thighs, it is called the 'pressing position'.

When the woman places one of her thighs across the thigh of her lover, it is called the 'twining position'.

When a woman forcibly holds the *lingam* in her *yoni* after it is in, it is called the 'mare's position'. This is learnt by practice only.

The above are the different ways of lying down, mentioned by Babhravya; Suvarnanabha, however, gives the following in addition.

When the female raises both of her thighs straight up, it is called the 'raising position'.

When she raises both of her legs, and places them on her lover's shoulders, it is called the 'yawning position'.

When the legs are contracted, and thus held by the lover before his bosom, it is called the 'pressed position'.

When only one of her legs is stretched out, it is called the 'half pressed position'.

When the woman places one of her legs on her

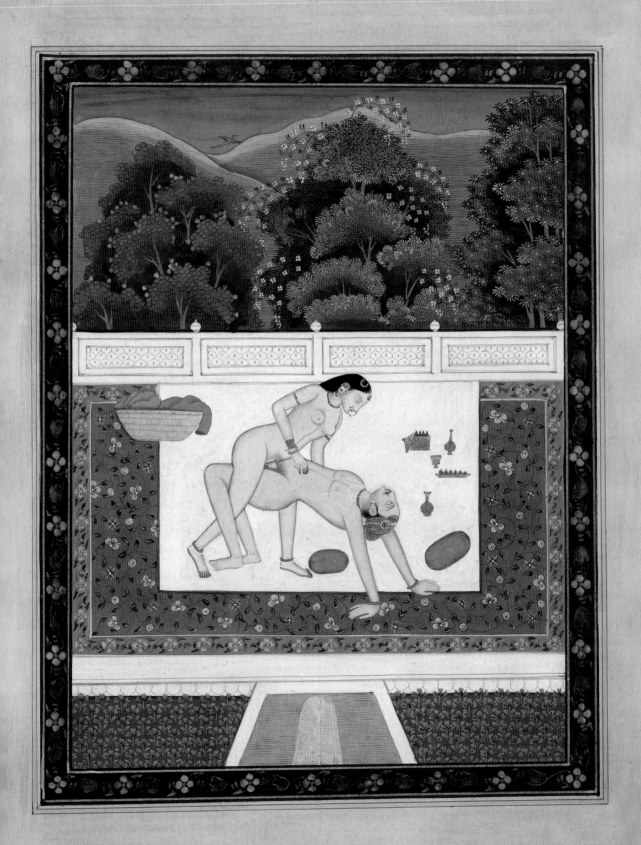

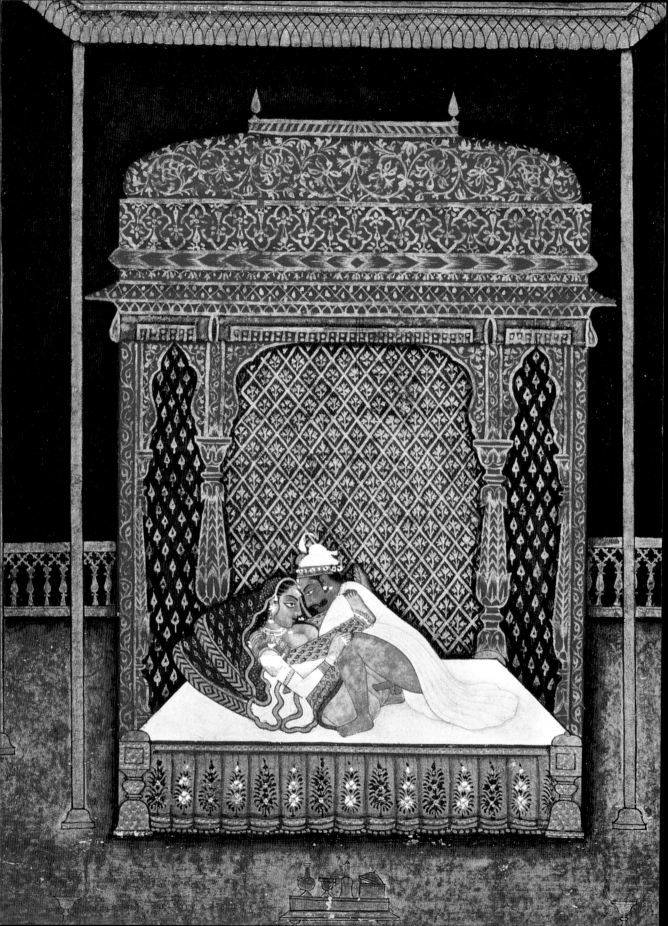

lover's shoulder, and stretches the other out, and then places the latter on his shoulder, and stretches out the other and continues to do so alternately, it is called the 'splitting of a bamboo'.

When one of her legs is placed on the head, and the other is stretched out, it is called the 'fixing of a nail'. This is learnt by practice only.

When both the legs of the woman are contracted, and placed on her stomach, it is called the 'crab's position'.

When the thighs are raised and placed one upon the other, it is called the 'packed position'.

When the shanks are placed one upon the other, it is called the 'lotus-like position'.

When a man, during congress, turns round, and enjoys the woman without leaving her, while she embraces him round the back all the time, it is called the 'turning position', and is learnt only by practice.

Thus says Suvarnanabha, these different ways of lying down, sitting, and standing should be practised in water because it is easy to do therein. But Vatsyayana is of the view that congress in water is improper, because it is prohibited by the religious law.

When a man and a woman support themselves on each other's bodies, or on a wall, or pillar, and thus while standing engage in congress, it is called the 'supported congress'.

When a man supports himself against a wall, and the woman, sitting on his hands joined together and held underneath her, throws her arms round his neck, and putting her thighs alongside his waist, moves herself by her feet, which are touching the wall against which the man is leaning, it is called the 'suspended congress'.

When a woman stands on her hands and feet like a quadruped, and her lover mounts her like a bull, it is called the 'congress of a cow'. At this time, everything that is ordinarily done on the bosom should be done on the back. In the same way can be carried on the congress

Facing page: The man must be gentle even as he is forceful.

91

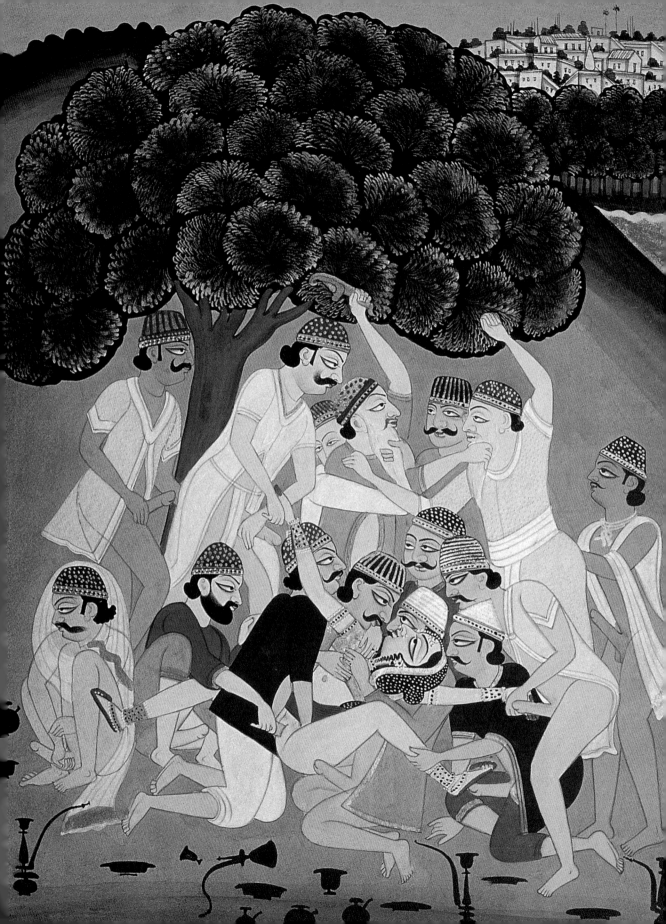

of a dog, the congress of a goat, the congress of a deer, the forcible mounting of an ass, the congress of a cat, the jump of a tiger, the pressing of an elephant, the rubbing of a boar, and the mounting of a horse. And in all these cases the characteristics of these different animals should be manifested by acting like them.

When a man enjoys two women at the same time, both of whom love him equally, it is called the 'united congress'.

When a man enjoys many women altogether, it is called the 'congress of a herd of cows'.

The following kinds of congress viz. sporting in water, or the congress of an elephant with many female elephants which is said to take place only in the water, the congress of a collection of goats, the congress of a collection of deer, take place in imitation of these animals.

In Gramaneri, many young men enjoy a woman, who may be married to one of them, either one after the other, or at the same time. Thus, one of them holds her, another enjoys her, a third uses her mouth, a fourth holds her middle part, and in this way they go on enjoying her several parts alternately. The same things can be done when several men are sitting in company with one courtesan, or when one courtesan is alone with many men. In the same way this can be done by the women of the king's harem, when they accidentally get hold of a man.

The people in the southern countries have also a congress in the anus, that is called the 'lower congress'.

Thus end the various kinds of congress. There are some verses on the subject as follows: 'An ingenious person should multiply the kinds of congress after the fashion of the different kinds of beasts and of birds. For these different kinds of congress, performed according to the usage of each country, and the liking of each individual, generate love, friendship, and respect in the hearts of women.' ੨੭

Facing page: In Gramaneri, the men have smoked their hookahs and sipped their wine, and now enjoy several parts of a woman alternately; but some others are busy quarrelling with each other.

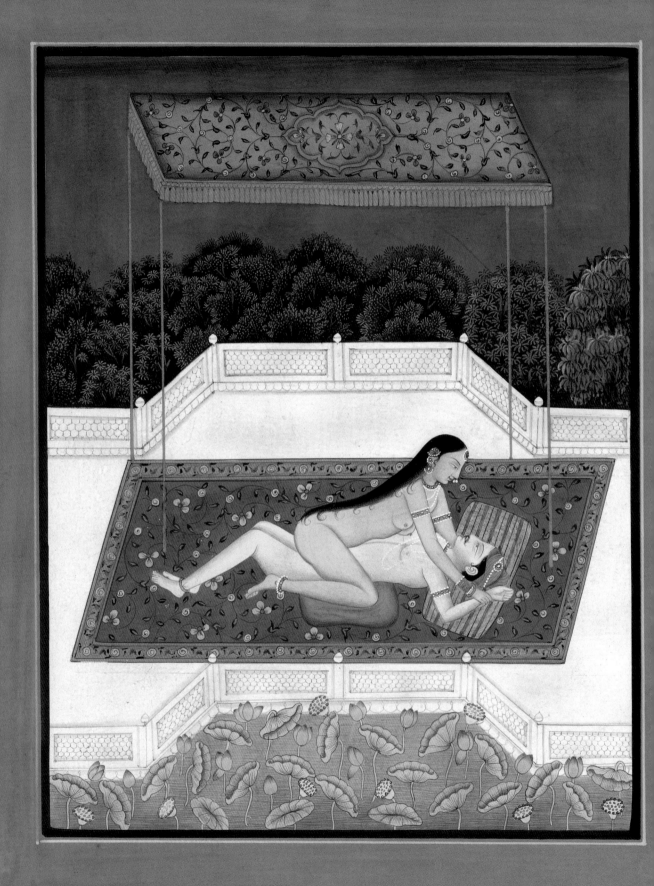

Of Role Reversal

When a woman sees that her lover is fatigued by constant congress, without having his desire satisfied, she should, with his permission, lay him down upon his back, and give him assistance by acting his part. She may also do this to satisfy the curiosity of her lover, or her own desire of novelty.

There are two ways of doing this. The first is when during congress she turns round, and gets on the top of her lover, in such a manner as to continue the congress, without obstructing the pleasure of it; and the other is when she acts the man's part from the beginning. At such a time, with her hair hanging loose, and her smiles broken by hard breathing, she should press upon her lover's bosom with her own breasts, and lowering her head frequently, should do in return the same actions which he used to do before, returning his blows, and chaffing him, should say, I was laid down by you, and fatigued with hard congress. I shall now therefore lay you down in return.' She should then again manifest her

Facing page: The woman's display of physical power over the man is a form of role reversal that lures both into unknown realms of pleasure.

own bashfulness, her fatigue, and her desire for stopping the congress.

Whatever is done by a man for giving pleasure to a woman is called the work of a man, and is as follows: While the woman is lying on his bed, and is as it were, abstracted by his conversation, he should loosen the knot of her undergarments, and when she begins to dispute with him, he should overwhelm her with kisses. Then when his *lingam* is erect, he should touch her with his hands in various places, and gently manipulate various parts of the body. If the woman is bashful, and if it is the first time that they have come together, the man should place his hands between her thighs, which she would probably keep close together, and if she is a very young girl, he should first get his hand upon her breast, which she would probably cover with her own hands, and under her armpits and on her neck. If, however, she is a seasoned woman, he should do whatever is agreeable either to him or to her, and whatever is fitting for the occasion. After this he should take hold of her hair, and hold her chin in his fingers for the purpose of kissing her. On this, if she is a young girl, she will become bashful and close her eyes. Anyhow he should gather from the action of the woman, what things would be pleasing to her during congress.

The signs of the enjoyment and satisfaction of the woman are as follows: her body relaxes, she closes her eyes, she puts aside all bashfulness, and shows increased willingness to unite the two organs as closely together as possible. On the other hand, the signs of her want of enjoyment and of failing to be satisfied are as follows:she shakes her hands, she does not let the man get up, feels dejected, bites the man, kicks him, and continues to go on moving after the man has finished. In such cases, the man should rub the *yoni* of the woman with his hand and fingers (as the elephant rubs anything with his trunk) before engaging in congress, until it is softened, and after that is done he should proceed to put his *lingam* into her.

Facing page: Courtesans were accomplished in the art of lovemaking, of which witty conversations are an integral part.

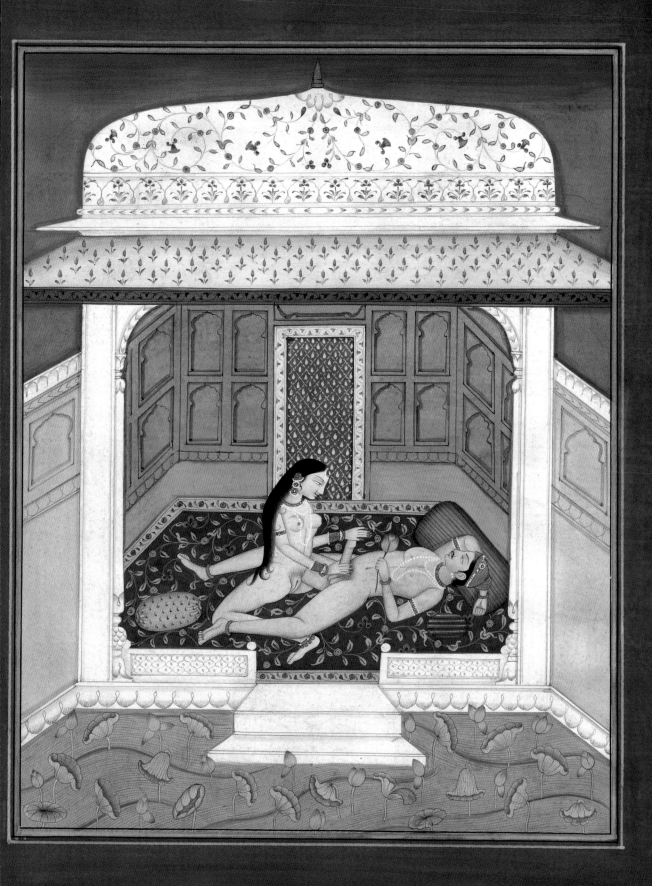

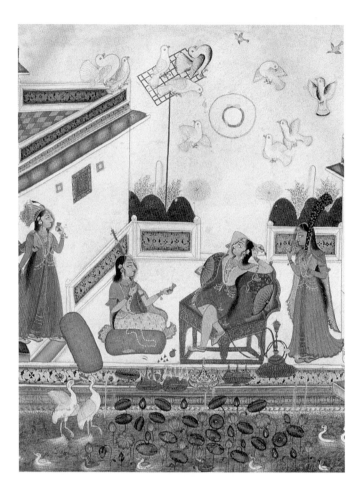

A woman in love looks on as mating birds fly overhead and spring blooms all around her. Her attendants keep her entertained with song and wine.

Facing page: The man makes a hammock out of the woman's body, as he cradles her in his arms.

The acts to be done by the man are: moving forward; friction or churning; piercing; rubbing; pressing; giving a blow; the blow of a boar; the blow of a bull; the sporting of a sparrow.

•When the organs are brought together properly and directly it is called 'moving the organ forward'.

• When the *lingam* is held with the hand, and turned all round in the *yoni*, it is called 'churning'.

• When the *yoni* is lowered, and the upper part of it is struck with the *lingam*, it is called 'piercing'.

•When the same thing is done on the lower part of the *yoni*, it is called 'rubbing'.

• When the *yoni* is pressed by the *lingam* for a long time, it is called 'pressing'.

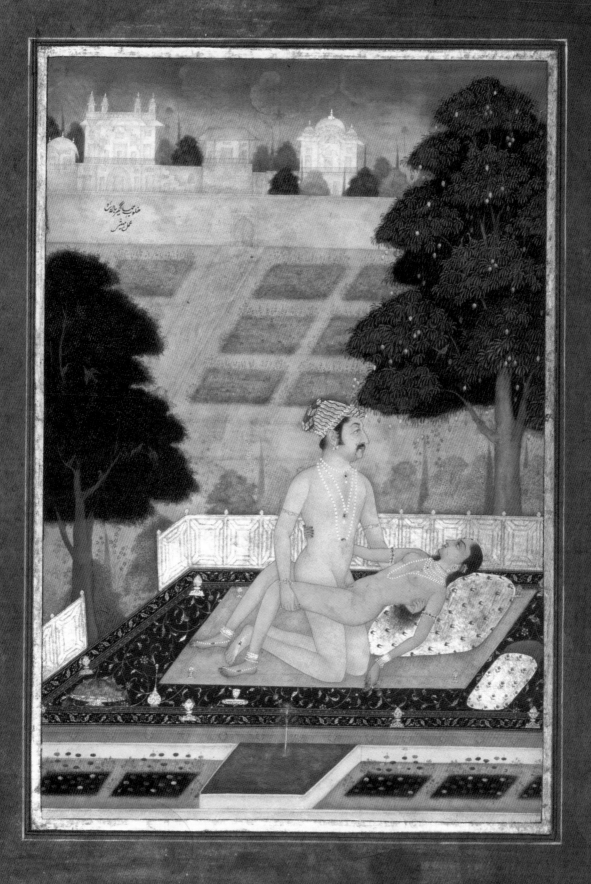

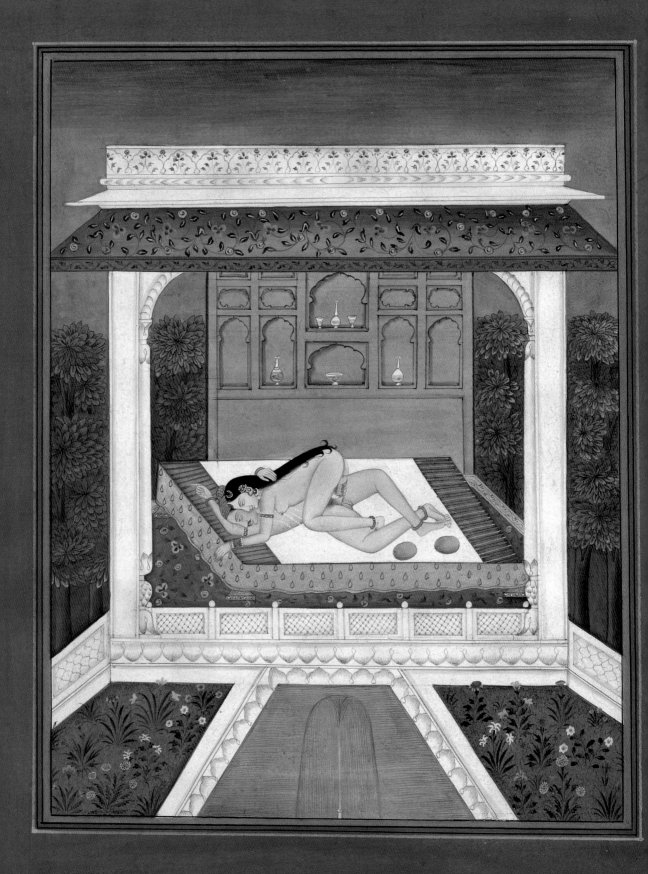

•When the *lingam* is removed to some distance from the *yoni*, and then forcibly strikes it, it is called 'giving a blow'.

• When only one part of the *yoni* is rubbed with the *lingam*, it is called the 'blow of a boar'.

• When both sides of the *yoni* are rubbed in this way, it is called the 'blow of a bull'.

• When the *lingam* is in the *yoni*, and moved up and down frequently, and without being taken out, it is called the 'sporting of a sparrow'. This takes place at the end of the congress.

When a woman acts the part of a man, she has the following things to do in addition to the nine given above viz. the pair of tongs; the top; the swing.

•When the woman holds the *lingam* in her *yoni*, draws it in, presses it, and keeps it thus in her for a long time, it is called the 'pair of tongs'.

•When, while engaged in congress, she turns round like a wheel, it is called the 'top'. This is learnt by practice only.

•When, on such an occasion, the man lifts up the middle part of the body, and the woman turns round her middle part, it is called the 'swing'.

When the woman is tired, she should place her forehead on that of her lover, and should thus take rest without disturbing the union of the organs, and when the woman has rested herself, the man should turn round and begin the congress again.

There are also some verses on the subject as follows: 'Though a woman is reserved, and keeps her feelings concealed, yet when she gets on the top of a man, she then shows all her love and desire. A man should gather from the actions of the woman of what disposition she is, and in what way she likes to be enjoyed. A woman during her monthly courses, a woman who has been lately confined, and a fat woman should not be made to act the part of a man.' ❧

Facing page: The woman possesses the body of her lover with force and power in the throes of passion.

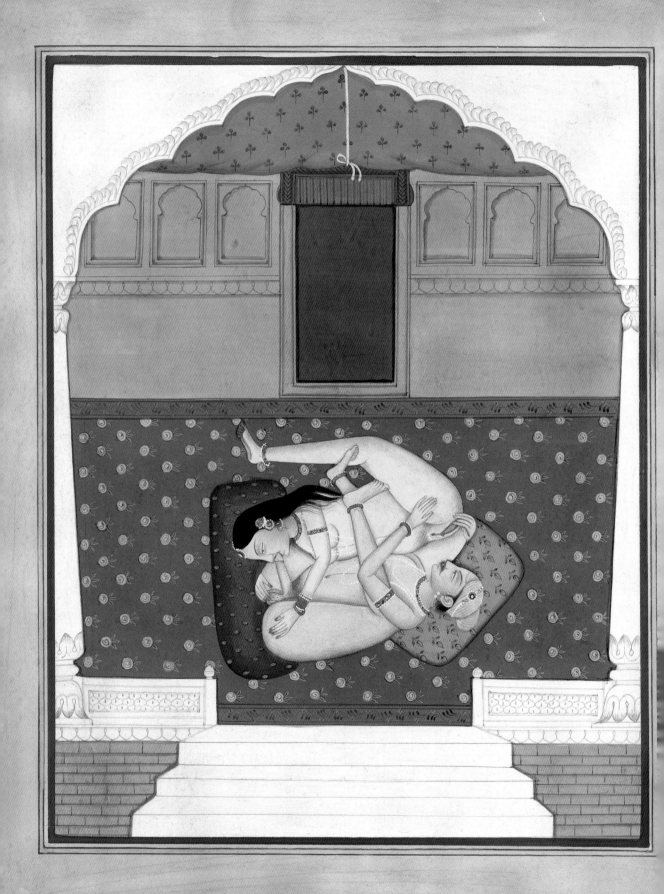

Of the Auparishtaka or Mouth Congress

There are two kinds of eunuchs, those that are disguised as males, and those that are disguised as females. Eunuchs disguised as females, imitate their dress, speech, gestures, tenderness, timidity, simplicity, softness and bashfulness. The acts that are done on the *jaghana* or middle parts of women, are done in the mouth of these eunuchs, and this is called Auparishtaka. These eunuchs derive their imaginable pleasure, and their livelihood from this kind of congress, and they lead the life of courtesans. So much concerning eunuchs disguised as females.

Eunuchs disguised as males, keep their desires secret, and when they wish to do anything they lead the life of shampooers. Under the pretence of shampooing, a eunuch of this kind embraces and draws towards himself, the thighs of the man whom he is shampooing, and after this he touches the joints of the thighs and his *jaghana,* or central portions of his body. Then, if he finds the *lingam* of the man erect, he presses it with his

Facing page: Vatsyayana encourages the use of all body parts in lovemaking because it is to be treated as a joyful sport.

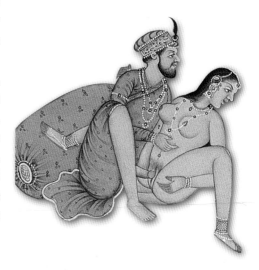

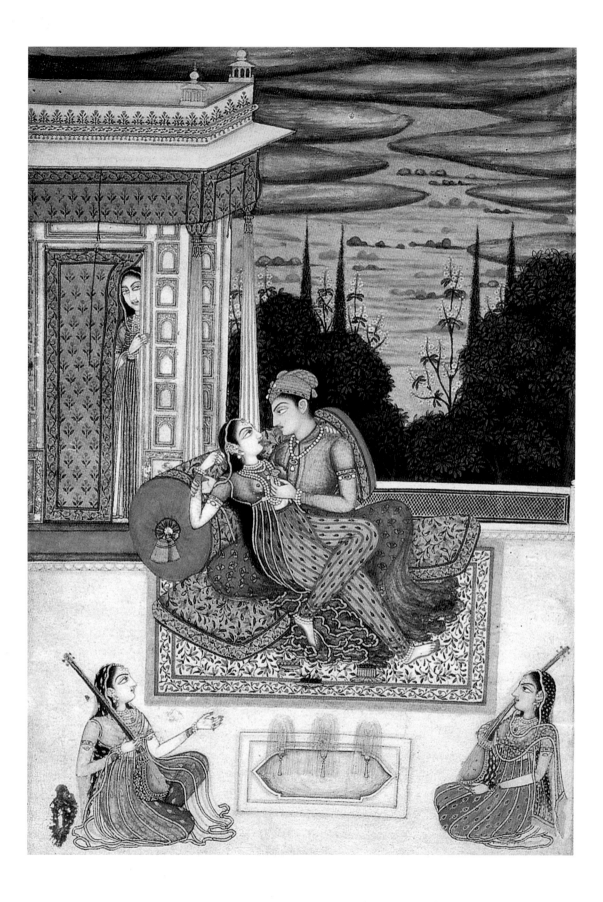

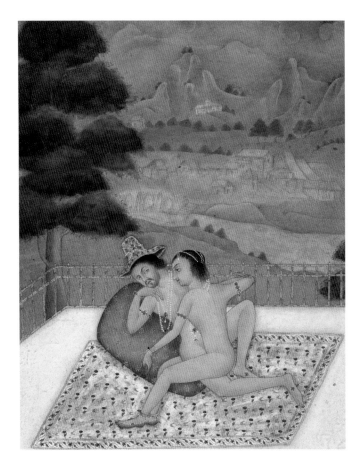

hands, and chaffs him for getting into that stage. If after this, and after knowing his intention, the man does not tell the eunuch to proceed, then the latter does it of his own accord and begins the congress. If however, he is ordered by the man to do it, then he disputes with him, and only consents at last with difficulty.

The following eight things are then done by the eunuch, one after the other viz. the nominal congress; biting the sides; pressing outside; pressing inside; kissing; rubbing; sucking a mango fruit; swallowing up.

At the end of each of these, the eunuch expresses his wish to stop, but when one of them is finished, the man desires him to do another, and after that is done, then the one that follows it, and so on.

• When, holding the man's *lingam* with his hand, and

The woman's strength is as important as that of the man.

Facing page: Another woman eagerly steals a glance into the court of the lovers, who entertain themselves with music and wine.

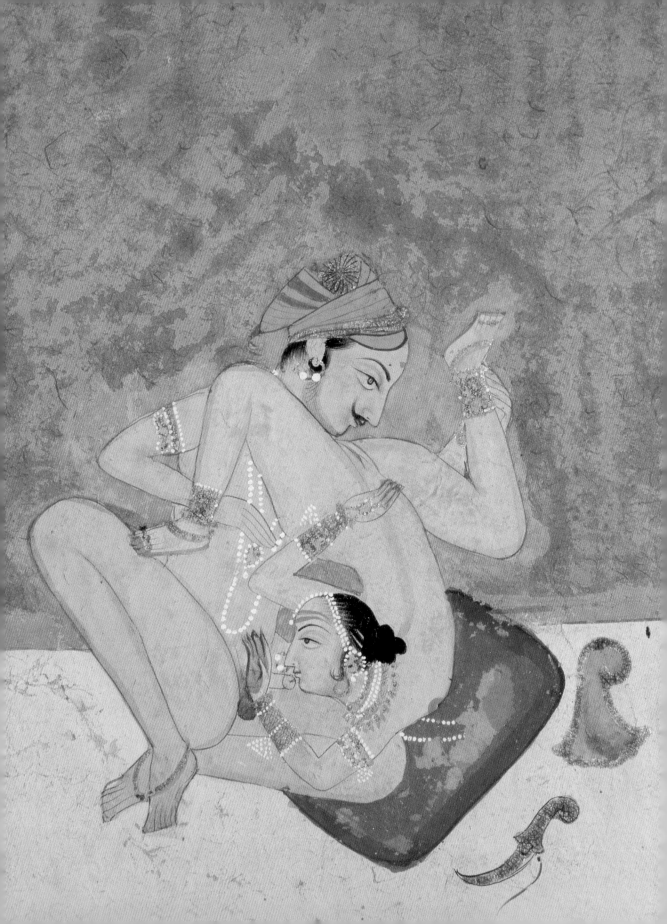

placing it between his lips, the eunuch moves his mouth about, it is called the 'nominal congress'.

• When, covering the end of the *lingam* with his fingers collected together like the bud of a plant or a flower, the eunuch presses the sides of it with the lips, using his teeth also, it is called 'biting the sides'.

• When, being desired to proceed, the eunuch presses the end of the *lingam* with his lips closed together, and kisses it as if he were drawing it out, it is called the 'outside pressing'.

• When, being asked to go on, he puts the *lingam* further into his mouth, and presses it with his lips and then takes it out, it is called the 'inside pressing'.

• When, holding the *lingam* in his hand, the eunuch kisses it as if he were kissing the lower part, it is called 'kissing'.

• When, after kissing it, he touches it with his tongue everywhere, and passes the tongue over the end of it, it is called 'rubbing'.

• When, in the same way, he puts the half of it into his mouth, and forcibly kisses and sucks it, this is called 'sucking a mango fruit'.

• And lastly, when, with the consent of the man, the eunuch puts the whole *lingam* into his mouth, and presses it to the very end, it is called 'swallowing up'.

Striking, scratching, and other things may also be done during this kind of congress.

The Auparishtaka is practised also by unchaste and wanton women, female attendants and serving maids, i.e. those who are not married to anybody, but who live by shampooing.

The Acharyas (i.e. ancient and venerable authors) are of the opinion that this Auparishtaka is the work of a dog and not a man, because it is a low practice, and opposed to the orders of the Holy Writ, and because the man himself suffers by bringing his *lingam* into contact with the mouth of eunuchs and women. But Vatsyayana says that the orders of the Holy Writ do not

Facing page: Mouth congress is acceptable as long as it is consensual and pleasurable for both lovers.

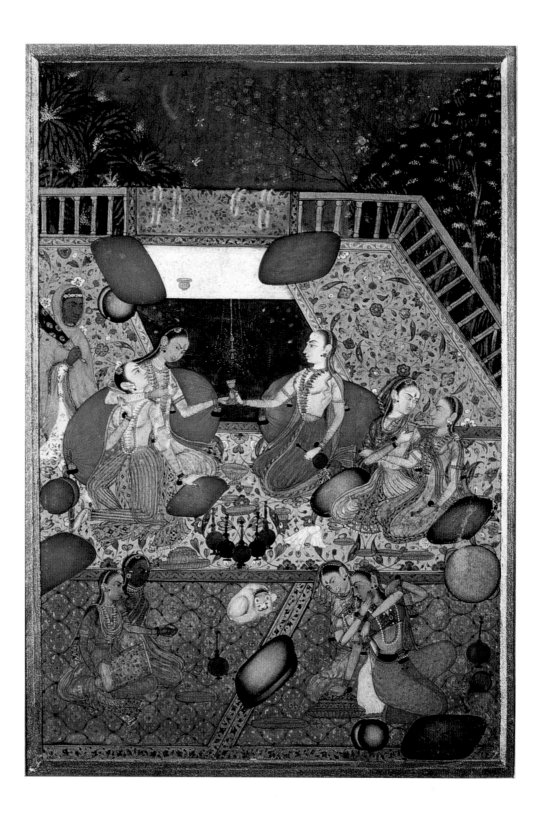

affect those who resort to courtesans, and the law only prohibits the practice of the Auparishtaka with married women. As regards the injury to the male, that can be easily remedied.

The male servants of some men carry on the mouth congress with their masters. It is also practised by some citizens who know each other well, among themselves. Some women of the harem, when they are amorous, do the acts of the mouth on the *yonis* of one another, and some men do the same thing with women. The way of doing this (i.e. of kissing the *yoni*) should be known from kissing the mouth. When a man and woman lie down in an inverted order, i.e. with the head of the one towards the feet of the other, and carry on this congress, it is called the 'congress of crow'.

For the sake of such things, courtesans abandon men possessed of good qualities, liberal and clever, and become attached to low persons, such as slaves and elephant drivers. The Auparishtaka, or mouth congress, should never be done by a learned Brahman, by a minister that carries on the business of a state, or by a man of good reputation, because though the practice is allowed by the Shastras, there is no reason why it should be carried on, and need only be practised in particular cases. As for instance, the taste, and the strength, and digestive qualities of the flesh of dogs are mentioned in works on medicine, but it does not therefore follow, that it should be eaten by the wise. In the same way, there are some men, some places and some times, with respect to which these practices can be made use of. A man should therefore pay regard to the place, to the time, and to the practice which is to be carried out, as also as to whether it is agreeable to his nature and to himself, and then he may or may not practice these things according to circumstances. But after all, these things being done secretly, and the mind of the man being fickle, how can it be known what any person will do at any particular time and for any particular purpose? ‏‏❧

Facing page: Women immerse themselves in sumptuous pleasure, as they eat, drink and love each other.

Following pages: As the man and woman grow fonder of each other, they move steadily towards spiritual ecstasy.

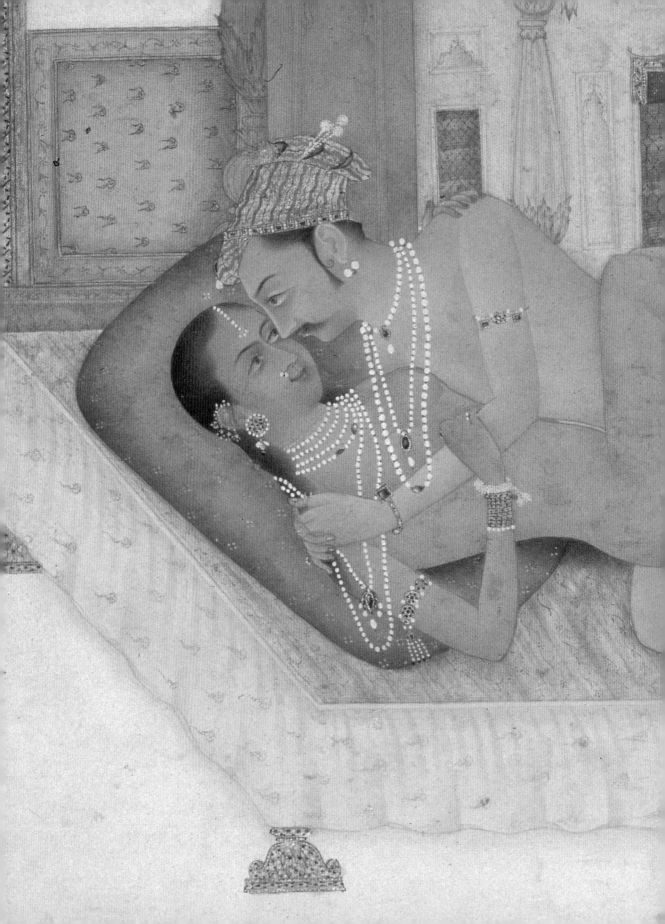

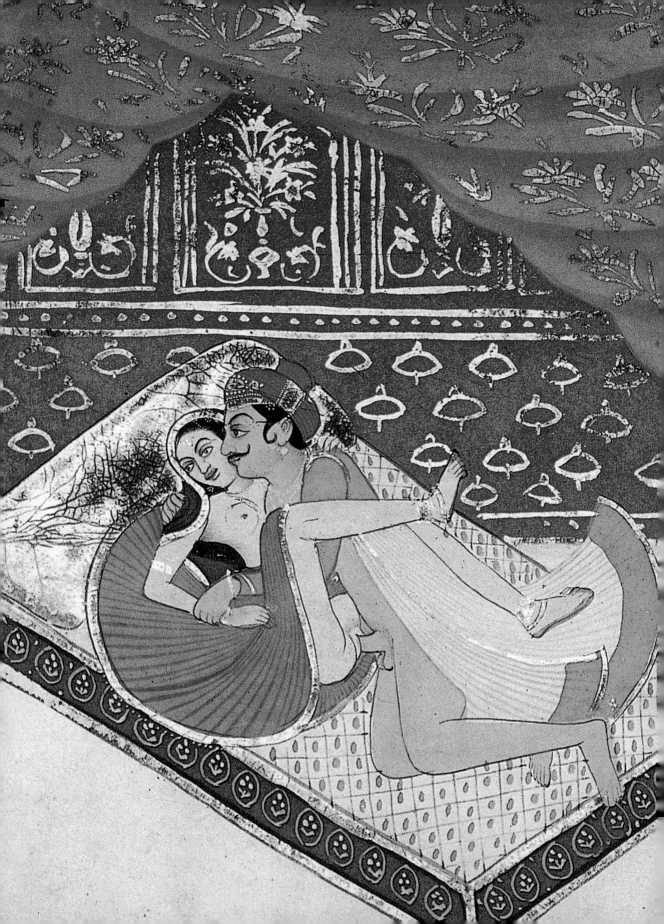

Of the Ways of Exciting Desire

If a man is unable to satisfy a Hastini, or elephant woman, he should have recourse to various means to excite her passion. At the commencement he should rub her *yoni* with his hand or fingers, and not begin to have intercourse with her until she becomes excited or experiences pleasure. This is one way of exciting a woman. Or, he may make use of certain Apadravyas, or things which are put on or around the *lingam* to supplement its length or its thickness, so as to fit it to the *yoni*. In the opinion of Babhravya, these Apadravyas should be made of gold, silver, copper, iron, ivory/ buffalo's horn, various kinds of woods, tin or lead, and should be soft, cool, provocative of sexual vigour, and well fitted to serve the intended purpose. Vatsyayana, however, says that they may be made according to the natural liking of each individual.

The following are the different kind of Apadravyas: the 'armlet' (Valaya) should be of the same size as the *lingam*, and should have its outer surface made rough

Facing page: The man must keep the woman's excitement alive at the beginning of their affair, through words of love coupled with firmness of desire.

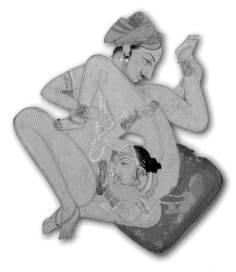

with globules; the 'couple' (*Sanghati*) is formed of two armlets; the 'bracelet' (*Chudaka*) is made by joining three or more armlets, until they come up to the required length of the *lingam*; the 'single bracelet' is formed by wrapping a single wire around the *lingam*, according to its dimensions; the Kantuka or Jalaka is a tube open at both ends, outwardly rough and studded with soft globules, and made to fit the side of the *yoni*, and tied to the waist.

When such a thing cannot be obtained, then a tube made of the wood apple, or tubular stalk of the bottle gourd, or a reed made soft with oil and extracts of plants, and tied to the waist with strings may be made use of, as also a row of soft pieces of wood tied together.

The above are the things that can be used in connection with or in the place of the *lingam*.

There are also some verses in conclusion: 'He who is acquainted with the true principles of this science of love pays regard to *Dharma, Artha, Kama,* and to his own experiences, as well as to the teachings of others, and does not act simply on the dictates of his own desire. As for the errors in the science which I have mentioned in this work, on my own authority as an author, I have, immediately after mentioning them, carefully censured and prohibited them.'

'An act is never looked upon with indulgence for the simple reason that it is authorized by the science, because it ought to be remembered that it is the intention of the science, that the rules which it contains should only be acted upon in particular cases. After reading and considering the works of Babhravya and other ancient authors, and thinking over the meaning of the rules given by them, the *Kama Sutra* was composed, according to the precepts of the Holy Writ, for the benefit of the world, by Vatsyayana, while leading the life of a religious student, and wholly engaged in the contemplation of the Deity.'

'This work is not intended to be used merely as

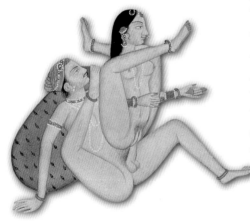

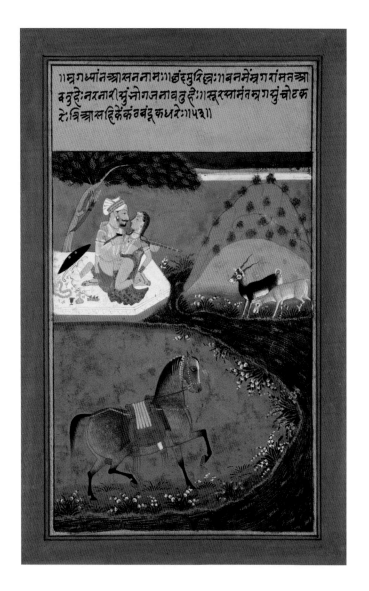

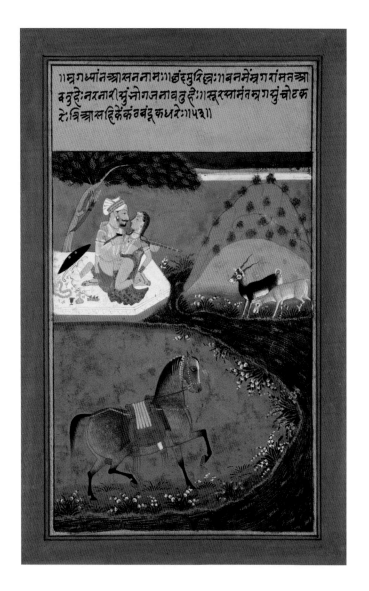

an instrument for satisfying our desires. A person acquainted with the true principles of this science, and who preserves his *Dharma*, *Artha*, and *Kama*, and has regard for the practices of the people, is sure to obtain the mastery over his senses.'

'In short, an intelligent and prudent person, attending to *Dharma* and *Artha* and attending to *Kama* also, without becoming the slave of his passions, obtains success in everything that he may undertake.' ॐ

The hunting of deer and the man's horse are symbolic of his prowess in the act of love and of the woman's wild tenderness.

Following page: The man and woman sit alone in a garden, as they caress each other and converse, while smoking the hookah and sipping wine.

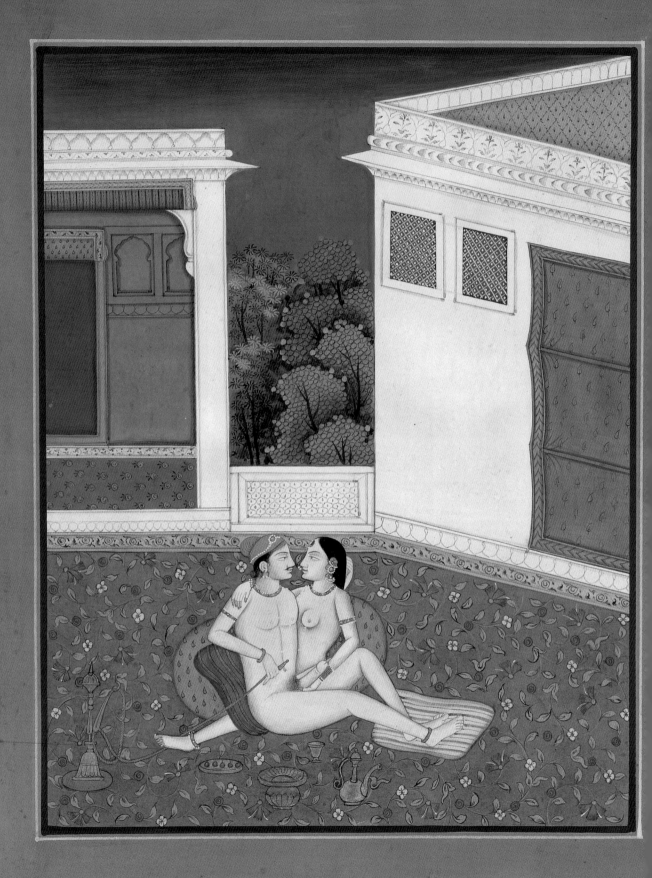

Part-II

On Seduction

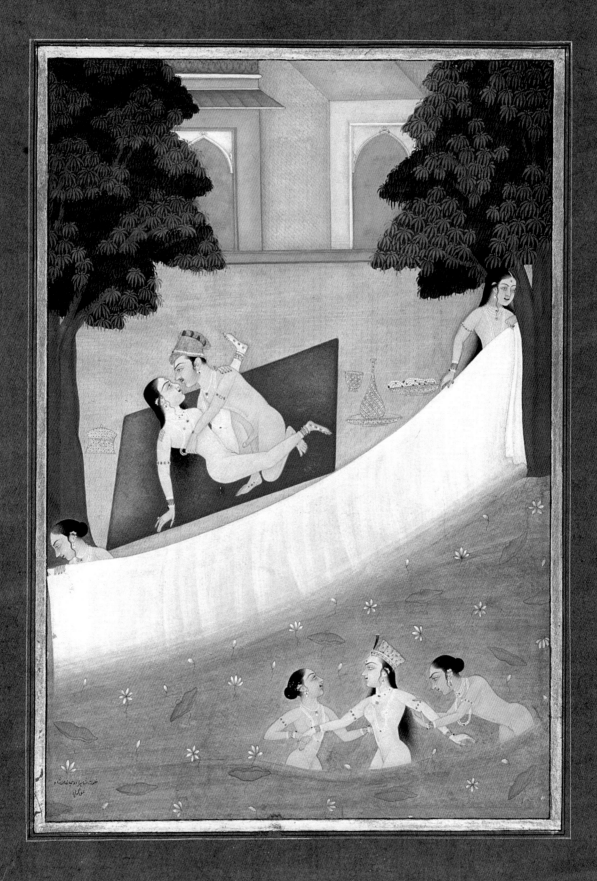

Of Characteristics of Men and Women

A man may resort to the wife of another, for the purpose of saving his own life, when he perceives that his love for her proceeds from one degree of intensity to another. These degrees are ten in number, and are distinguished by the following marks: love of the eye; attachment of the mind; constant reflection, destruction of sleep; emaciation of the body; turning away from objects of enjoyment; removal of shame; madness; fainting; death.

Ancient authors say that a man should know the disposition, truthfulness, purity and will of a young woman, as also the intensity or weakness of her passions, from the form of her body, and from her characteristic marks and signs. But Vatsyayana is of the view that the forms of bodies, and the characteristic marks or signs are but erring tests of character, and that women should be judged by their conduct, by the outward expression of their thoughts, and by the movements of their bodies. Now as a general rule, Gonikaputra says that a woman

Facing page: Two women conceal the prince behind a screen as he makes love to a woman, while the angry princess is held back by her attendants.

Following pages: The gopis bathe and frolic in the river on a full moon night while Krishna keeps his arms around Radha and enjoys their attention.

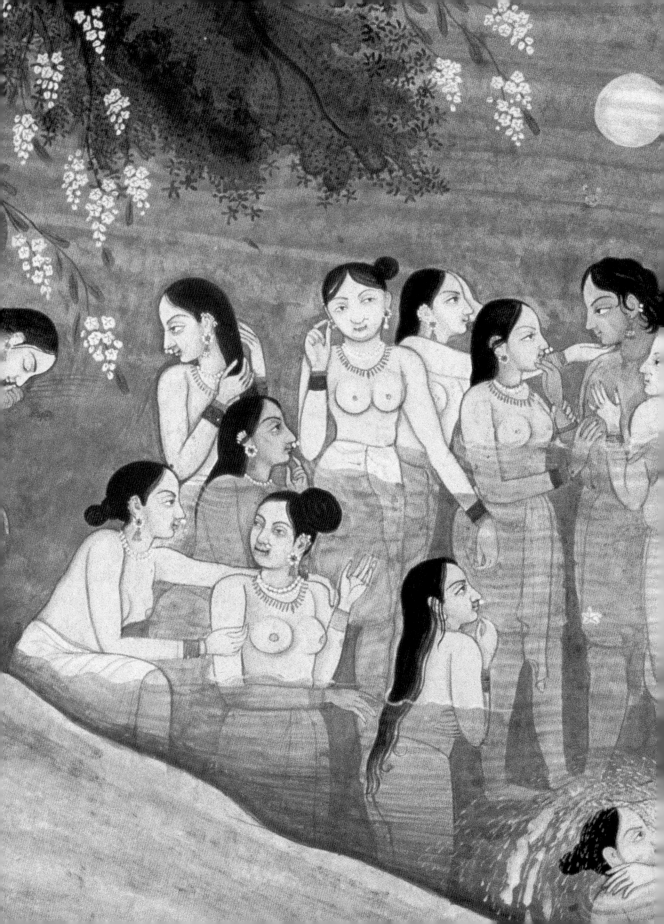

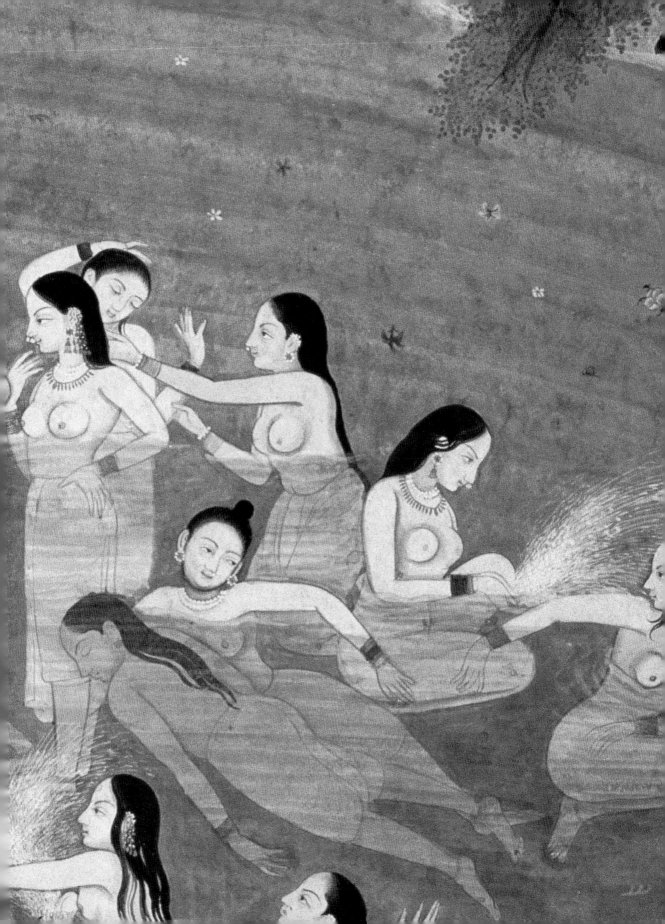

falls in love with every handsome man she sees, and frequently does not take any other steps, owing to various considerations. In love the following circumstances are peculiar to the woman. She loves without regard to right or wrong, and does not try to gain over a man simply for the attainment of some particular purpose. Moreover, when a man first makes up to her, she appears unwilling to unite herself with him. But when the attempts to gain her are repeated and renewed, she at last consents. But with a man, even though he may have begun to love, he conquers his feelings from a regard for morality and wisdom, and although his thoughts are often on the woman, he does not yield, even though an attempt be made to gain him over. He sometimes makes an attempt or effort to win the object of his affections, and having failed, he leaves her alone for the future. In the same way, when a woman is once gained, he often becomes indifferent about her.

The causes of a woman rejecting the addresses of a man are as follows: affection for her husband; desire of lawful progeny; want of certainty on account of the man being devoted to travelling; thinking that the man may be attached to some other person; fear of the man's not keeping his intentions secret; thinking that the man is too devoted to his friends, and has too great a regard for them; the apprehension that he is not in earnest; bashfulness on account of his being an illustrious man; fear on account of his being powerful, or possessed of too impetuous a passion, in the case of the deer woman; bashfulness on account of his being too clever; the thought of having once lived with him only, on friendly terms; contempt of his want of knowledge of the world; distrust of his low character; disgust at his want of perception of her love for him; in the case of an elephant woman, the thought that he is a hare man, or a man of weak passion; compassion lest anything should befall him on account of his passion; despair at her own imperfection; fear of discovery; disillusion at seeing his

Facing page: A strong, ambidextrous man makes a good and entertaining lover.

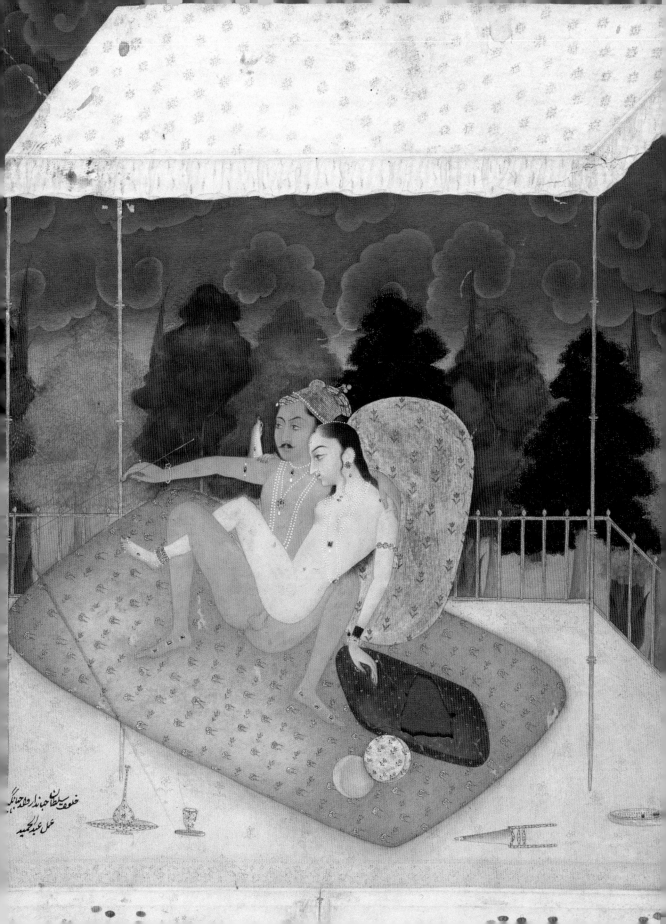

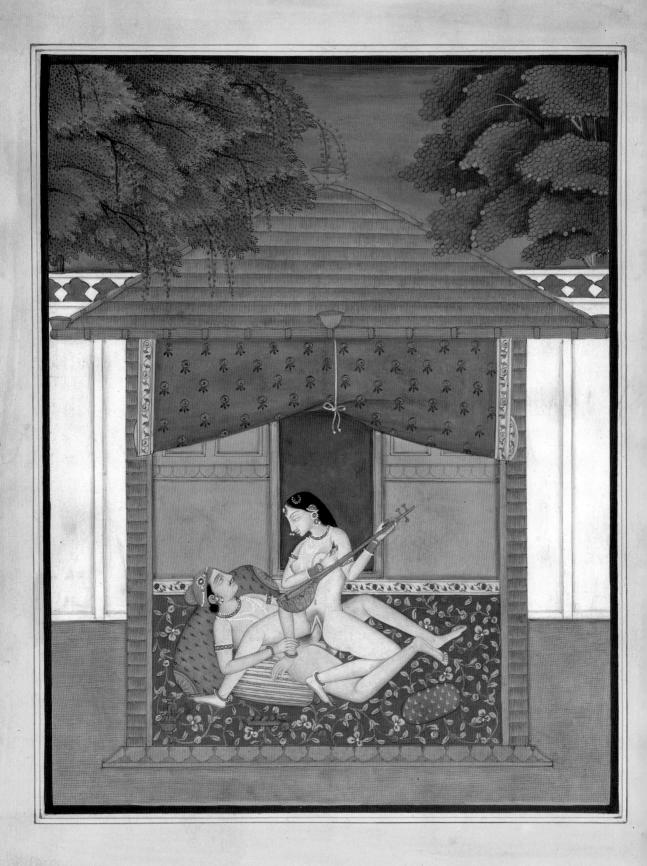

grey hair or shabby appearance; fear that he may be employed by her husband to test her chastity; the thought that he has too much regard for morality.

Whichever of the above causes a man may detect, he should endeavour to remove it from the very beginning. Thus, the bashfulness that may arise from his greatness or his ability, he should remove by showing his great love and affection for her. The difficulty of the want of opportunity, or of his inaccessibility, he should remove by showing her some easy way of access. The excessive respect entertained by the woman for him should be removed by making himself very familiar. The difficulties that arise from his being thought a low character, he should remove by showing his valour and his wisdom; those that come from neglect, by extra attention; and those that arise from fear, by giving her proper encouragement.

The following are the men who generally obtain success with women: men well versed in the science of love; men skilled in telling stories; men acquainted with women from their childhood; men who have secured their confidence; men who send presents to them; men who talk well; men who do things that they like; men who have not loved other women previously; men who act as messengers; men who know their weak points; men who are desired by good women; men who are united with their female friends; men who are good looking; men who have been brought up with them; men who are their neighbours; men who are devoted to sexual pleasures, even though these be their own servants; the lovers of the daughters of their nurse; men who have been lately married; men who like picnics and pleasure parties; men who are liberal; men who are celebrated for being very strong (bull men); enterprising and brave men; men who surpass their husbands in learning and good looks, in good qualities, and in liberality; men whose dress and manner of living are magnificent.

Facing page: Music acts as an amusing distraction as well as an aphrodisiac during the act of love. A woman accomplished in music pleases her lover well.

The following are the women who are easily gained over: women who stand at the doors of their houses; women who are always looking out on the street; women who sit conversing in their neighbour's house; a woman who always stares at men; a female messenger; a woman who looks sideways at men; a woman whose husband has taken another wife without any just cause; a woman who hates her husband, or who has not had any children; a woman whose family or caste is not well known; a woman whose children are dead; a woman who is very fond of society; a woman who is apparently very affectionate with her husband; the wife of an actor; a widow; a poor woman; a woman fond of enjoyment; the wife of a man with many younger brothers; a vain woman; a woman whose husband is inferior to her in rank or abilities; a woman who is proud of her skill in the arts; a woman disturbed in mind by the folly of her husband; a woman who has been married in her infancy to a rich man, and not liking him when she grows up, desires a man possessing a disposition, talents, and wisdom suitable to her own tastes; a woman who is slighted by her husband without any cause; a woman who is not respected by other women of the same rank or beauty as herself; a woman whose husband is devoted to travelling; the wife of a jeweller; a jealous woman; a covetous woman; an immoral woman; a barren woman; a lazy woman; a cowardly woman; a humpbacked woman; a dwarfish woman; a deformed woman; a vulgar woman; an ill-smelling woman; a sick woman; an old woman.

There are also some verses on the subject as follows: 'Desire which springs from nature, and which is increased by art, and from which all danger is taken away by wisdom, becomes firm and secure. A clever man, depending on his own ability, and observing carefully the ideas and thoughts of women, and removing the causes of their turning away from men, is generally successful with them.' ❧

Facing page: The man and woman should take trips to develop a sense of togetherness.

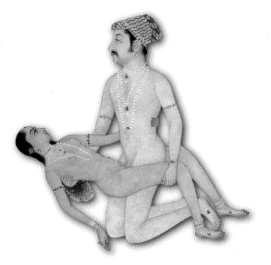

127

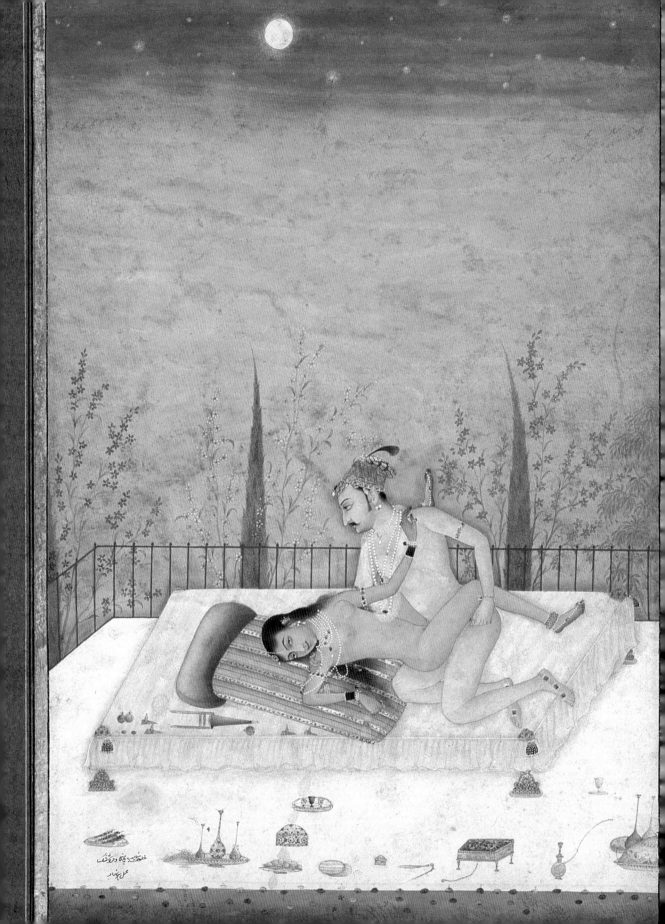

Of Examining the
State of a Woman's Mind

When a man is trying to gain over a woman, he should examine the state of her mind, and act as follows. If she listens to him, but does not manifest to him in any way her own intentions, he should then try to gain her over by means of a go-between. If she meets him once, and again comes to meet him better dressed than before, or comes to him in some lonely place, he should be certain that she is capable of being enjoyed by the use of a little force. A woman who lets a man make up to her, but does not give herself up, even after a long time, should be considered as a trifler in love, but owing to the fickleness of the human mind, even such a woman can be conquered by always keeping up a close acquaintance with her.

When a woman avoids the attentions of a man, and on account of respect for him, and pride in herself, will not meet him or approach him, she can be gained over with difficulty, either by endeavouring to keep on familiar terms with her, or else by an exceedingly clever go-

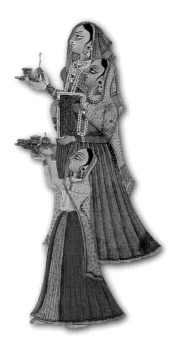

Facing page: As the woman playfully pushes the man away at the peak of her excitement, she fosters their mutual appetite.

between. When a man makes up to a woman, and she reproaches him with harsh words, she should be conquered by patience, and by continued efforts as follows:

If she happens to go to sleep in his vicinity, he should put his left arm round her, and see when she awakes whether she repulses him in reality, or only repulses him in such a way as if she was desirous of the same thing being done to her again. And what is done by the arm can also be done by the foot. If the man succeeds in this point he should embrace her more closely, and if she will not stand the embrace and gets up, but behaves with him as usual the next day, he should consider then that she is not unwilling to be enjoyed by him. If, however, she does not appear again, the man should try to win her over by means of a go-between; and if, after having disappeared for some time, she again appears, and behaves with him as usual, the man should then consider that she would not object to be united with him. When a woman gives a man an opportunity, and makes her own love manifest to him, he should proceed to enjoy her.

When a woman neither gives encouragement to a man, nor avoids him, but hides herself and remains in some lonely place, she must be got at by means of the female servant who may be near her. If, when called by the man, she acts in the same way, then she should be gained over by means of a skilful go-between. But if she will have nothing to say to the man, he should consider well about her before he begins any further attempts to gain her over.

Thus ends the examination of the state of a woman's mind.

A man should first get himself introduced to a woman, and then carry on a conversation with her. He should give her hints of his love for her, and if he finds from her replies that she receives these hints favourably, he should then set to work to gain her over without any fear. A woman who shows her love by outward signs to

Facing page: The man and woman can make love at any time, during breakfast or evening tea, because the limits of desire cannot be defined.

130

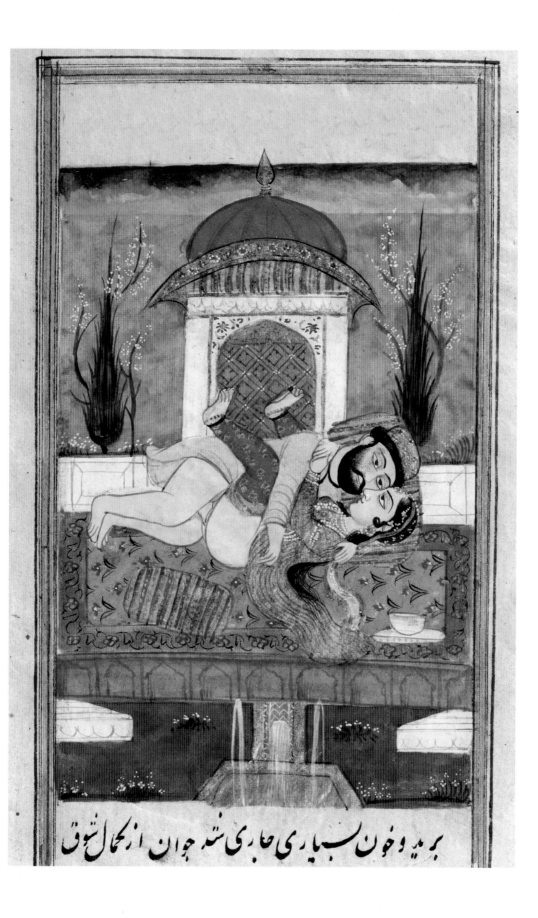

بر ميه و خون سب ياری جا ری ستہ جوان از لحال شوق

Facing page: A woman softly caresses her lover with her hand and a flower, as they rest in the midst of luxuriant natural surroundings.

the man at his first interview, should be gained over very easily. In the same way a lascivious woman, who when addressed in loving words replies openly in words expressive of her love, should be considered to have been gained over at that very moment. With regard to all women, whether they be wise, simple, or confiding, this rule is laid down, that those who make an open manifestation of their love are easily gained over.

Now a girl always shows her love by outward signs and actions, such as the following: she never looks the man in the face, and becomes abashed when she is looked at by him; she looks secretly at him though he has gone away from her side; hangs down her head when she is asked some question by him, and answers in indistinct words and unfinished sentences; delights to be in his company for a long time; speaks to her attendants in a peculiar tone with the hope of attracting his attention towards her when she is at a distance from him; under some pretext or other, makes him look at different things, narrates to him tales and stories very slowly so that she may continue conversing with him for a long time; kisses and embraces before him, a child sitting in her lap; draws ornamental marks on the foreheads of her female servants; performs sportive and graceful movements when her attendants speak jestingly to her in the presence of her lover; confides in her lover's friends, and respects and obeys them; shows kindness to his servants, converses with them, and engages them to do her work as if she were their mistress, and listens attentively to them when they tell stories about her lover to somebody else; enters his house when induced to do so by the daughter of her nurse, and by her assistance manages to converse and play with him; avoids being seen by her lover when she is not dressed and decorated, gives him by the hand of her female friend, her ear ornament, ring, or

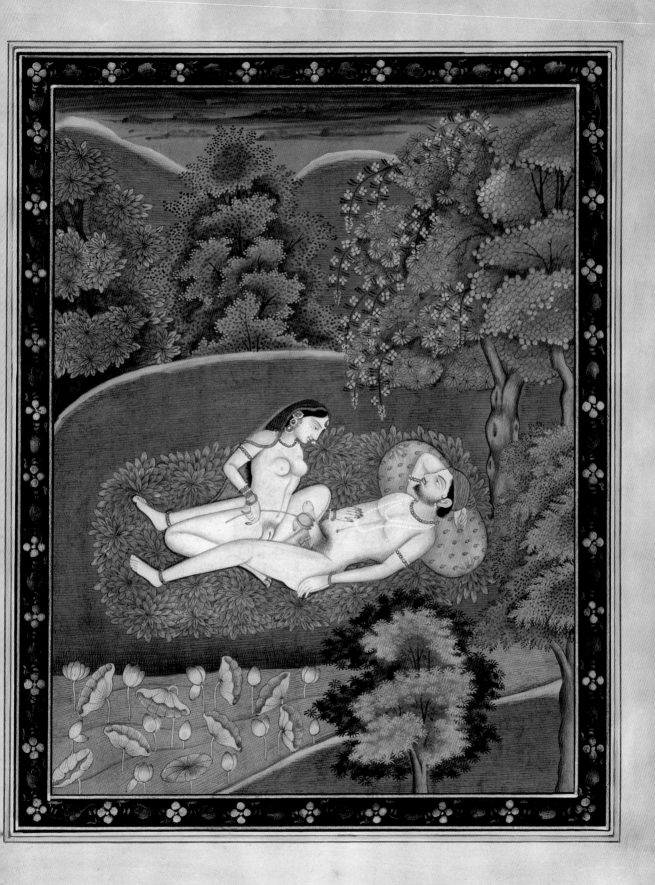

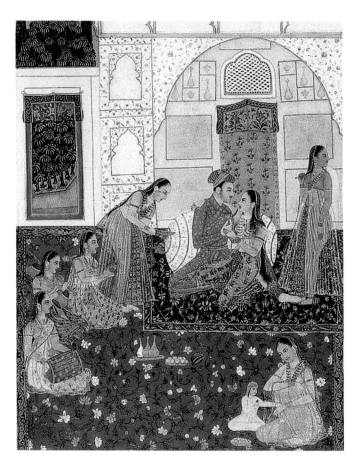

Above: The woman has to be entertained and reassured by her lover that he will be attentive and respectful towards her desires and needs.

Facing page: A man woos his beloved by imitating Kamadeva, who darts lotus-arrows to induce amour among mortals.

garland of flowers that he may have asked to see; always wears anything that he may have presented to her, becomes dejected when any other bridegroom is mentioned by her parents, and does not mix with those who may be of his party, or who may support his claims.

There are also some verses on the subject as follows: 'A man who has seen and perceived the feelings of the girl towards him, and who has noticed the outward signs and movements by which those feelings are expressed, should do everything in his power to effect a union with her. He should gain over a young girl by childlike sports, a damsel come-of-age by his skill in the arts, and a girl that loves him by having recourse to persons in whom she confides.' ෂ

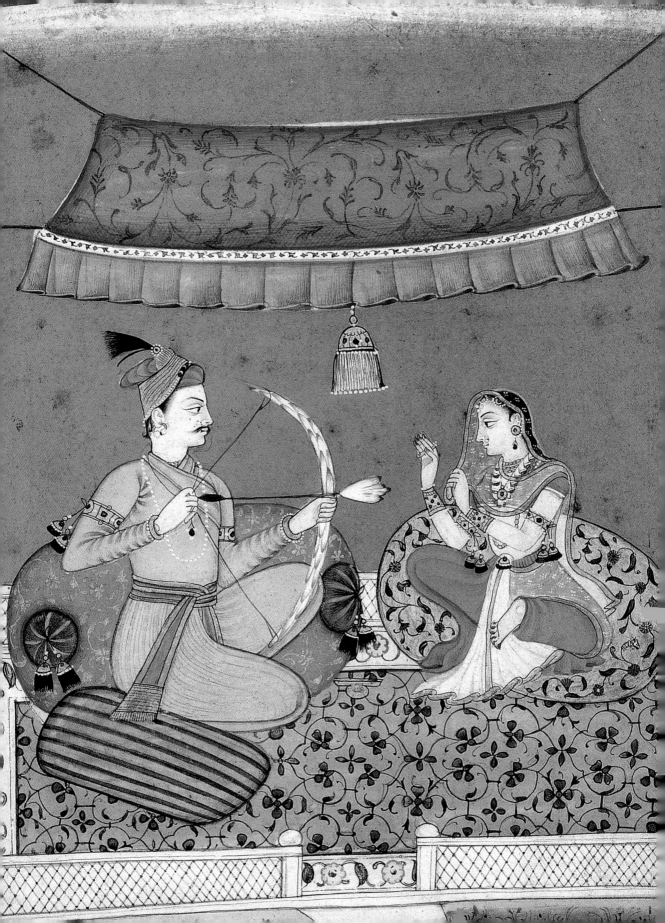

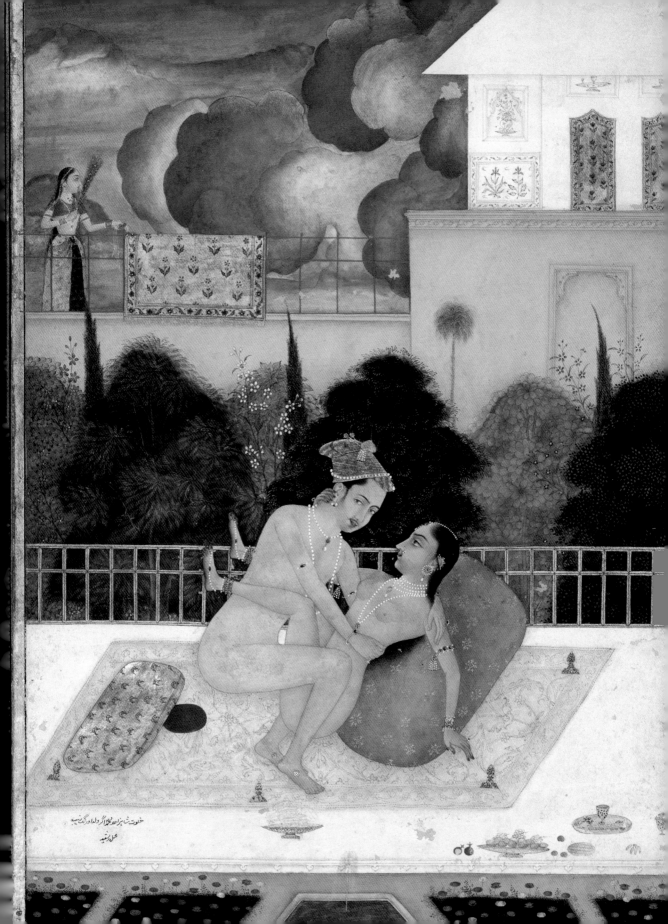

Of Winning Over the Woman

Ancient authors are of the opinion that girls are not so easily seduced by employing female messengers as by the efforts of the man himself, but that the wives of others are more easily got at by the aid of female messengers than by the personal efforts of the man. But Vatsyayana lays it down that whenever it is possible, a man should always act himself in these matters, and it is only when such is impracticable, or impossible, that female messengers should be employed. As for the saying that women who act and talk boldly and freely are to be won by the personal efforts of the man, and that women who do not possess those qualities are to be got at by female messengers, it is only a matter of talk.

Now when a man acts himself in the matter, he should first of all make the acquaintance of the woman he loves in the following manner:

First, he should arrange to be seen by the woman either on a natural or special opportunity. A natural opportunity is when they meet either at the house of a

Facing page: The man should remember to keep wine, food, unguents and oils near at hand while lovemaking.

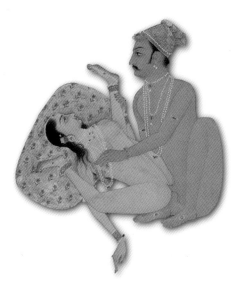

friend, or a caste-fellow, or a minister or a physician, as also on the occasion of marriage ceremonies, sacrifices, festivals, funerals, and garden parties.

Second, when they do meet, the man should be careful to look at her in such a way as to cause the state of his mind to be made known to her; he should pull about his moustache, make a sound with his nails, cause his own ornaments to tinkle, bite his lower lip, and make various other signs of that description. When she is looking at him, he should speak to his friends and other women about her and should show to her his liberality and his appreciation of enjoyments. When sitting by the side of a female friend, he should yawn and twist his body, contract his eyebrows, speak very slowly as if he was weary, and listen to her indifferently. A conversation having two meanings should also be carried on with a child or some other person, apparently having regard to a third person, but really having reference to the woman he loves, and in this way his love should be made manifest under the pretext of referring to others rather than to herself. He should make marks that have reference to her, on the earth with his nails, or with a stick, and should embrace and kiss a child in her presence, and give it the mixture of betel nut and betel leaves with his tongue, and press its chin with his fingers in a caressing way. All these things should be done at the proper time and in proper places.

Third, the man should fondle a child that may be sitting on her lap, and give it something to play with, and also take the same back again. Conversation with respect to the child may also be held with her, and in this manner he should gradually become well acquainted with her, and he should also make himself agreeable to her relations. Afterwards, this acquaintance should be made a pretext for visiting her house frequently, and on such occasions he should converse on the subject of love in her absence, but within her hearing. As his intimacy with her increases he should place in her charge some

Facing page: Dancing and singing together ensures that the lovers will give each other wholesome enjoyment.

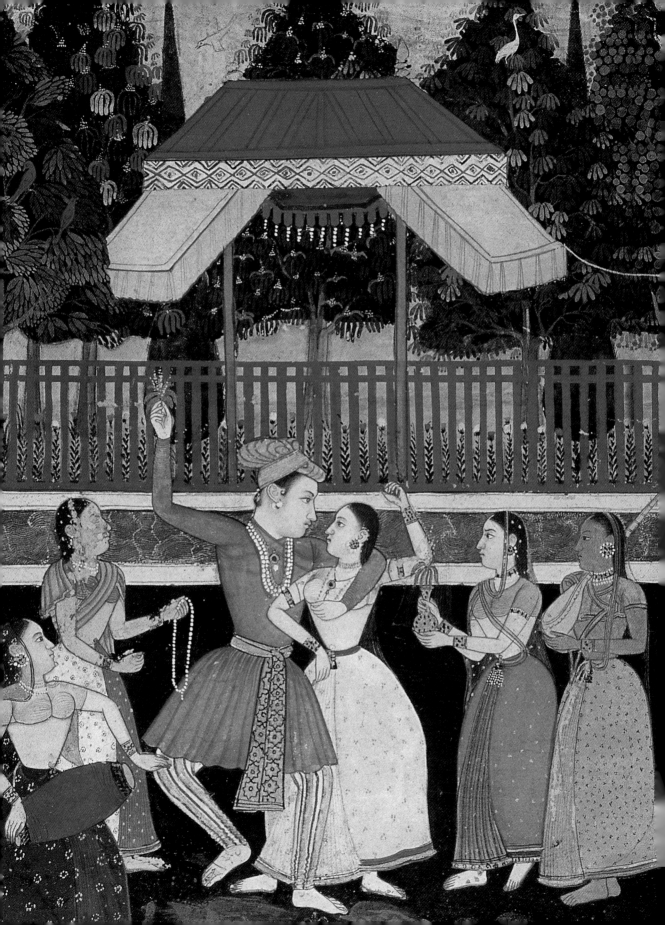

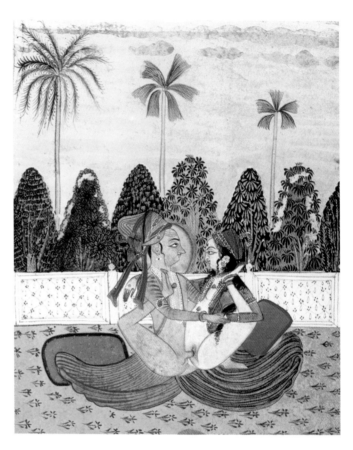

kind of deposit or trust, and take away from it a small portion at a time; or he may give her some fragrant substances, or betel nuts to be kept for him by her. After this he should endeavour to make her well acquainted with his own wife, and get them to carry on confidential conversations, and to sit together in lonely places. In order to see her frequently, he should arrange so that the same goldsmith, the same jeweller, the same basket maker, the same dyer, and the same washerman should be employed by the two families. And he should also pay her long visits openly under the pretence of being engaged with her on business, and one business should lead to another, so as to keep up the intercourse between them. Whenever she wants anything, or is in need of money, or wishes to acquire skill in one of the arts, he should cause her to understand that he is willing and

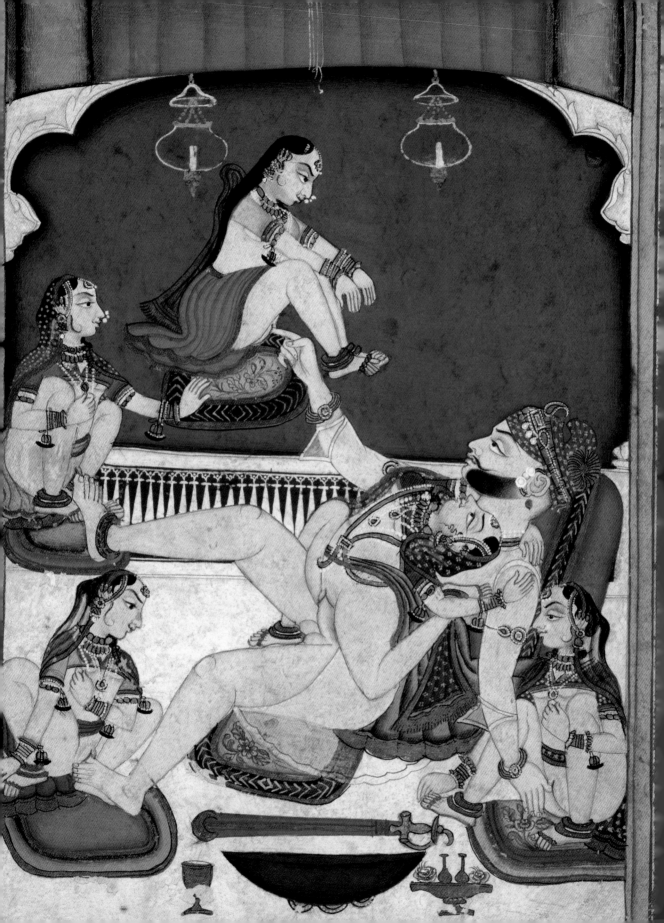

able to do anything that she wants, to give her money, or teach her one of the arts, all these things being quite within his ability and power. In the same way, he should hold discussions with her in company with other people, and they should talk of the doings and sayings of other persons, and examine different things, like jewellery, precious stones, etc. On such occasions he should show her certain things with the values of which she may be acquainted, and if she begins to dispute with him about the things or their value, he should not contradict her, but point out that he agrees with her in every way.

Thus end the ways of making the acquaintance of the woman desired.

Now after a girl has become acquainted with the man as above described, and has manifested her love to him by the various outward signs, and by the motions of her body, the man should make every effort to gain her over. But as girls are not acquainted with sexual union, they should be treated with the greatest delicacy, and the man should proceed with considered caution, though in the case of other women, accustomed to sexual intercourse, this is not necessary. When the intentions of the girl are known, and her bashfulness put aside, the man should begin to make use of his money, and an interchange of clothes, rings, and flowers should be made. In this, the man should take particular care that the things given by him are handsome and valuable. He should moreover, receive from her a mixture of betel nut and betel leaves, and when he is going to a party, he should ask for the flower in her hair or for the flower in her hand. If he himself gives her a flower, it should be a sweet smelling one, and marked with marks made by his nails or teeth. With increasing assiduity he should dispel her fears, and by degrees get her to go with him to some lonely place, and there he should embrace and kiss her. And finally at the time of giving her some betel nut, or of receiving the same from her, or at the time of making an exchange of flowers, he should touch and press her

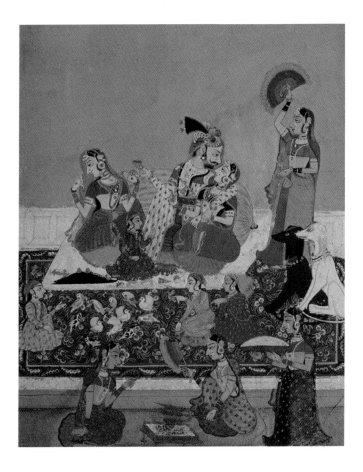

private parts, thus bringing his efforts to a satisfactory conclusion.

When a man is endeavouring to seduce one woman, he should not attempt to seduce any other at the same time. But after he has succeeded with the first, and enjoyed her for a considerable time, he can keep her affections by giving her presents that she likes, and then commence making up to another woman. When a man sees the husband of a woman going to some place near his house, he should not enjoy the woman then, even though she may be easily gained over at that time. A wise man, having a regard for his reputation, should not think of seducing a woman who is apprehensive, timid, not to be trusted, well guarded, or possessed of a father-in-law or mother-in-law. ❧

If a man has two wives, he should give equal attention to both and never let one feel neglected.

143

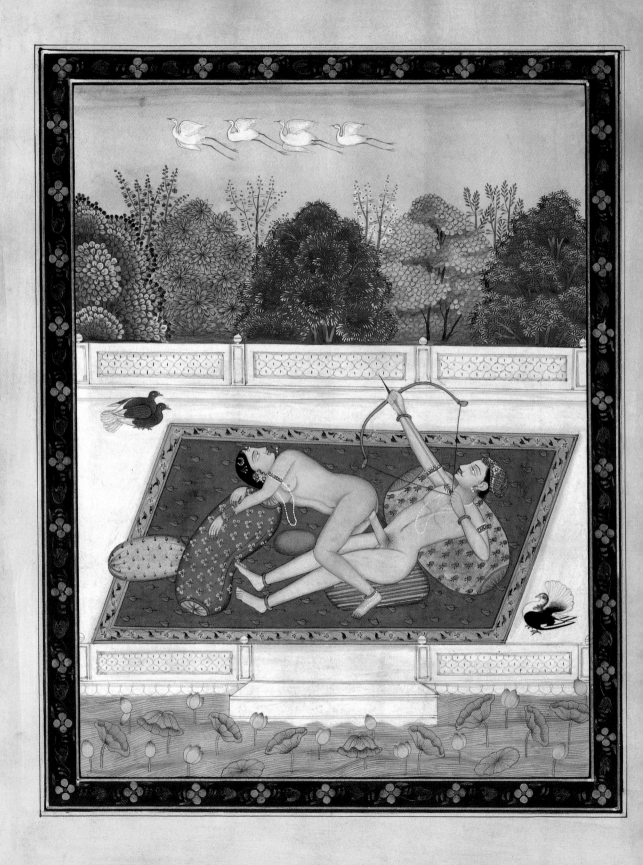

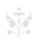

Of the Art of Enticement

I f a girl begins to show her love by outward signs and motions, the lover should try to gain her over entirely by various ways and means, such as the following: When engaged with her in any game or sport, he should intentionally hold her hand. He should practise upon her the various kinds of embraces, such as the touching embrace, and others already described in a preceding chapter. He should show her a pair of human beings cut out of the leaf of a tree, and suchlike things, at intervals. When engaged in water sports, he should dive at a distance from her, and come up close to her. He should show an increased liking for the new foliage of trees and suchlike things. He should describe to her the pangs he suffers on her account. He should relate to her the beautiful dream that he has had with reference to other women. At parties and assemblies of his caste he should sit near her, and touch her under some pretence or other, and having placed his foot upon hers, he should slowly touch each of her toes, and press the ends of the nails;

Facing page: Hunting while lovemaking brings the act nearer to its primitive nature, thereby enhancing the mutual climax.

The man becomes the bow and the woman takes up the arrow in a form of role reversal.

if successful in this, he should get hold of her foot with his hand and repeat the same thing. He should also press a finger of her hand between his toes, when she happens to be washing his feet; and whenever he gives anything to her or takes anything from her, he should show her by his manner and look how much he loves her.

He should sprinkle upon her the water brought for rinsing his mouth; and when alone with her in a lonely place, or in darkness, he should make love to her, and tell her the true state of his mind without distressing her in any way.

Whenever he sits with her on the same seat or bed, he should say to her, 'I have something to tell you in private;' and then, when she comes to hear it in a quiet place, he should express his love to her more by manner and signs than by words. When he comes to know the state of her feelings towards him he should pretend to be

ill, and should make her come to his house to speak to
him. There he should intentionally hold her hand, place
it on his eyes and forehead, and under the pretence of
preparing some medicine for him, he should ask her to do
the work for his sake in the following words: 'This work
must be done by you, and by nobody else.' When she
wants to go away he should let her go, with an earnest
request to come and see him again. This device of illness
should be continued for three days and three nights. After
this, when she begins coming to see him frequently, he
should carry on long conversations with her, for, says
Ghotakamukha, 'Though a man loves a girl ever so much,
he never succeeds in winning her without a great deal of
talking.' At last when the man finds the girl completely
gained over, he may then begin to enjoy her. As for the
saying that women grow less timid than usual during the
evening, and in darkness, and are desirous of congress at
those times, and do not oppose men then, and should only
be enjoyed at these hours, it is a matter of talk only.

When it is impossible for the man to carry on his
endeavours alone, he should, by means of the daughter
of her nurse, or of a female friend in whom she
confides, cause the girl to be brought to him without
making known to her his design, and he should then
proceed with her in the manner above described. Or
he should in the beginning, send his own female
servant to live with the girl as her friend, and
should then gain her over by other means.

At last, when he knows the state of her
feelings by her outward manner
and conduct towards him at
religious ceremonies, marriage
ceremonies, fairs, festivals,
theatres, public assemblies, and
suchlike occasions, he should
begin to enjoy her when she is
alone, for Vatsyayana lays it down that
women, when resorted to at proper times

and in proper places, do not turn away from their lovers.

When a girl, possessed of good qualities and well-bred, though born in a humble family, or destitute of wealth and therefore not desired by her equals, or an orphan girl, or one deprived of her parents, but observing the rules of her family and caste, should wish to bring about her own marriage when she comes of age, such a girl should endeavour to gain over a strong and good-looking young man, or a person whom she thinks would marry her on account of the weakness of his mind, and even without the consent of his parents. She should do this by such means as would endear her to the said person, as well as by frequently seeing and meeting him. Her mother also, should constantly cause them to meet by means of her female friends, and the daughter of her nurse. The girl herself should try to get alone with her beloved in some quiet place, and at odd times should give him flowers, betel nut, betel leaves and perfumes. She should also show her skill in the practice of the arts, in shampooing, in scratching and in pressing with the nails. She should also talk to him on the subjects he likes best, and discuss with him the ways and means of gaining over and winning the affections of a girl.

But old authors say that although the girl loves the man ever so much, she should not offer herself, make the first overtures, for a girl who does this loses her dignity, and is liable to be scorned and rejected. But when the man shows his wish to enjoy her, she should be favourable to him and should show no change in her demeanour when he embraces her, and should receive all the manifestations of his love as if she were ignorant of the state of his mind. But when he tries to kiss her she should oppose him; when he begs to be allowed to have sexual

intercourse with her, she should let him touch her private parts only, and with considerable difficulty; and though importuned by him, she should not yield herself up to him as if of her own accord, but should resist his attempts to have her. It is only, moreover, when she is certain that she is truly loved, and that her lover is indeed devoted to her, and will not change his mind, that she should then give herself up to him, and persuade him to marry her quickly. After losing her virginity, she should tell her confidential friends about it.

There are also some verses on the subject as follows: 'A girl who is much sought after should marry the man that she likes, and whom she thinks would be obedient to her, and capable of giving her pleasure. But when from the desire of wealth, a girl is married by her parents to a rich man, without taking into consideration the character or looks of the bridegroom, or when given to a man who has several wives, she never becomes attached to the man, even though he be endowed with good qualities, obedient to her will, active, strong and healthy, and anxious to please her in every way. A husband who is obedient but yet master of himself, though he be poor and not good-looking, is better than one who is common to many women, even though he be handsome and attractive. The wives of rich men, where there are many wives, are not generally attached to their husbands, and are not confidential with them, and even though they possess all the external enjoyments of life, still have recourse to other men. A man who is of a low mind, who has fallen from his social position, and who is much given to travelling, does not deserve to be married; neither does one who has many wives and children, or one who is devoted to sport and gambling, and who comes to his wife only when he likes. Of all the lovers of a girl, he only is her true husband who possesses the qualities that are liked by her, and such a husband only enjoys real superiority over her, because he is the husband of love.' ❧

Facing page: A man should be careful about his appearance when he is going to court a woman.

Following page: Married couples slowly learn how to fulfil each other and add to their sensuous lives.

150

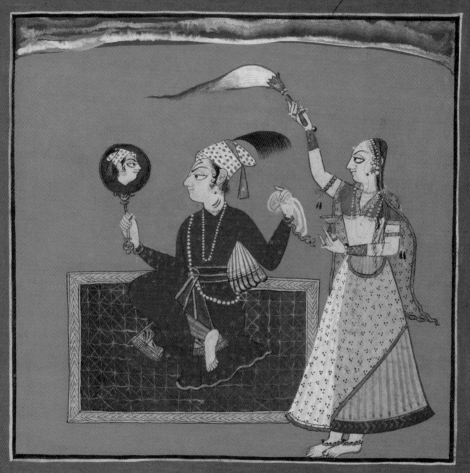

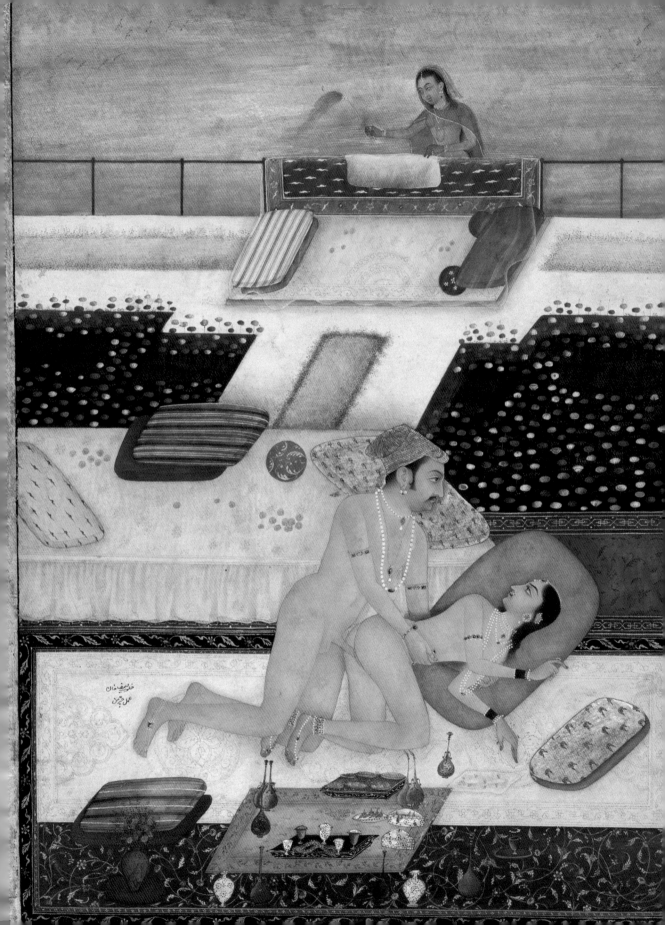

Part III
On Marriage

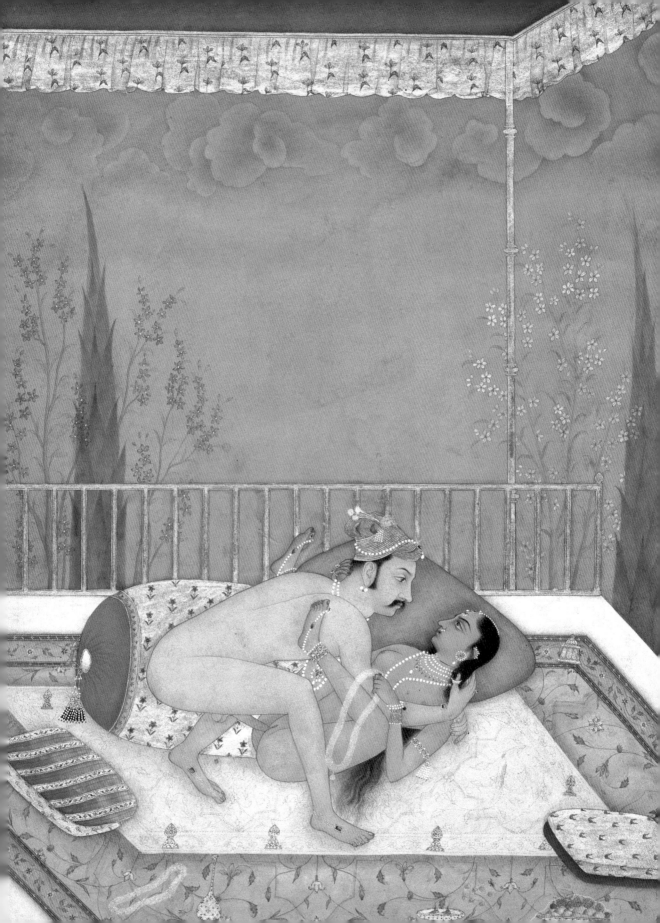

Of Acquiring the Right Kind of Wife

When a girl of the same caste and a virgin is married in accordance with the precepts of the Holy Writ, the results of such a union are: the acquisition of *Dharma* and *Artha*, offspring, affinity, increase of friends, and untarnished love. For this reason a man should fix his affection upon a girl who is of good family, whose parents are alive, and who is three years or more younger than himself. She should be born of a highly respectable family, possessed of wealth, well connected, and with many relations and friends. She should also be beautiful, of a good disposition, with lucky marks on her body, and with good hair, nails, teeth, ears, eyes, and breasts neither more nor less than they ought to be, and no one of them entirely wanting, and not troubled with a sickly body. The man should, of course, also possess these qualities himself. But at all events, says Ghotakamukha, a girl who has been already joined with others (i.e. no longer a maiden) should never be loved, for it would be reproachable to do such a thing. Now in

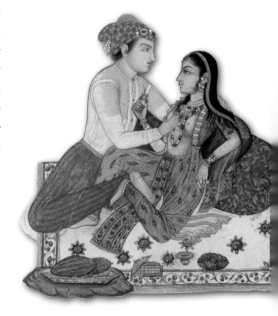

The man caresses the woman's hair as she holds a garland while he makes love from a distance to add to their pleasure.

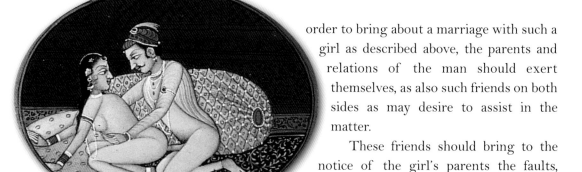

Looking back during congress from behind acts as a stimulant for the man.

Facing page: Twilight is an appropriate time for the woman to relax and prepare her being for the lover.

order to bring about a marriage with such a girl as described above, the parents and relations of the man should exert themselves, as also such friends on both sides as may desire to assist in the matter.

These friends should bring to the notice of the girl's parents the faults, both present and future, of all the other men that may wish to marry, her, and should at the same time extol, even to exaggeration, all the excellences, ancestral and paternal, of their friend, so as to endear him to them, and particularly to those that may be liked by the girl's mother. One of the friends should also disguise himself as an astrologer, and declare the future good fortune and wealth of his friend by showing the existence of all the lucky omens and signs, the good influence of planets, the auspicious entrance of the sun into a sign of the Zodiac, propitious stars and fortunate marks on his body. Others again should rouse the jealousy of the girl's mother by telling her that their friend has a chance of getting from some other quarter, even a better girl than hers.

A girl should be taken as a wife or given in marriage, when fortune, signs, omens, and the words of others are favourable, for, says Ghotakamukha, a man should not marry at any time he likes. A girl who is asleep, crying, or gone out of the house when sought in marriage, or who is betrothed to another, should not be married. The following also should be avoided: one who is kept concealed; one who has an ill-sounding name; one who has her nose depressed; one who has her nostril turned up; one who is formed like a male; one who is bent down; one who has crooked thighs; one who has a projecting forehead; one who has a bald head; one who does not like purity; one who has been polluted by another; one who is affected with the *gulma*; one who is disfigured in any way; one who has not fully arrived at puberty; one who

156

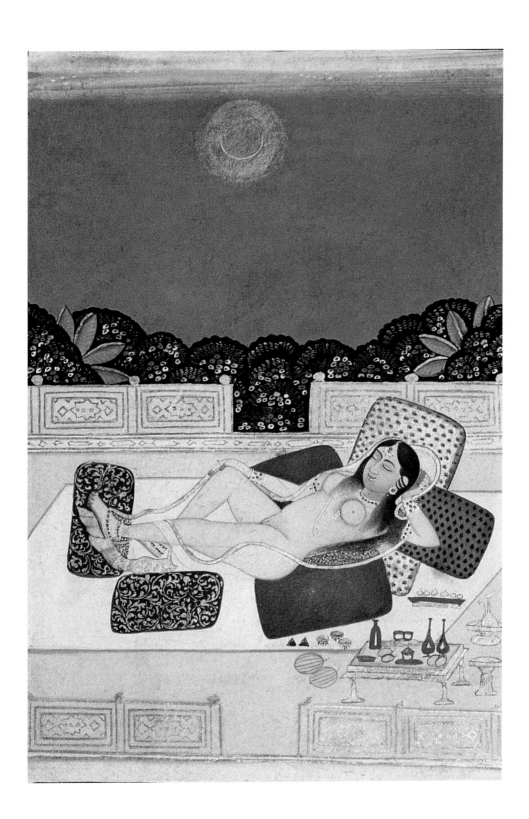

is a friend; one who is a younger sister; one who is a Varshakari.

In the same way, a girl who is called by the name of one of the twenty-seven stars, or by the name of a tree, or of a river, is considered worthless, as also a girl whose name ends in 'r' or 'l'. But some authors say that prosperity is gained only by marrying the girl to whom one becomes attached, and that therefore, no other girl but the one who is loved should be married by anyone.

When a girl becomes marriageable, her parents should dress her smartly, and should place her where she can be easily seen by all. Every afternoon, having dressed her and decorated her in a becoming manner, they should send her with her female companions to sports, sacrifices, and marriage ceremonies, and thus show her to advantage in society, because she is a kind of merchandise. They should also receive, with kind words and signs of friendliness, those of an auspicious appearance who may come, accompanied by their friends and relations for the purpose of marrying their daughter, and under some pretext or other having first dressed her becomingly, should then present her to them.

After this they should await the pleasure of fortune, and with this object, should appoint a future day on which a determination could be come to with regard to their daughter's marriage. On this occasion, when the persons have come, the parents of the girl should ask them to bathe and dine, and should say, 'Everything will take place at the proper time,' and should not then comply with the request, but should settle the matter later.

When a girl is thus acquired, either according to the custom of the country, or according to his own desire, the man should marry her in accordance with the precepts of the Holy Writ, according to one of the four kinds of marriage.

Amusement in society, such as completing verses begun by others, marriages, and auspicious ceremonies

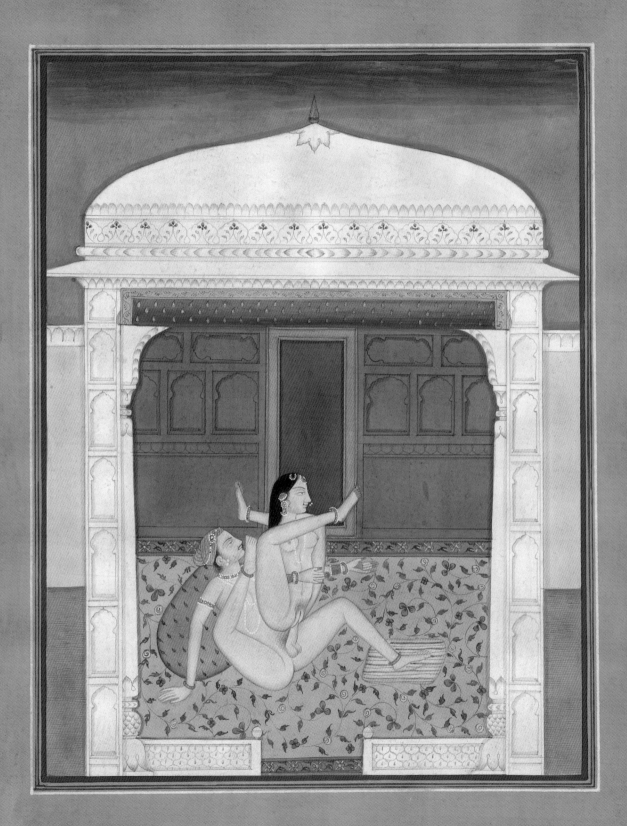

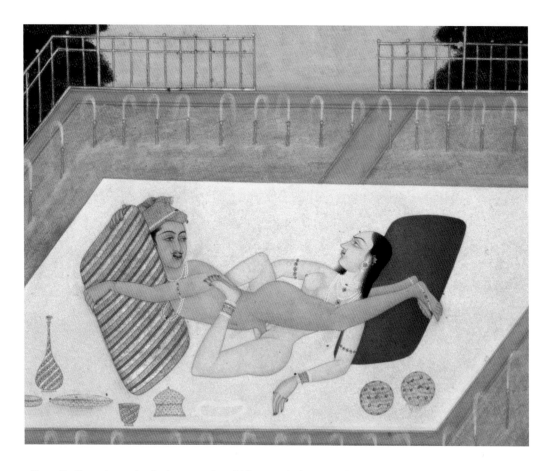

should be carried on neither with superiors, nor inferiors, but with equals. That should be known as a high connection when a man, after marrying a girl, has to serve her and her relations afterwards like a servant, and such a connection is censured by the good. On the other hand, that reproachable connection, where a man together with his relations, lords it over his wife, is called a low connection by the wise. But when both the man and the woman afford mutual pleasure to each other, and when the relatives on both sides pay respect to one another, such is called a connection in the proper sense of the word. Therefore, a man should contract neither a high connection by which he is obliged to bow down afterwards to his kinsmen, nor a low connection, which is universally reprehended by all. ॐ

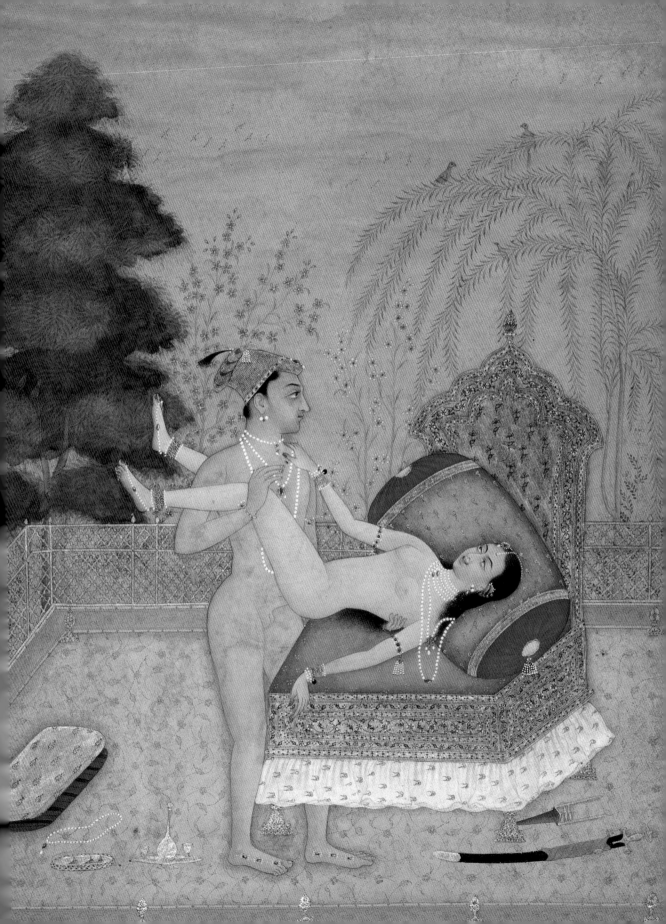

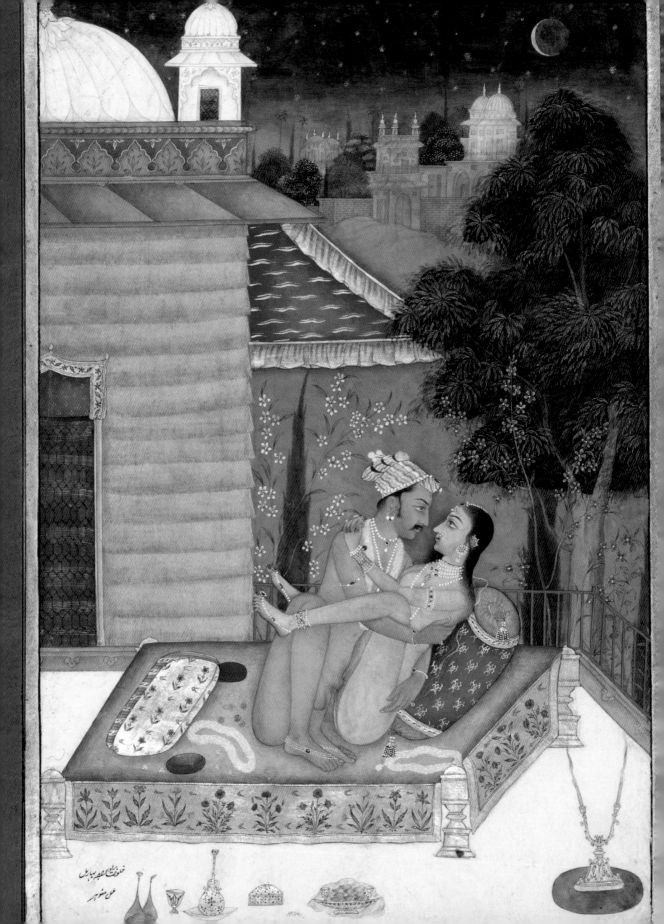

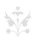

Of Creating Confidence
in the Girl

For the first three days after marriage, the girl and her husband should sleep on the floor, abstain from sexual pleasures, and eat their food without seasoning it either with alkali or salt. For the next seven days they should bathe amidst the sounds of auspicious musical instruments, should decorate themselves, dine together and pay attention to their relations as well as to those who may have come to witness their marriage. This is applicable to persons of all castes. On the night of the tenth day, the man should begin in a lonely place with soft words, and thus create confidence in the girl. Some authors say that for the purpose of winning her over, he should not speak to her for three days, but the followers of Babhravya are of the view that if the man does not speak with her for three days, the girl may be discouraged by seeing him spiritless like a pillar, and becoming dejected, she may begin to despise him as a eunuch. Vatsyayana says that the man should begin to win her over and to create confidence in her, but should abstain

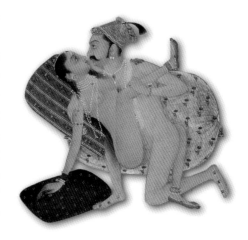

at first from sexual pleasures. Women being of a tender nature, want tender beginnings, and when they are forcibly approached by men with whom they are but slightly acquainted, they sometimes suddenly become haters of sexual connection, and sometimes even haters of the male sex.

The man should therefore approach the girl according to her liking, and should make use of those devices by which he may be able to establish himself more and more into her confidence.

When the girl accepts the embrace, the man should put a *tambula* or screw of betel nut and betel leaves in her mouth, and if she will not take it, he should induce her to do so by conciliatory words, entreaties, oaths, and kneeling at her feet, for it is a universal rule, that however bashful or angry a woman may be, she never disregards a man kneeling at her feet. At the time of giving this *tambula* he should kiss her mouth softly and gracefully, without making any sound. When she is gained over in this respect he should then make her talk, and so that she may be induced to talk he should ask questions about things of which he knows or pretends to know nothing, and which can be answered in a few words. If she does not speak to him, he should not frighten her, but should ask her the same thing again and again in a conciliatory manner. If she does not then speak he should urge her to give a reply, because as Ghotakamukha says, 'All girls hear everything said to them by men, but do not themselves sometimes say a single word.' When she is thus importuned, the girl should give replies by shakes of the head, but if she is annoyed with the man, she should not even do that. When she is asked by the man whether she wishes for him, and whether she likes him, she should remain silent for a long time, and when at last importuned to reply, should give him a favourable answer by a nod of her head. If the man is previously acquainted with the girl, he should converse with her by means of a female friend,

Facing page: Lovers should experience making love on the bare grass of the jungle, with the gentle cranes for company.

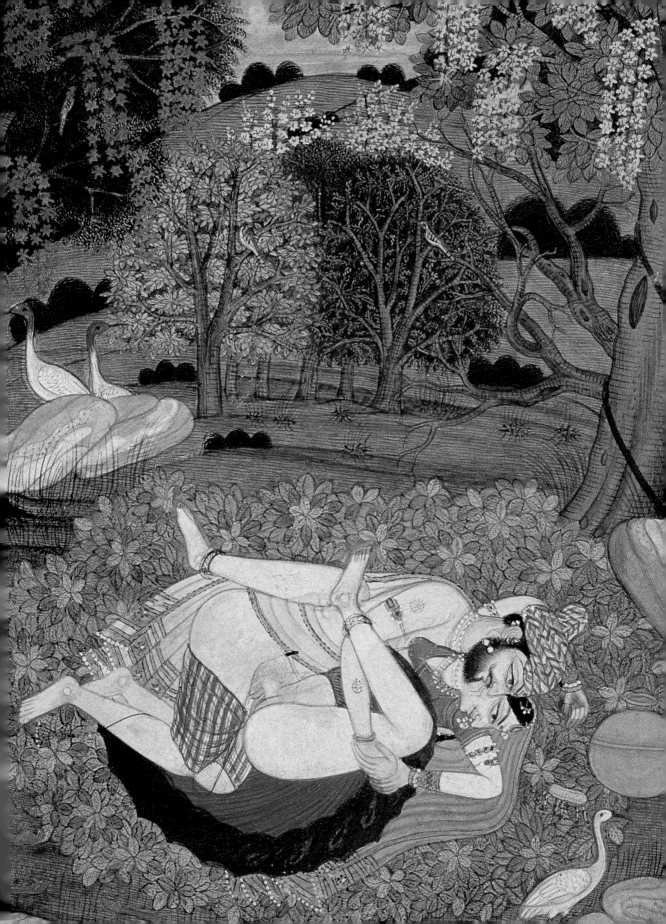

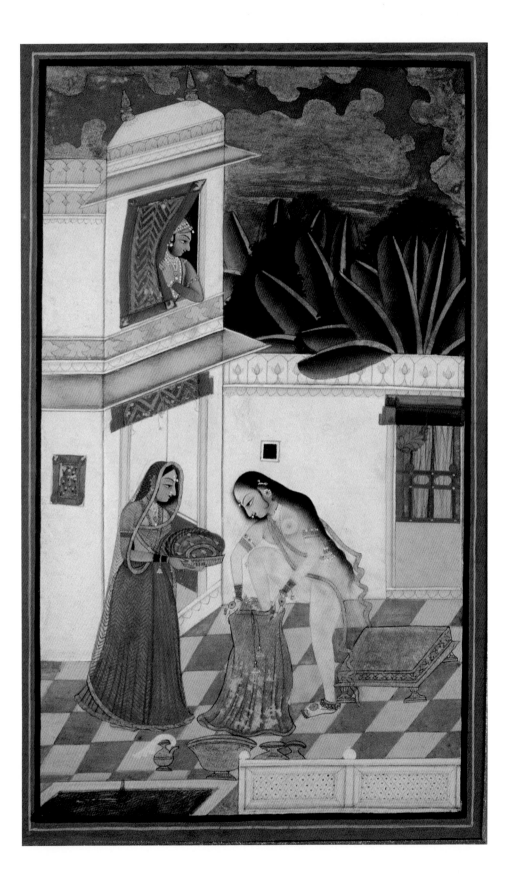

who may be favourable to him, and in the confidence of both, and carry on the conversation on both sides. On such an occasion, the girl should smile with her head bent down, and if the female friend says more on her part than she was desired to do, she should chide her and dispute with her. The female friend should say in jest even what she is not desired to say by the girl, and add, 'she says so,' on which the girl should say indistinctly and prettily, 'Oh no! I did not say so,' and she should then smile and throw an occasional glance towards the man.

If the girl is familiar with the man, she should place near him without saying anything, the *tambula*, the ointment, or the garland that he may have asked for, or she may tie them up in his upper garment. While she is engaged in this, the man should touch her young breasts in the sounding way of pressing with the nails, and if she prevents him doing this, he should say to her, 'I will not do it again if you will embrace me,' and should in this way cause her to embrace him. While he is being embraced by her, he should pass his hand repeatedly over and about her body. By and by he should place her in his lap, and try more and more to gain her consent, and if she will not yield to him he should frighten her by saying, 'I shall impress marks of my teeth and nails on your lips and breasts, and then make similar marks on my own body and shall tell my friends that you made them. What will you say then?' In this and other ways, as fear and confidence are created in the minds of children, so should the man gain her over to his wishes.

On the second and third nights, after her confidence has increased still more, he should feel the whole of her body with his hand, and

Facing page: A woman is helped in dressing up by her attendant while her lover sneaks a glance at her from above.

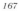

kiss her all over; he should also place his hands upon her thighs and shampoo them, and if he succeeds in this, he should then shampoo the joints of her thighs. If she tries to prevent him doing this he should say to her, 'What harm is there in doing it?' and should persuade her to let him do it. After gaining this point he should touch her private parts, should loosen her girdle and the knot of her dress, and turning up her lower garment should shampoo the joints of her naked thighs. Under various pretences he should do all these things, but he should not at that time begin actual congress. After this he should teach her the sixty-four arts, should tell her how much he loves her, and describe to her the hopes which he formerly entertained regarding her. He should also promise to be faithful to her in future, and should dispel all her fears with respect to rival women, and, at last, after having overcome her bashfulness, he should begin to enjoy her in a way so as not to frighten her. So much about creating confidence in the girl; and there are, moreover, some verses on the subject as follows:

'A man acting according to the inclinations of a girl, should try and gain her over so that she may love him and place her confidence in him. A man does not succeed either by implicitly following the inclinations of a girl, or by wholly opposing her, and he should, therefore, adopt a middle course. He who knows how to make himself beloved by women, as well as to increase their honour and create confidence in them, this man becomes an object of their love. But he who neglects a girl thinking she is too bashful, is despised by her as a beast ignorant of the workings of the female mind. Moreover, a girl forcibly enjoyed by one who does not understand the hearts of girls becomes nervous, uneasy, and dejected, and suddenly begins to hate the man who has taken advantage of her; and then, when her love is not understood or returned, she sinks into despondency and becomes either a hater of mankind altogether, or, hating her own man, she has recourse to other men.' ཨ

Facing page: Flexibility should be one of the aims, for man and woman alike, for delightful lovemaking.

Following pages: Making love with the woman seated on the man's thigh tests the man's prowess and increases their intimacy. The woman can also shyly play with her garland to excite the man further.

168

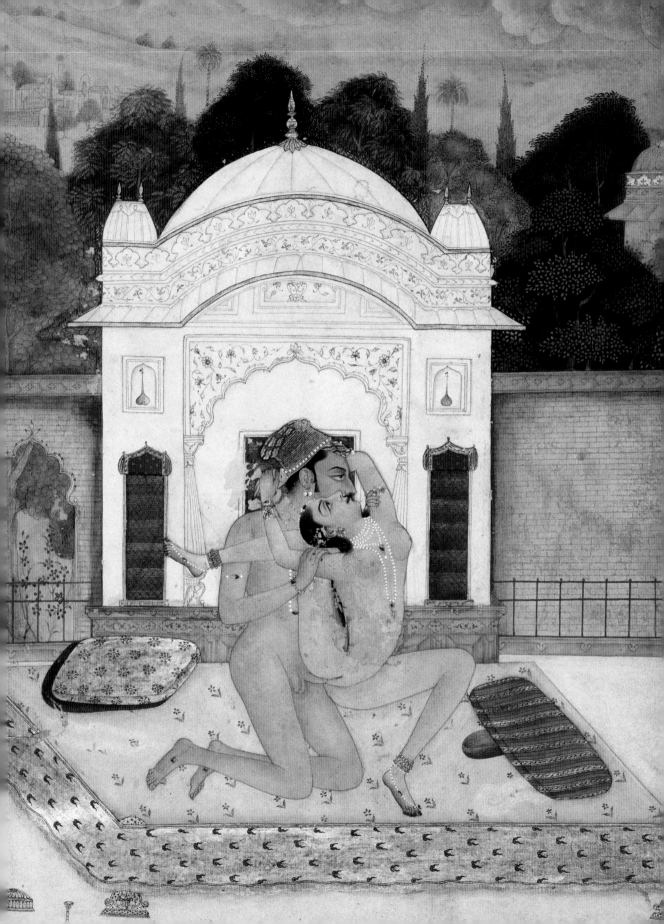

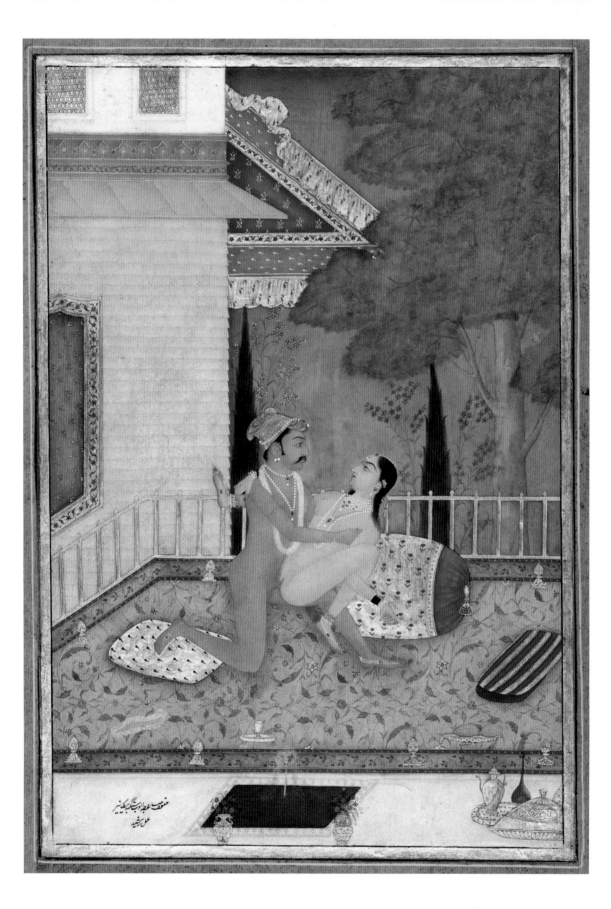

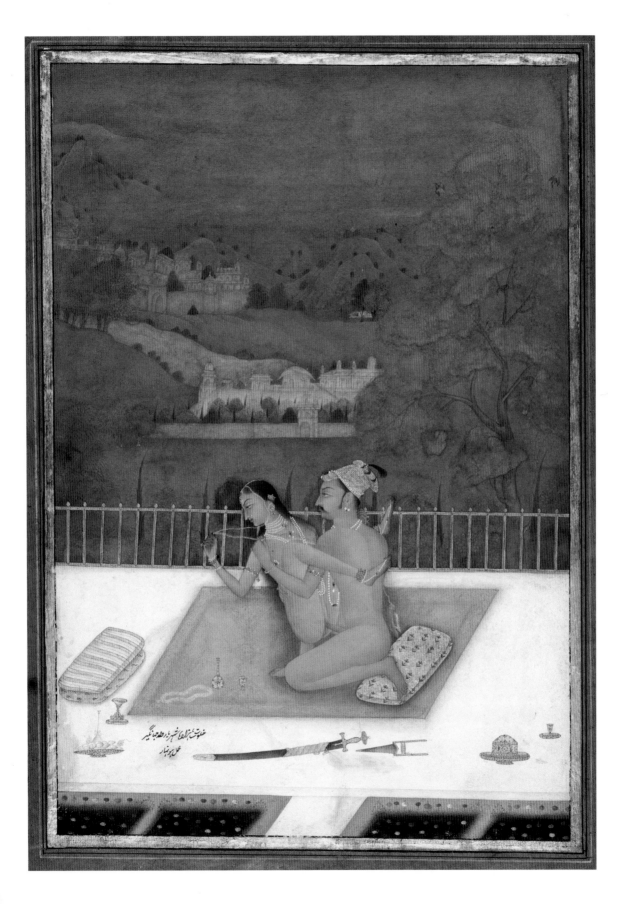

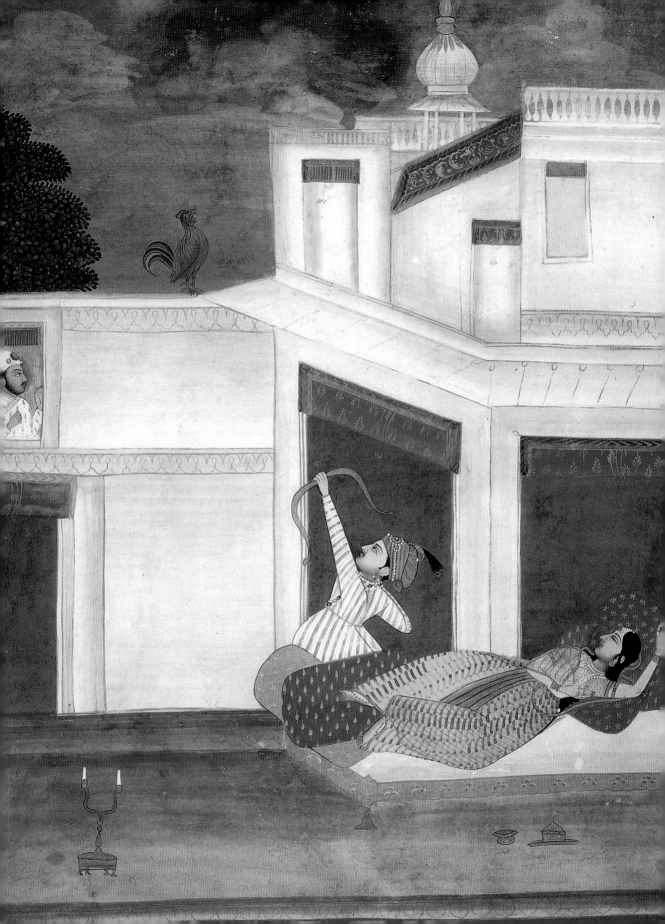

Of Living as a Virtuous Wife

A virtuous woman, who has affection for her husband, should act in conformity with his wishes as if he were a divine being, and with his consent should take upon herself the whole care of his family, she should keep the whole house well cleaned, and arrange flowers of various kinds in different parts of it, and make the floor smooth and polished so as to give the whole a neat and becoming appearance. She should surround the house with a garden, and place ready in it all the materials required for the morning, noon and evening sacrifices. Moreover, she should herself revere the sanctuary of the household gods, for says Gonardiya, 'Nothing so much attracts the heart of a householder to his wife as a careful observance of the things mentioned above.'

Towards the parents, relations, friends, sisters, and servants of her husband she should behave as they deserve. In the garden she should plant beds of green vegetables, bunches of sugarcane, and clumps of the fig tree, the mustard plant, the parsley plant, the fennel

Facing page: The husband practises his martial skill as his wife looks on in encouragement.

Following pages: The husband should keep his wife beside him at all times, even when he enjoys the company of courtesans and singers.

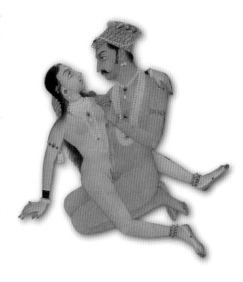

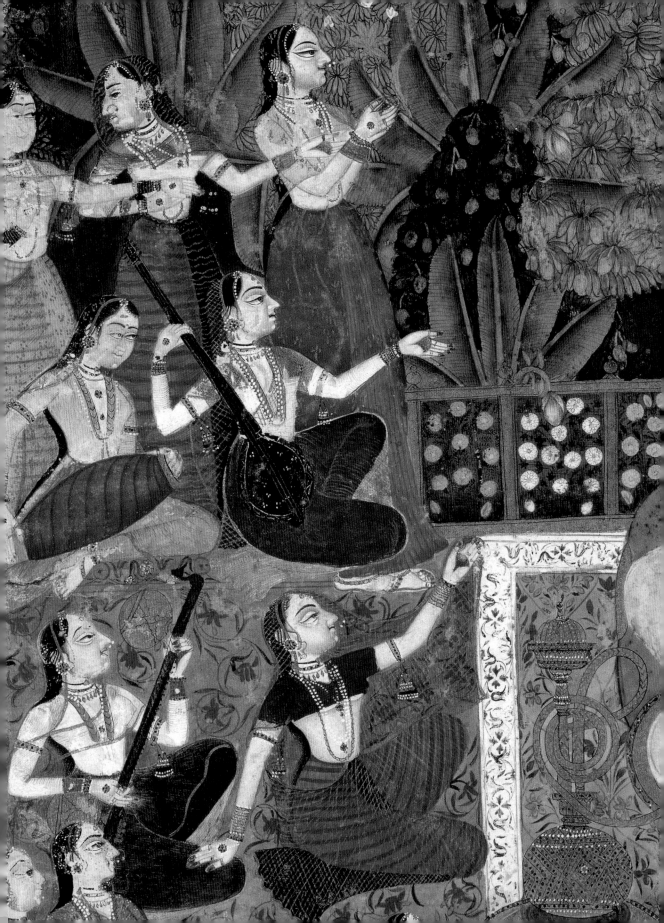

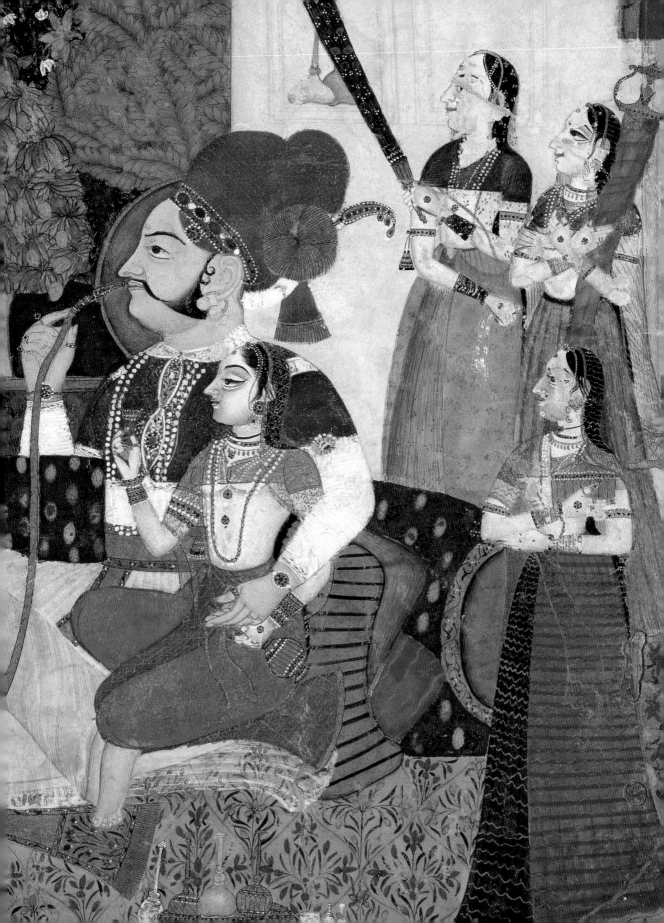

plant, and the *xanthochymus pictorius*. Clusters of various flowers such as the *trapa bispinosa*, the jasmine, the *gasminum grandiflorum*, the yellow amaranth, the wild jasmine, the *tabernamontana coronaria*, the *nadyaworta*, the china rose and others, should likewise be planted, together with the fragrant grass *andropogon schaenanthus*, and the fragrant root of the plant *andropogon miricatus*. She should also have seats and arbours made in the garden, in the middle of which a well, tank, or pool should be dug.

The wife should always avoid the company of female beggars and mendicants, unchaste and roguish women, female fortune tellers and witches. As regards meals she should always consider what her husband likes and dislikes, and what things are good for him and what are injurious to him. When she hears the sounds of his footsteps coming home she should at once get up, and be ready to do whatever he may command her, and either order her female servant to wash his feet, or wash them herself. When going anywhere with her husband, she should put on her ornaments, and without his consent she should not either give or accept invitations, or attend marriages and sacrifices, or sit in the company of female friends, or visit the temples of the gods. And if she wants to engage in any kind of games or sports, she should not do it against his will. In the same way she should always sit down after him, and get up before him, and should never awaken him when he is asleep. The kitchen should be situated in a quiet and retired place, so as not to be accessible to strangers, and should always look clean.

In the event of any misconduct on the part of her husband, she should not blame him excessively, though she be a little displeased. She should not use abusive language towards him, but rebuke him with conciliatory words, whether he be in the company of friends or alone. Moreover, she should not be a scold, for says Gonardiya, There is no cause of dislike on the part of a husband so

Facing page: As the wife complies with the husband's wishes, the husband takes care to satisfy her desire and widen their sensuous experience.

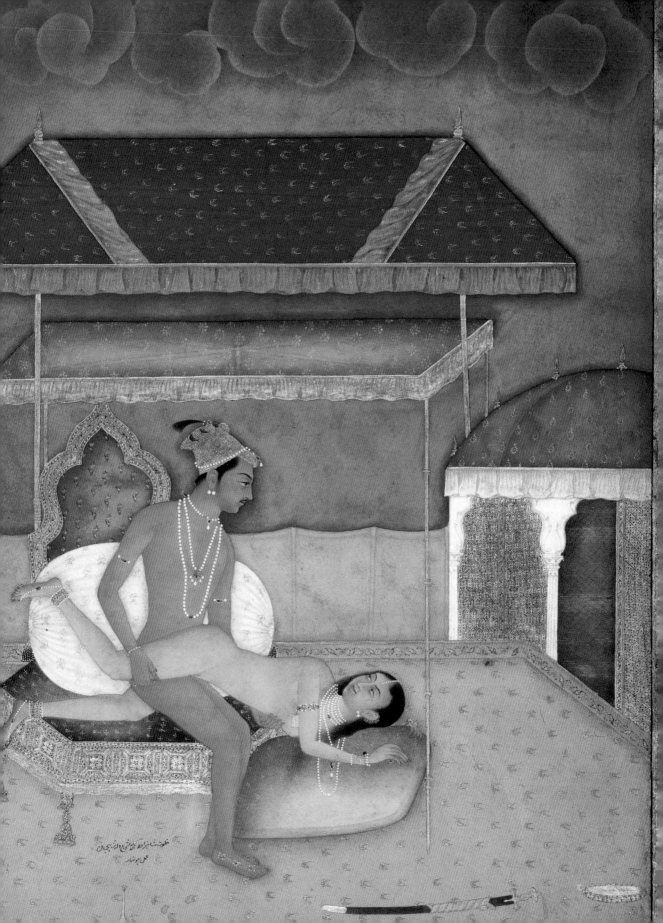

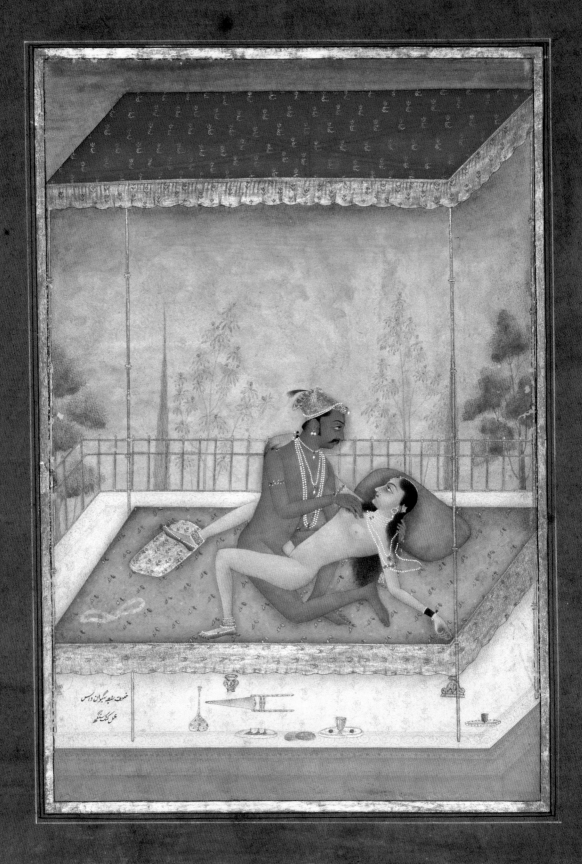

great as this characteristic in a wife.' Lastly, she should avoid bad expressions, sulky looks, speaking aside, standing in the doorway and looking at passers-by, conversing in the pleasure groves, and remaining in a lonely place for a long time; and finally she should always keep her body, her teeth, her hair and everything belonging to her tidy, sweet, and clean.

When the wife wants to approach her husband in private, her dress should consist of many ornaments, various kinds of flowers, and a cloth decorated with different colours, and some sweet-smelling ointments or unguents. But her everyday dress should be composed of a thin close-textured cloth, a few ornaments and flowers, and a little scent, not too much. She should also observe the fasts and vows of her husband, and when he tries to prevent her doing this, she should persuade him to let her do it.

At appropriate times of the year, and when they happen to be cheap, she should buy earth, bamboos, firewood, skins, and iron pots, as also salt and oil. Fragrant substances, vessels made of the fruit of the plant *wrightea antidysenterica*, or oval-leaved *wrightea*; medicines, and other things which are always wanted, should be obtained when required and kept in a secret place of the house. The seeds of the radish, the potato, the common beet, the Indian wormwood, the mango, the cucumber, the egg plant, the *kushmanda*, the pumpkin gourd, the *surana*, the *bignonia indica*, the sandalwood, the *premna spinosa*, the garlic plant, the onion, and other vegetables, should be bought and sown the proper seasons.

The wife, moreover, should not tell to strangers the amount of her wealth, nor the secrets which her husband has confided to her. She should surpass all the women of her own rank in life in her cleverness, her appearance, her knowledge of cookery, her pride, and her manner of serving her husband. The expenditure of the year should be regulated by the profits. The milk that remains

Facing page: Passionate conversation is a must between husband and wife, and not only during the act of love.

after the meals should be turned into ghee or clarified butter. Oil and sugar should be prepared at home; spinning and weaving should also be done there; and a store of ropes and cords, and barks of trees for twisting into ropes should be kept. She should also attend to the pounding and cleaning of rice, using its small grain and chaff in some way or other. She should pay the salaries of the servants, look after tilling of the fields, and take care of the rams, cocks, qulais, parrots, starlings, cuckoos, peacocks, monkeys, and deer; and finally adjust the income and expenditure of the day. The worn-out clothes should be given to those servants who have done good work, in order to show them that their services have been appreciated, or they may be applied to some other use. The vessels in which wine is prepared, as well as those in which it is kept, should be carefully looked after, and put away at the proper time. All sales and purchases should also be well attended to. The friends of her husband she should welcome by presenting them with flowers, ointment, incense, betel leaves, and betel nut. Her father-in-law and mother-in-law she should treat as they deserve, always remaining dependent on their will, never contradicting them, speaking to them in few and not harsh words, not laughing loudly in their presence, and acting with their friends and enemies as with her own. In addition to the above, she should not be vain, or too much taken up with her enjoyments. She should be liberal towards her servants, and reward them on holidays and festivals, and not give away anything without first making it known to her husband.

Thus ends the manner of living of a virtuous woman.

During the absence of her husband on a journey, the virtuous woman should wear only her auspicious ornaments, and observe the fasts in honour of the gods. While anxious to hear the news of her husband, she should still look after her household affairs. She should sleep near the elder women of the house, and make

Facing page: The woman should patiently show her husband where and how to give her pleasure.

180

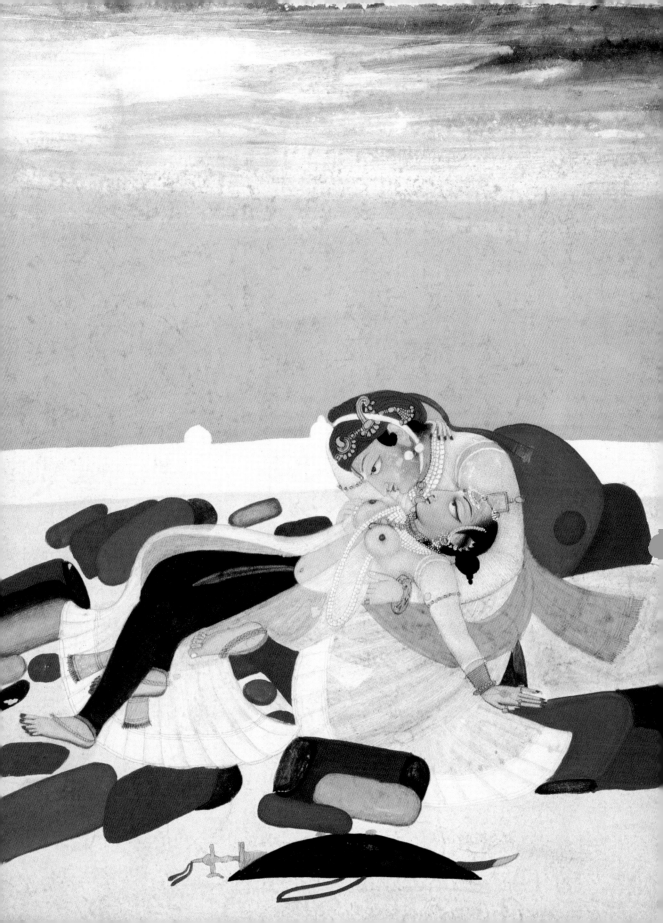

Facing page: The standing posture of lovemaking requires strength and control.

Following pages: Lord Krishna converses at the door, while the bed of love has been arranged for him and Radha waits inside.

herself agreeable to them. She should look after and keep in repair the things that are liked by her husband, and continue the works that have been begun by him. She should not go to the abode of her relations except on occasions of joy and sorrow, and then she should go in her usual travelling dress, accompanied by her husband's servants, and not remain there for a long time. The fasts and feasts should be observed with the consent of the elders of the house. The resources should be increased by making purchases and sales according to the practice of the merchants, and by means of honest servants, superintended by herself. The income should be increased, and the expenditure diminished as much as possible. And when her husband returns from his journey, she should receive him, at first in her ordinary clothes so that he may know in what way she has lived during his absence, and should bring to him some presents, and also materials for the worship of the deity.

Thus ends the part relating to the behaviour of a wife during the absence of her husband on journey.

There are also some verses on the subject as follows: The wife, whether she be a woman of noble family, or a virgin widow remarried, or a concubine, should lead a chaste life, devoted to her husband, and doing everything for his welfare. Women acting thus, acquire Dharma, Artha, and Kama, obtain a high postion, and generally keep their husbands devoted to them.' ঽ

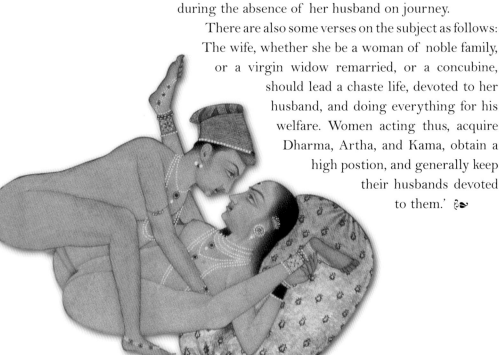

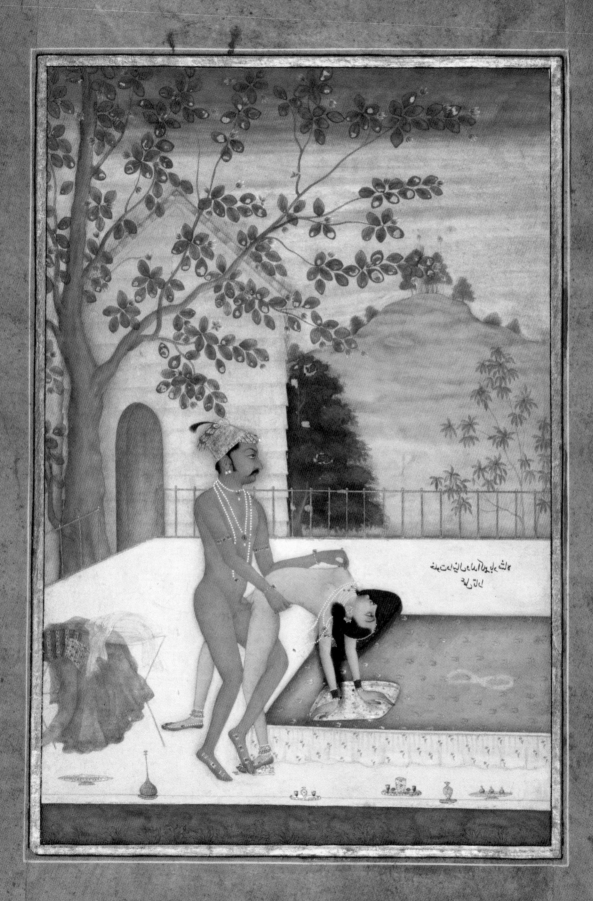

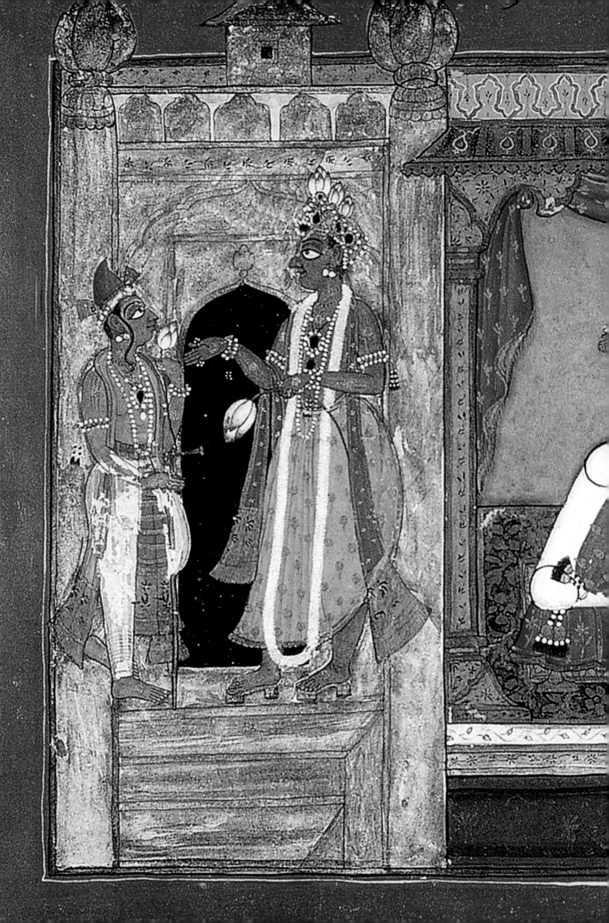

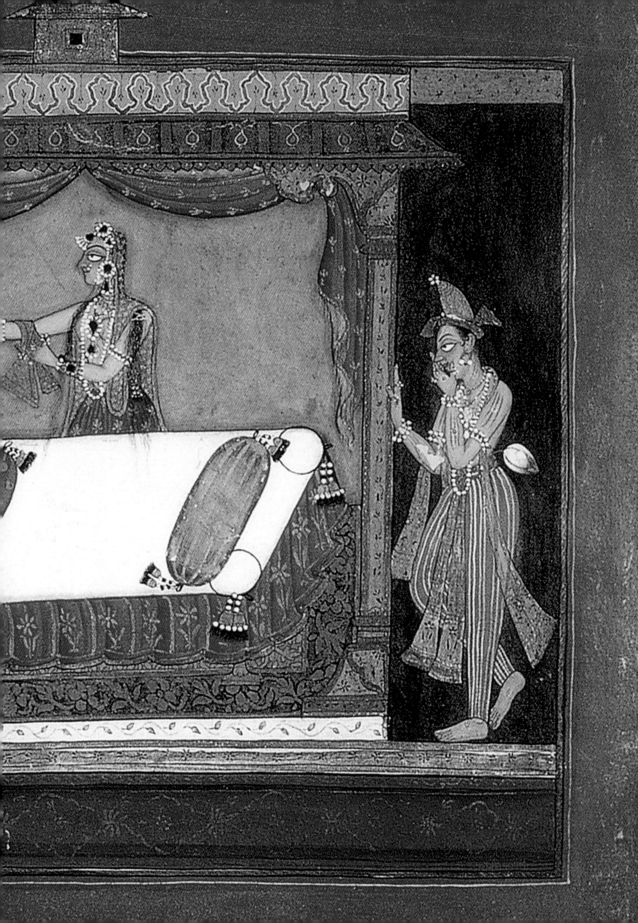

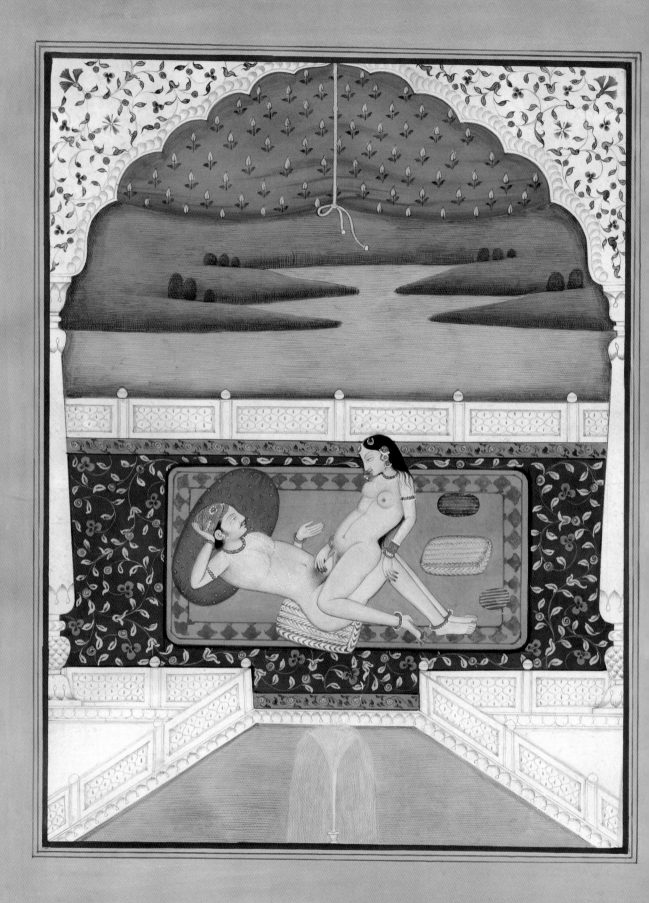

Of the Conduct of Husbands and Wives

The causes of re-marrying during the lifetime of the wife are as follows: the folly or ill temper of the wife; her husband's dislike of her; the want of offspring; the continual birth of daughters; the incontinence of the husband.

From the very beginning, a wife should endeavour to attract the heart of her husband by showing to him continually her devotion, her good temper, and her wisdom. If however, she bears him no children, she should herself tell her husband to marry another woman. And when the second wife is married, and brought to the house, the wife should give her a position superior to her own, and look upon her as a sister. In the morning, the elder wife should forcibly make the younger one decorate herself in the presence of their husband, and should not mind all the husband's favour being given to her. If the younger wife does anything to displease her husband, the elder one should not neglect her, but should always be ready to give her most careful advice,

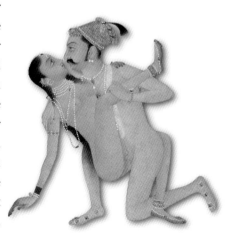

Facing page: A vista opening out to natural beauty is the perfect backdrop for intimate conversation and making love.

and should teach her to do various things in the presence of her husband. Her children she should treat as her own, her attendants she should look upon with more regard even than on her own servants, her friends she should cherish with love and kindness, and her relations with great honour.

When there are many other wives besides herself, the elder wife should associate with the one who is immediately next to her in rank and age, and should instigate the wife who has recently enjoyed her husband's favour to quarrel with the present favourite. After this she should sympathize with the former, and having collected all the other wives together, should get them to denounce the favourite as a scheming and wicked woman, without however committing herself in any way. If the favourite wife happens to quarrel with the husband, then the elder wife should take her part and give her false encouragement, and thus cause the quarrel to be increased. If there be only a little quarrel between the two, the elder wife should do all she can to work it up into a large quarrel. But if after all this, she finds the husband still continues to love his favourite wife, she should then change her tactics, and endeavour to bring about a conciliation between them, so as to avoid her husband's displeasure. Thus ends the conduct of the elder wife.

The younger wife should regard the elder wife of her husband as her mother, and should not give anything away, even to her own relations, without her knowledge. She should tell her everything about herself, and not approach her husband without her permission. Whatever is told to her by the elder wife she should not reveal to others, and she should take care of the children of the senior even more than of her own. When alone with her husband she should serve him well, but should not tell him of the pain she suffers from the existence of a rival wife. She may also obtain secretly from her husband some marks of his particular regard for her, and may tell

Facing page: The wife should keep herself clean and beautiful at all times for her husband.

Following pages: (Left) The husband should not sleep after making love to his wife, but gently caress and talk to her. (Right) The husband should urge his wife to overcome her shyness and take charge of their lovemaking.

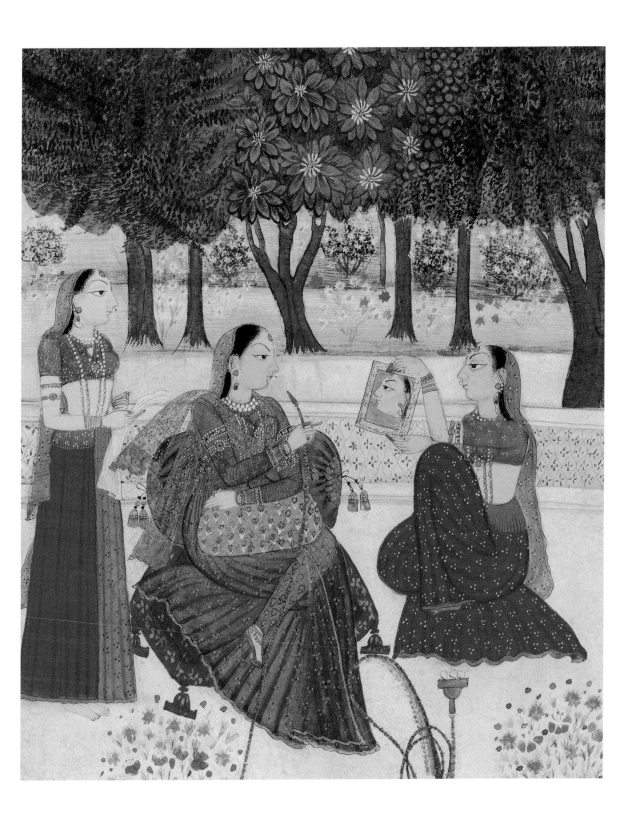

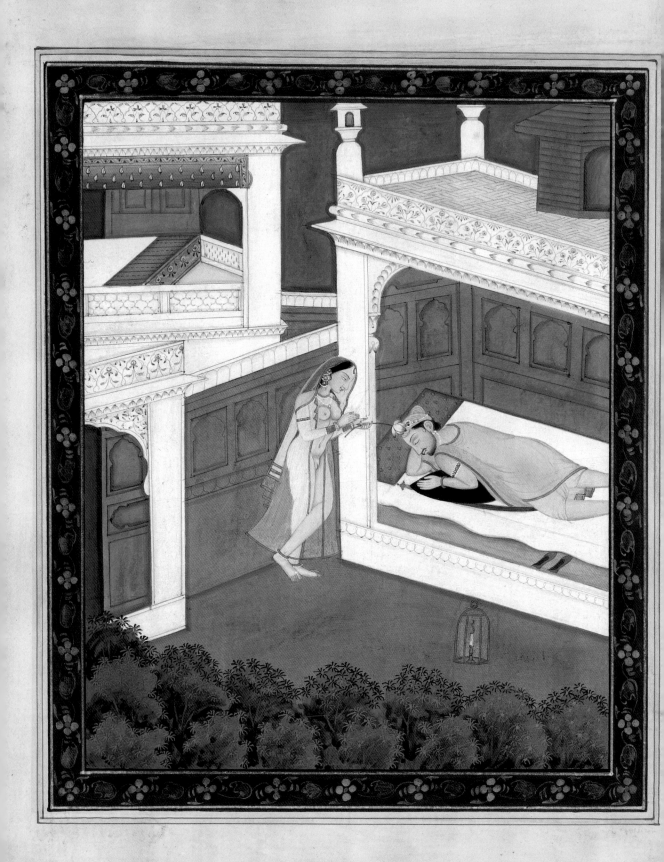

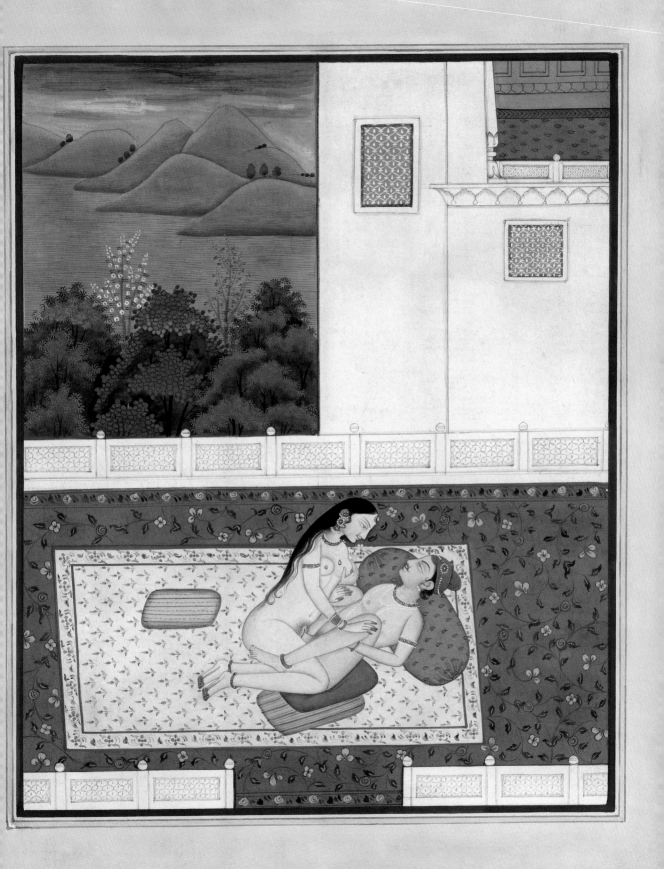

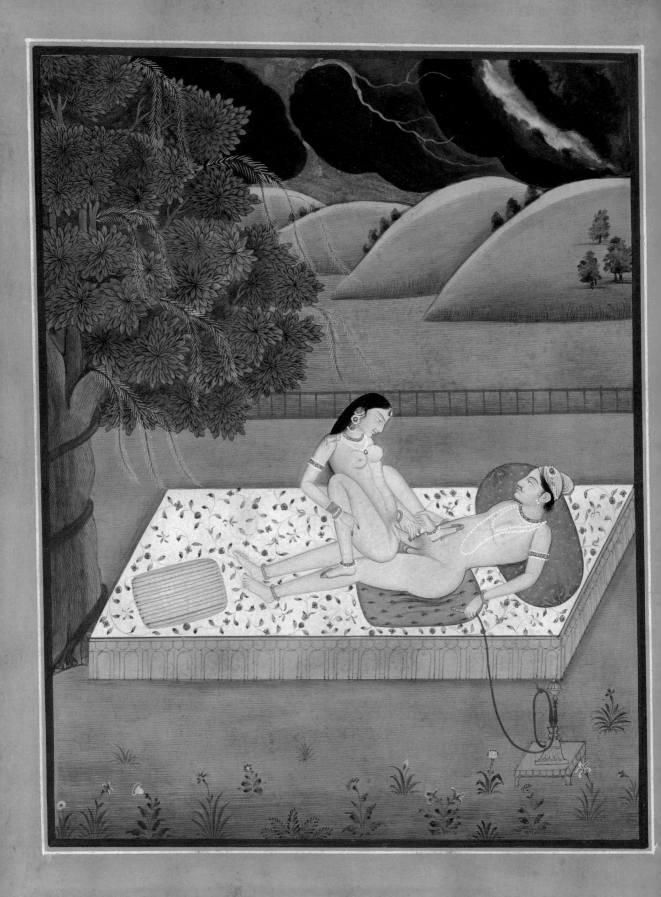

him that she lives only for him, and for the regard that he has for her. She should never reveal her love for her husband, nor her husband's love for her to any person, either in pride or in anger, for a wife that reveals the secrets of her husband is despised by him. As for seeking to obtain the regard of her husband, Gonardiya says, this should always be done in private, for fear of the elder wife. If the elder wife be disliked by her husband, or be childless, she should sympathize with her, and should ask her husband to do the same, but should surpass her in leading the life of a chaste woman. Thus ends the conduct of the younger wife towards the elder.

A widow in poor circumstances, or of a weak nature, and who allies herself again to a man, is called a widow re-married. The followers of Babhravya say that a virgin widow should not marry a person whom she may be obliged to leave on account of his bad character, or of his being destitute of the excellent qualities of a man, she thus being obliged to have recourse to another person. Gonardiya is of the opinion that as the cause of a widow marrying again is her desire for happiness, and as happiness is secured by the possession of excellent qualities in her husband, joined to love of enjoyment, it is better therefore, to secure a person endowed with such qualities in the first instance. Vatsyayana however, thinks that a widow may marry any person that she likes, and that she thinks will suit her.

At the time of her marriage, the widow should obtain from her husband the money to pay the costs of drinking parties, and picnics with her relations, and of giving them and her friends kindly gifts and presents; or she may do these things at her own cost if she likes. In the same way, she may wear either her husband's orna-ments or her own. As to the presents of affection mutually exchanged between the husband and herself, there is no fixed rule about them. If she leaves her husband after marriage of her own accord, she should

Over time, lovers learn how to relax during the act of love, even as they build up the intensity of the climax.

restore to him whatever he may have given her, with the exception of the mutual presents. If however, she is driven out of the house by her husband, she should not return anything to him.

After her marriage, she should live in the house of her husband like one of the chief members of the family, but should treat the other ladies of the family with kindness, the servants with generosity, and all the friends of the house with familiarity and good temper. She should show that she is better acquainted with the sixty-four arts than the other ladies of the house, and in any quarrels with her husband, she should not rebuke him severely, but in private do everything that he wishes, and make use of the sixty-four ways of enjoyment. She should be obliging to the other wives of her husband, and to their children she should give presents, behave as their mistress, and make ornaments and playthings for their use. In the friends and servants of her husband she should confide more than in his other wives, and finally she should have a liking for drinking parties, going to picnics, attending fairs and festivals, and for carrying out all kinds of games and amusements. Thus ends the conduct of a virgin widow remarried.

A woman who is disliked by her husband, and annoyed and distressd by his other wives, should associate with the wife who is liked most by her husband, and who serves him more than the others, and should teach her all the arts with which she is acquainted. She should act as the nurse of her husband's children, and having gained over his friends to her side, should through them make him acquainted of her devotion to him. In religious ceremonies she should be a leader, as also in vows and fasts, and should not hold too good an opinion of herself. When her husband is lying on his bed, she should only go near him when it is agreeable to him, and should never rebuke him, or show obstinacy in any way. If her husband happens to quarrel with any of his other wives, she should reconcile them to each other, and if he desires

Facing page: The wife can make love to another man together with her husband if both so desire.

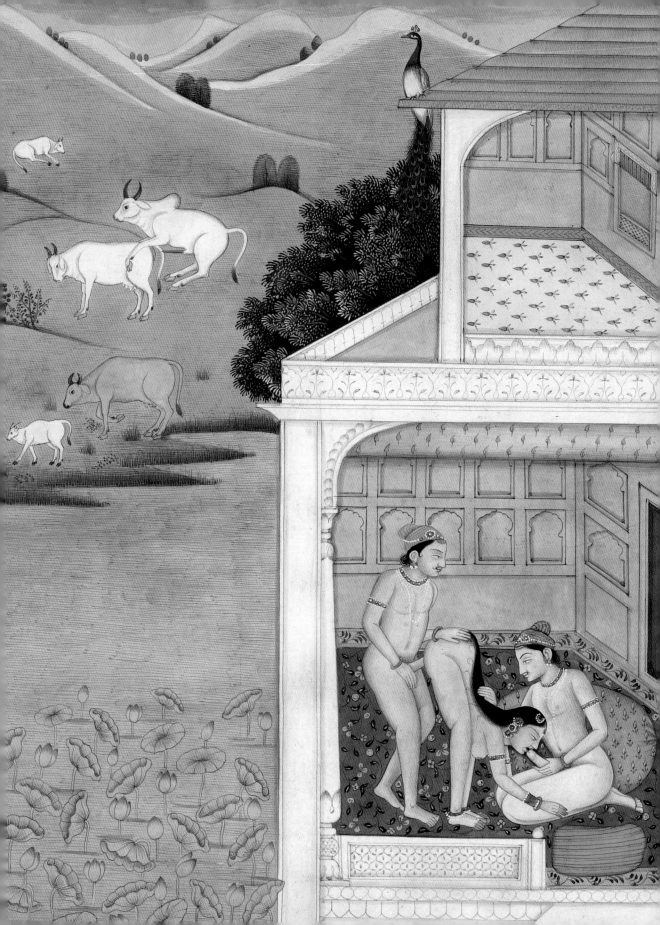

Facing page: The husband can ask his wife to excite him orally, for the pleasure of both.

to see any woman secretly, she should manage to bring about the meeting between them. She should, moreover, make herself acquainted with the weak points of her husband's character, but always keep them secret, and on the whole behave herself in such a way as may lead him to look upon her as a good and devoted wife. Here ends the conduct of a wife disliked by her husband.

A man marrying many wives should act fairly towards them all. He should neither disregard nor pass over their faults, and should not reveal to one wife the love, passion, bodily blemishes, and confidential reproaches of the other. No opportunity should be given to any one of them of speaking to him about their rivals, and if one of them should begin to speak ill of another, he should chide her and tell her that she has exactly the same blemishes in her character. One of them he should please by secret confidence, another by secret respect, and another by secret flattery, and he should please them all by going to gardens, by amusements, by presents, by honouring their relations, by telling them secrets, and lastly by loving unions. A youngwoman who is of a good temper, and who conducts herself according to the precepts of the Holy Writ, wins her husband's attachment, and obtains a superiority over her rivals. ❧

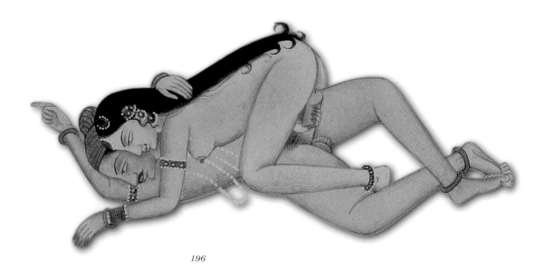

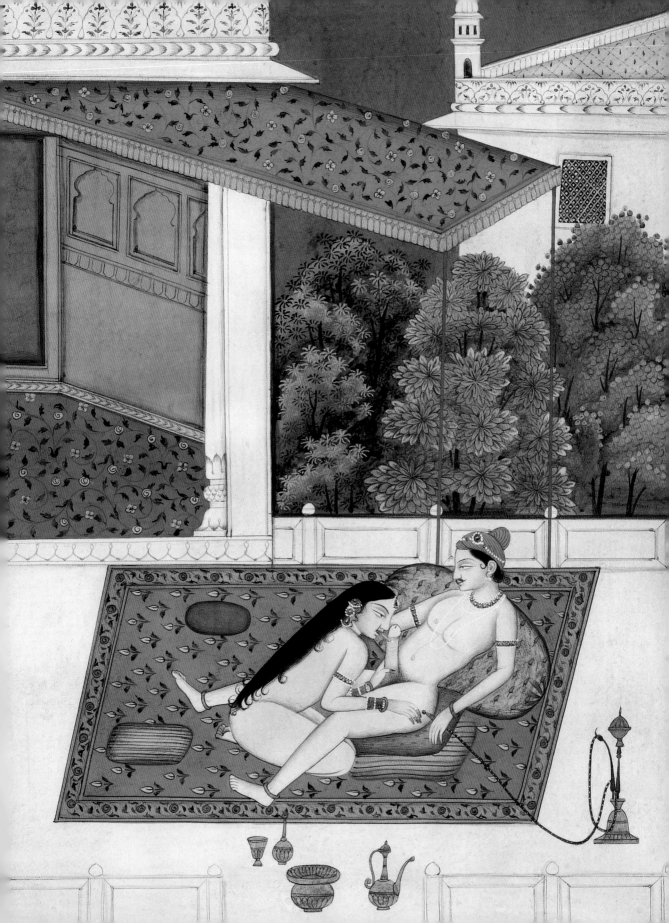

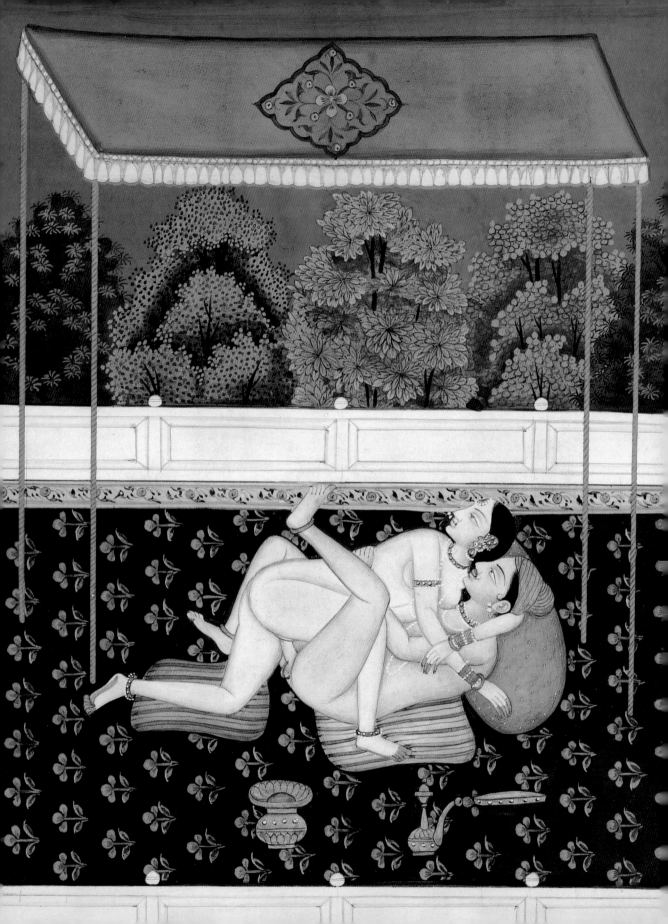

Of Manifestation of the Feelings by Outward Signs and Deeds

A poor man possessed of good qualities, a man born of a low family possessed of mediocre qualities, a neighbour possessed of wealth, and one under the control of his father, mother or brothers, should not marry without endeavouring to gain over the girl from her childhood, to love and esteem them. Thus a-boy separated from his parents, and living in the house of his uncle, should try to gain over the daughter of his uncle, or some other girl, even though she be previously betrothed to another. And this way of gaining over a girl, says Ghotakamukha, is unexpectional, because Dharma can be accomplished by means of it, as well as by any other way of marriage.

When a boy has thus begun to woo the girl he loves, he should spend his time with her and amuse her with various games and diversions fitted for their age and acquaintanceship, such as picking and collecting flowers, making garlands of flowers, playing the roles of members of a fictitious family, cooking food, playing with dice,

Facing page: The man and woman in love must enjoy the beautiful sights and sounds of nature for long-lasting pleasure and its memory.

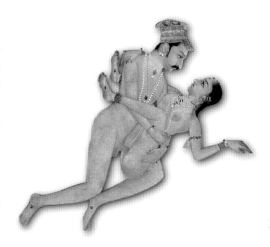

playing with cards, the game of odd and even, the game of finding out the middle finger, the game of six pebbles, and such other games as may be prevalent in the country, and agreeable to the disposition of the girl. In addition to this, he should carry on various amusing games played by several persons together, such as hide and seek, playing with seeds, hiding things in several small heaps of wheat and looking for them, blind-man's buff, gymnastic exercises, and other games of the sort, in company with the girl, her friends and female attendants. The man should also show great kindness to any woman whom the girl thinks fit to be trusted, and should also make new acquaintances, but above all he should attach to himself by kindness and little services, the daughter of the girl's nurse, for if she be gained over, even though she comes to know of his design, she does not cause any obstruction, but is sometimes even able to effect an union between him and the girl. And though she knows the true character of the man, she always talks of his many excellent qualities to the parents and relations of the girl, even though she may not be desired to do so by him.

In the next place he should get her to meet him in some place privately, and should then tell her that the reason of his giving presents to her in secret was the fear that the parents of both of them might be displeased, and then he may add that the things which he had given her had been much desired by other people. When her love begins to show signs of increasing, he should relate to her agreeable stories if she expresses a wish to hear such narratives. Or if she takes delight in legerdemain, he should amaze her by performing various tricks of jugglery; or if she feels a great curiosity to see a performance of the various arts, he should show his own skill in them. When she is delighted with singing he should entertain her with music, and festivals, and at the time of her return after being absent from home, he should present her with bouquets of flowers, and with

Facing page: The woman should tenderly caress the man and show her affection to him through words and expressions.

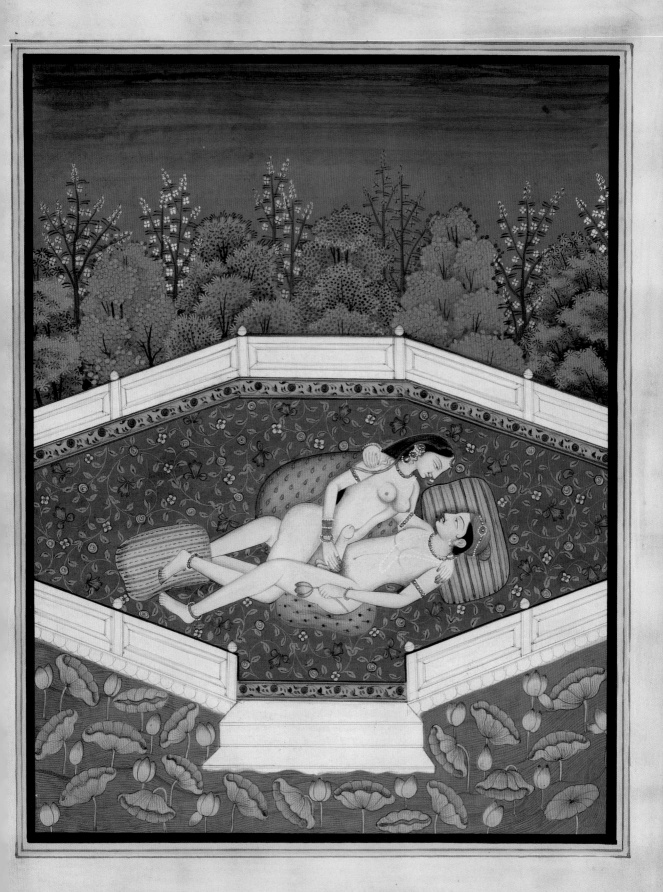

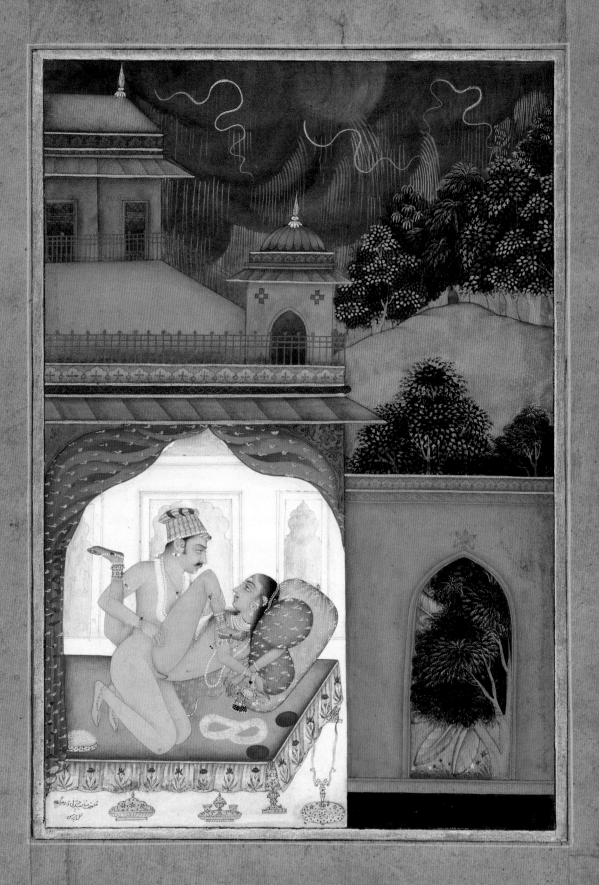

chaplets for the head, and with ear ornaments and rings, for these are the proper occasions on which such things should be presented.

He should also teach the daughter of the girl's nurse all the sixty-four means of pleasure practised by men, and under this pretext should also inform her of his great skill in the art of sexual enjoyment. All this time he should wear a fine dress, and make as good an appearance as possible, for young women love men who live with them, and who are handsome, good looking and well dressed. As for the saying that though women may fall in love, they still make no effort themselves to gain over the object of their affections, that is only a matter of idle talk.

Thus ends this treatise on the art of love

Thus ends the Kama Sutra of Vatsyayana, which might otherwise be called a treatise on men and women, their mutual relationship, and connection with each other. It is a work that should be studied by all; both old and young; the former will find in it real truths, gathered by experience, and already tested by themselves, while the latter will derive the great advantage of learning things, which some perhaps may otherwise never learn at all, or which they may only learn when it is too late to profit by the learning.

It can also be fairly commended to the student of social science and of humanity, and above all to the student of those early ideas, which have gradually filtered down through the sands of time, and which seem to prove that the human nature of today is much the same as the human nature of long ago. It has been said of Balzac that he seemed to have inherited a natural and intuitive perception of the feeling of men and women, and has described them with an analysis worthy of a man of science. The author of the present work must also have had a considerable knowledge of humanity. Many of his remarks are so full of simplicity and truth, that they have stood the test of time, and

Facing page: The body becomes a pliable tool of pleasure in the hands of the lover.

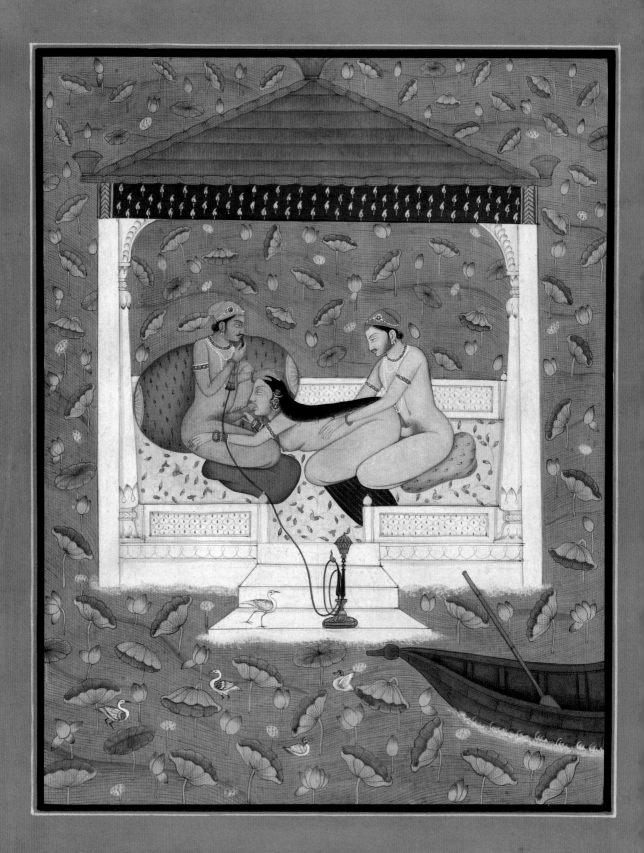

stand out still as clear and true as when they were first written, some eighteen hundred years ago.

As a collection of facts, told in plain and simple language, it must be remembered that in those early days there was apparently no idea of embellishing the work, either with a literary style, a flow of language, or quantity of superfluous padding. The author tells the world what he knows in very concise language, without any attempt to produce an interesting story. From his facts how many novels could be written!

And now, one word about the author of the work, the good old sage Vatsyayana. It is much to be regretted that nothing can be discovered about his life, his belongings, and his surroundings. He states that he wrote the work while leading the life of a religious student (probably at Benares) and while wholly engaged in the contemplation of the Deity. He must have arrived at a certain age at that time, for throughout he gives us the benefit of his experience and of his opinions, and these bear the stamp of age rather than youth; indeed the work could hardly have been written by a young man.

In a beautiful verse of the Vedas of the Christians it has been said of the peaceful dead, that they rest from their labours, and that their works do follow them. Yes indeed, the works of men of genius do follow them, and remain as a lasting treasure. And though there may be disputes and discussions about the immortality of the body or the soul, nobody can deny the immortality of genius which ever remains as a bright and guiding star to the struggling humanities of succeeding ages. This work, then, which has stood the test of centuries, has placed Vatsyayana among the immortals, and on this, and on him no better elegy or eulogy can be written than the following lines:

So long as lips shall kiss, and eyes shall see,

So long lives this, and This gives life to thee. ঌ

Facing page: The three engrossed lovers indulge themselves in the centre of a lake surrounded by lotus flowers, which are used by Kamadeva to awaken love.

Following pages: The man must woo his beloved with gifts and surprise encounters before she agrees to make love.

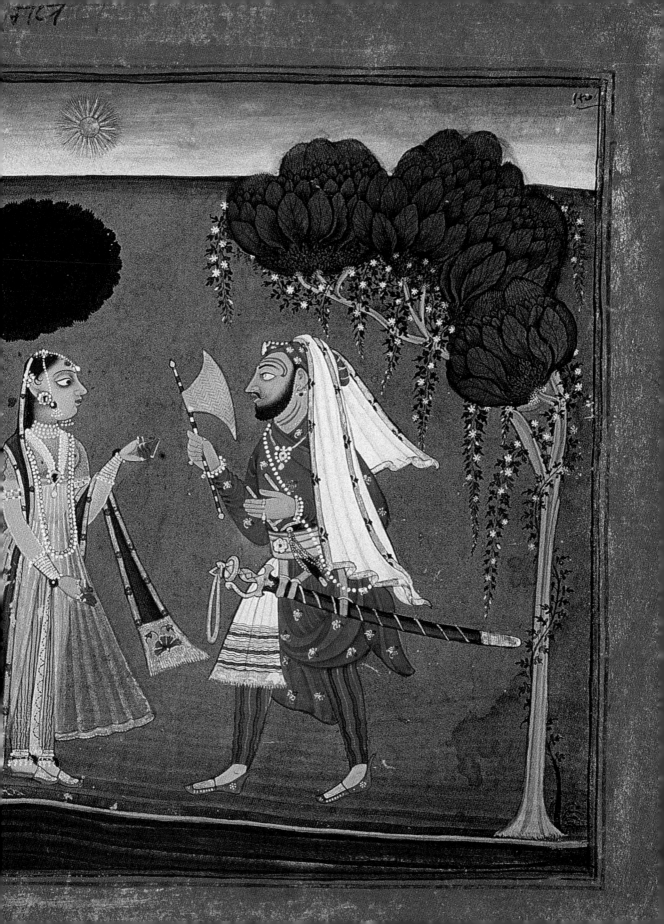

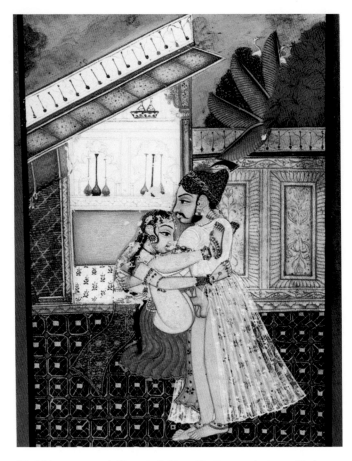

PHOTO CREDITS

Bridgeman - 2, 25, 27, 29, 32, 40, 49, 52, 64, 70, 74, 79, 80, 86, 99, 105, 110-111, 118, 123, 128, 131, 136, 141, 152, 154, 160, 161, 162, 169, 170, 171, 177, 178, 183, 202

Corbis - 6, 11, 20, 43, 45, 60, 126

Roli - 1, 4-5, 10. 14. 15, 17, 18, 19, 30, 33, 35, 38-39, 44, 47, 48, 68, 72, 84, 89, 90, 92, 94, 97, 98, 100, 102, 104, 112, 115, 116, 120-121, 124, 133, 139,143, 144, 146, 157, 159, 165, 166, 181, 186, 189, 190, 191, 192, 195, 197, 198, 201, 204, 206-207

Sandhya Mulchandani - 140, 208

Private Collection - Cover, 8, 12-13, 22, 37, 56, 58, 62-63, 67, 108, 134, 135, 148, 151, 172, 174-175, 184-185

Warner Forman Archive, London - 55, 82-83, 106

ISBN: 978-81-7436-706-8

© Roli & Janssen BV 2009
Published in India by Roli Books
in arrangement with Roli & Janssen BV
M-75, Greater Kailash-II Market
New Delhi-110 048, India.
Ph.: ++91-11-40682000
Fax: ++91-11-29217185
Email: info@rolibooks.com; Website: rolibooks.com

Editor: Richa Burman
Design: Supriya Saran
Production: Naresh Nigam

Printed and bound in India